Chaumet
Photographers' gaze

Chaumet
Photographers' gaze

CITADELLES
& MAZENOD

Foreword	**7**
# New shared perspectives	**9**
Chaumet and **photography** *by Carol Woolton*	**25**
# Anthology	**41**
# Shared perspectives	**97**
Jewellery **under the lens** *by Sylvie Lécallier*	**145**

Contents

153 Anthology

209 **Eyes on gemstones**
by Flora Triebel

217 Joseph Chaumet's studio

233 **Index of photographers**

Foreword

A cast of the eye and a tilt of the head, looks and poses, styles and lightings, instants that last forever: the hushed salons on Place Vendôme and darkrooms speak the same secret language. Chaumet and photography have a shared history, fuelling and feeding off each other to such an extent that they are almost one and the same.

Testament to the excellence of its savoir-faire, the Maison's bold and magnificent High Jewellery creations draw in all eyes, turn all heads and even crown a few favoured ones, including those of models or actresses like Stella Tennant, Diane Kruger, Kate Moss, Jessica Miller and Anne Gunning Parker.

In addition to showcasing the Maison's most emblematic projects, with two new series especially photographed by Elizaveta Porodina and Karim Sadli, this first major photographic retrospective reproduces an exceptional set of fashion editorials spanning from 1934 to the current decade, featuring Chaumet creations shot by leading photographers such as Henry Clarke, Guy Bourdin, Mario Testino, Bettina Rheims, Mario Sorrenti and Richard Burbridge. The book closes with a special insert presenting a remarkable selection of precious autochrome glass plates depicting iconic pieces from the early twentieth century.

At the end of the nineteenth century, Joseph Chaumet, successor to the Maison's founder, created his own photography laboratory. Since his time, the Maison's leadership teams have continued to build up an exceptional photographic heritage, which now includes 211,000 photographs and 33,000 autochrome glass plates.

Three prominent specialists in the field of photography explore the close connections between the Maison and the photographic medium: Carol Woolton, jewellery editor of British Vogue for twenty years; Sylvie Lécallier, curator in charge of photographic collections at the Palais Galliera, Fashion museum of Paris; and Flora Triebel, curator of nineteenth-century photographs at the National Library of France.

Here, almost two hundred images shed new light on the history of jewellery, photography and the representation of women from the early twentieth century to the present day. ❖

The following
unprecedented series
have been shot by
Karim Sadli and
Elizaveta Porodina
for this book.

New shared perspectives

Opposite
and following pages:

Karim Sadli

2024

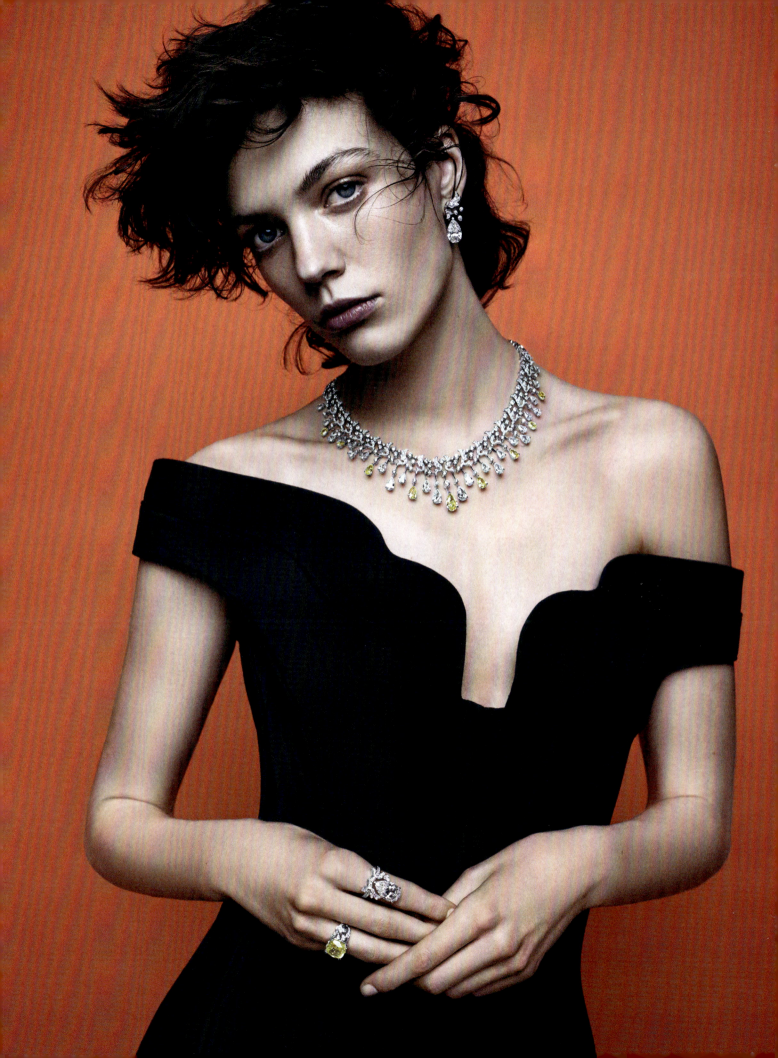

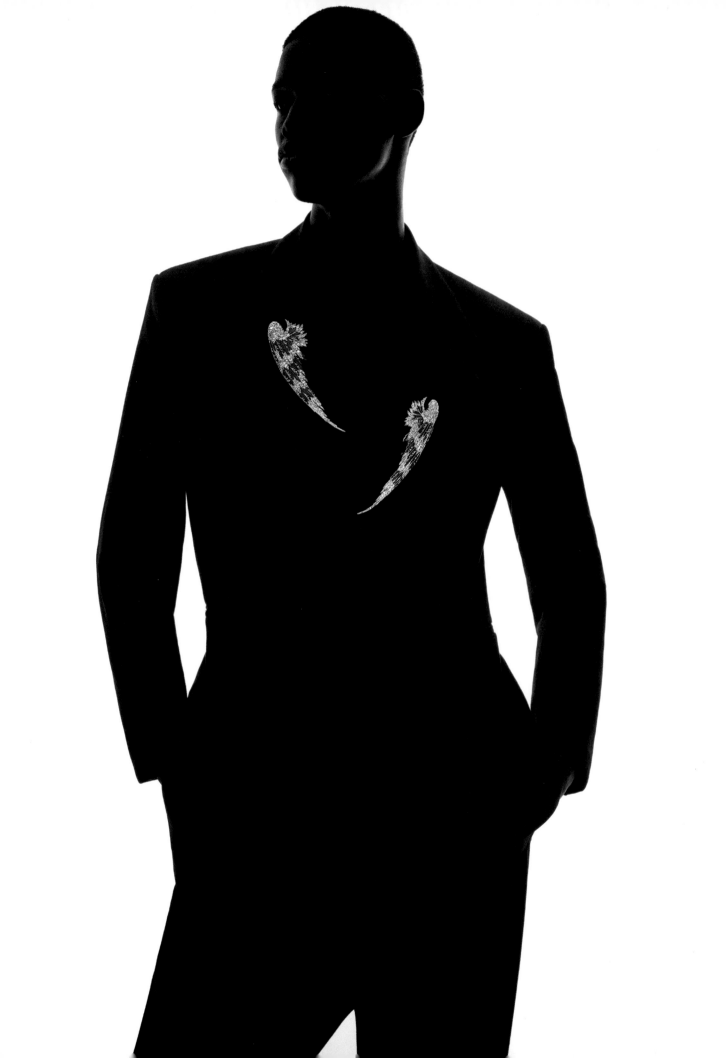

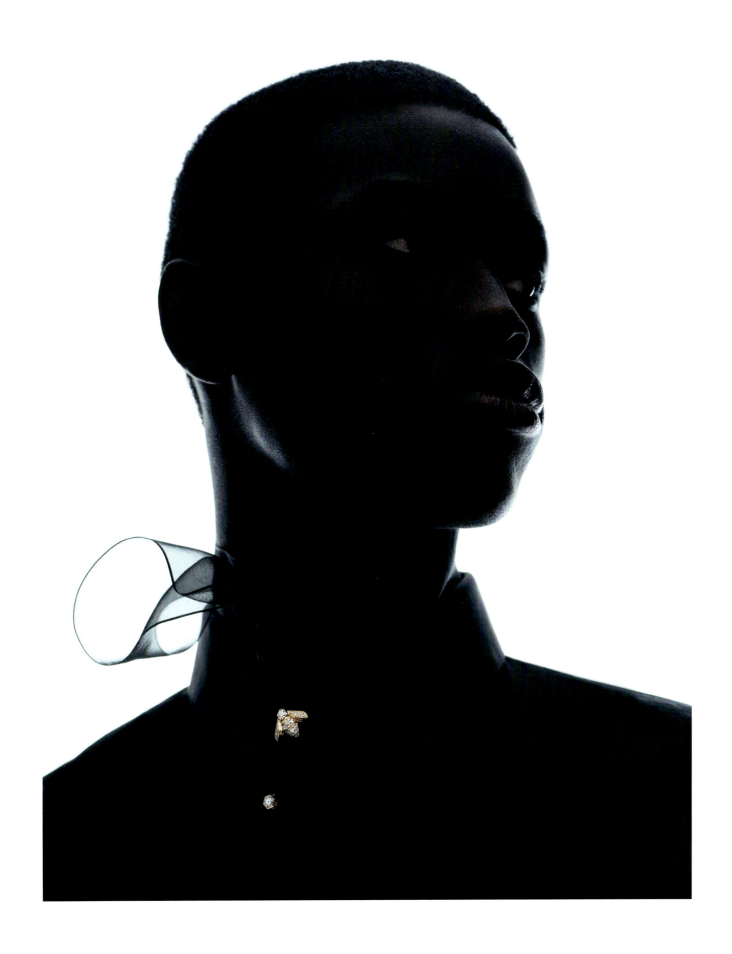

NEW SHARED PERSPECTIVES

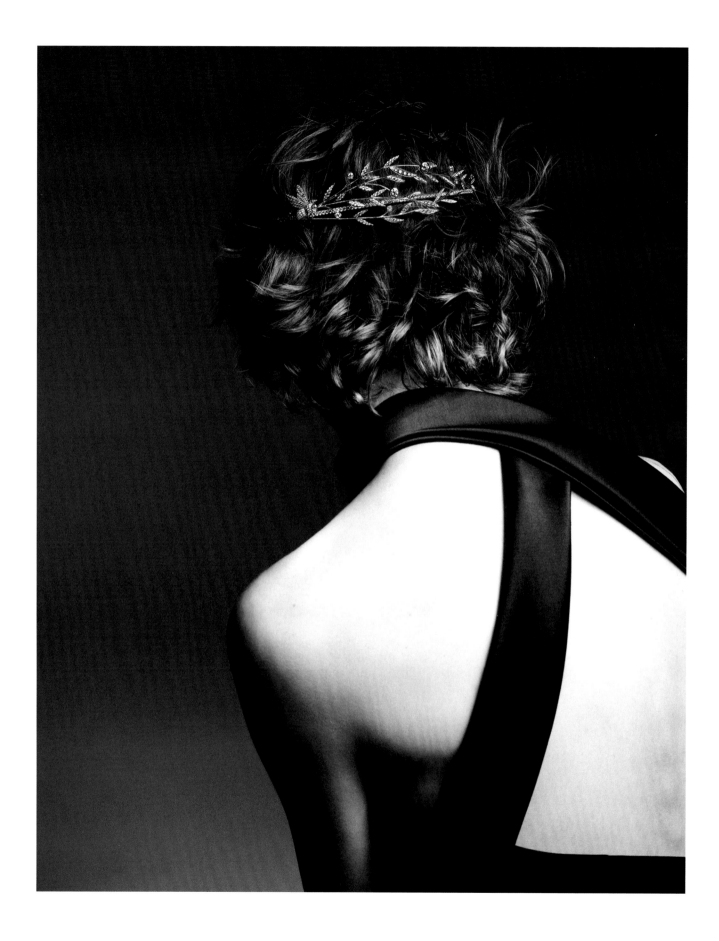

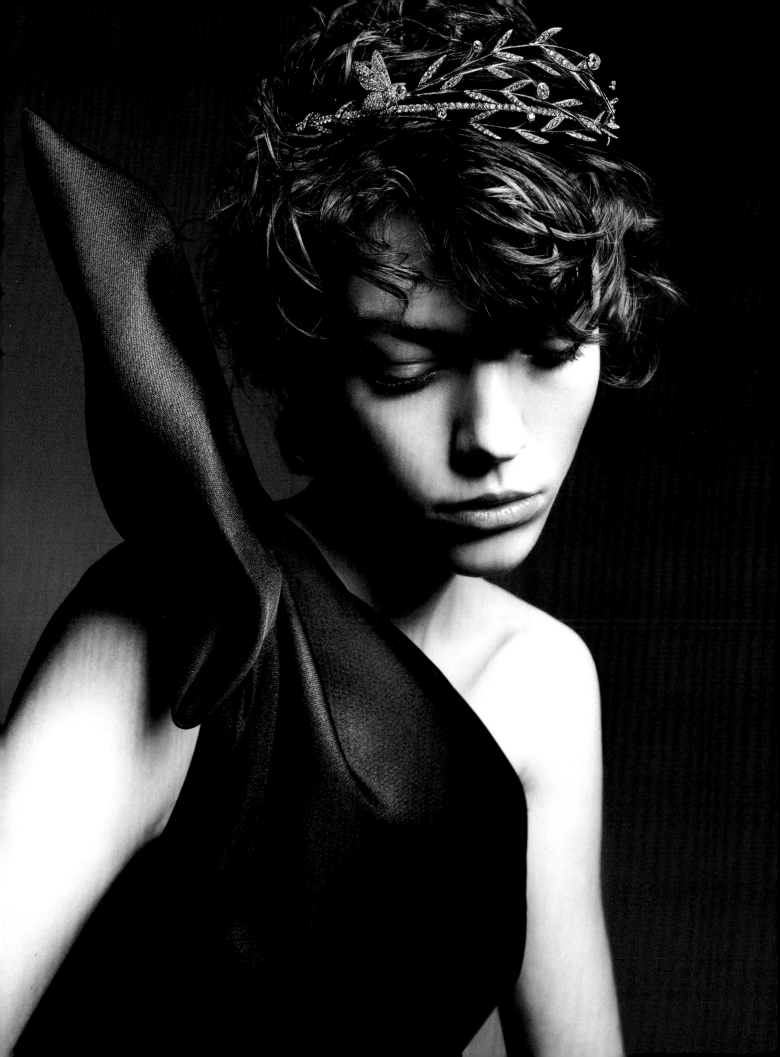

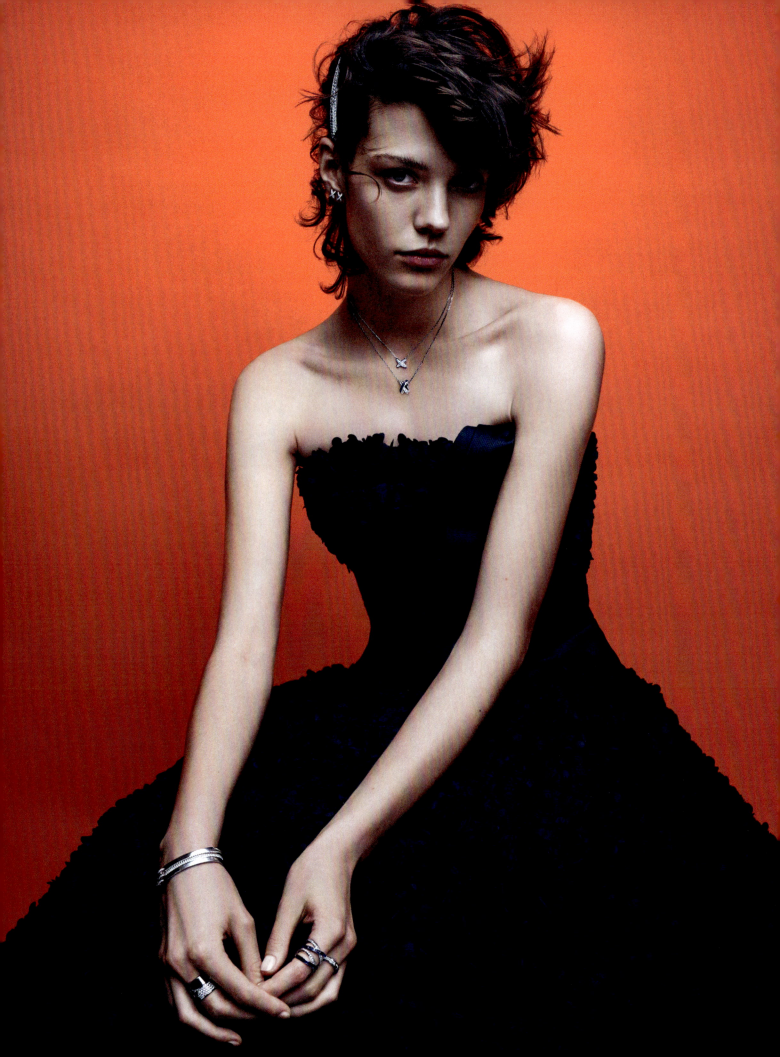

Following pages:
Elizaveta Porodina
2024

NEW SHARED PERSPECTIVES

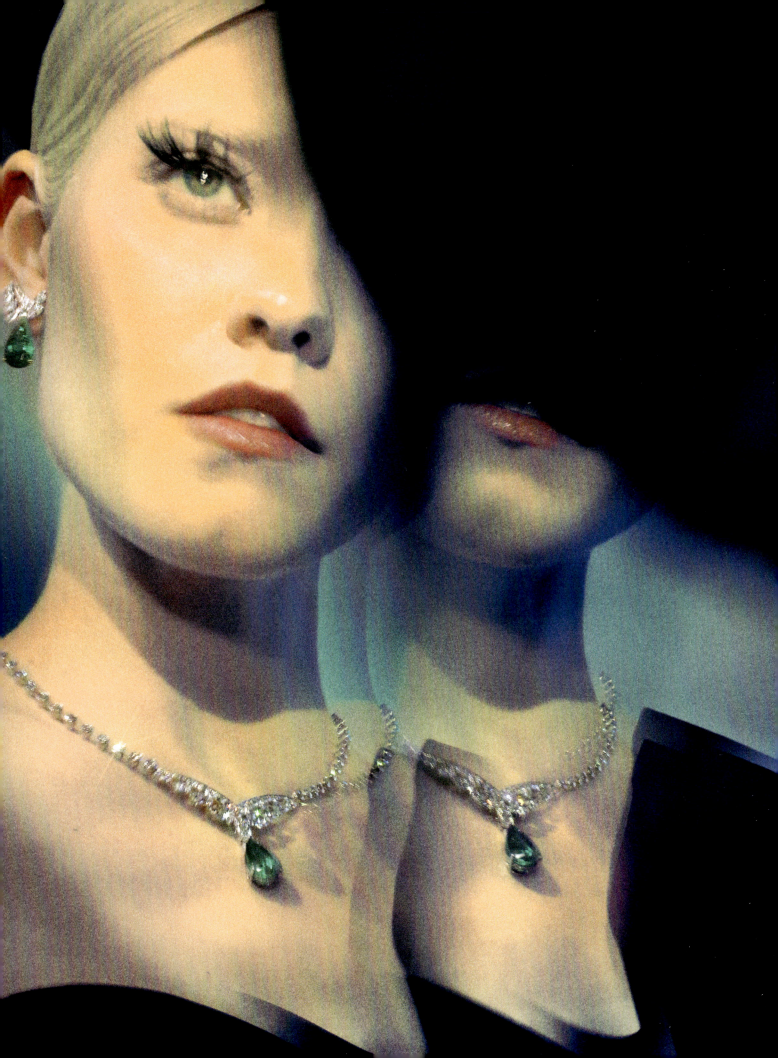

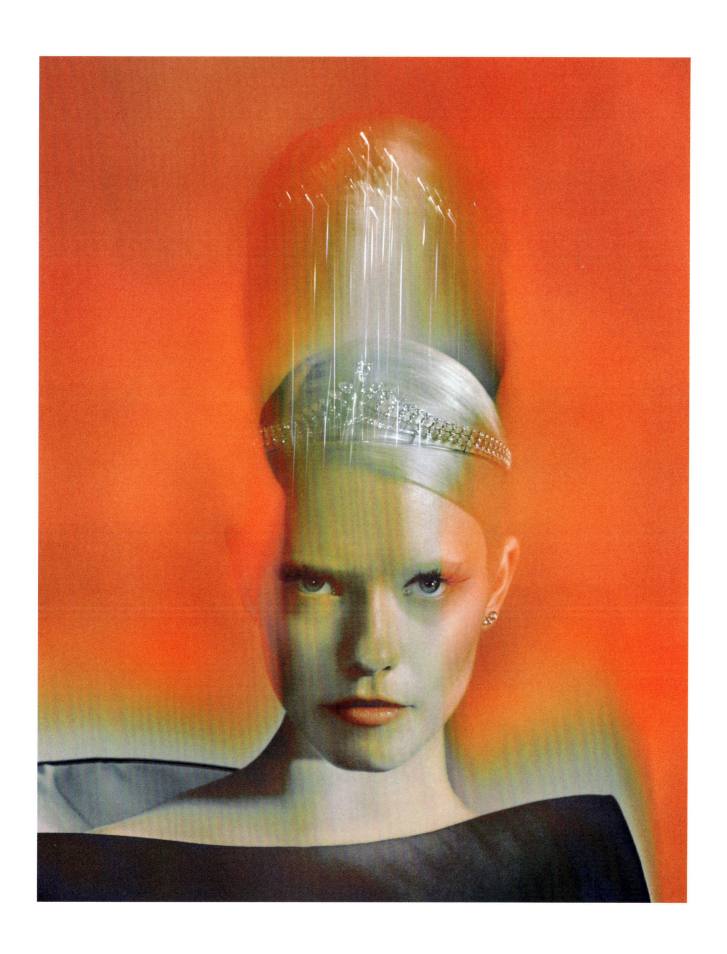

NEW SHARED PERSPECTIVES

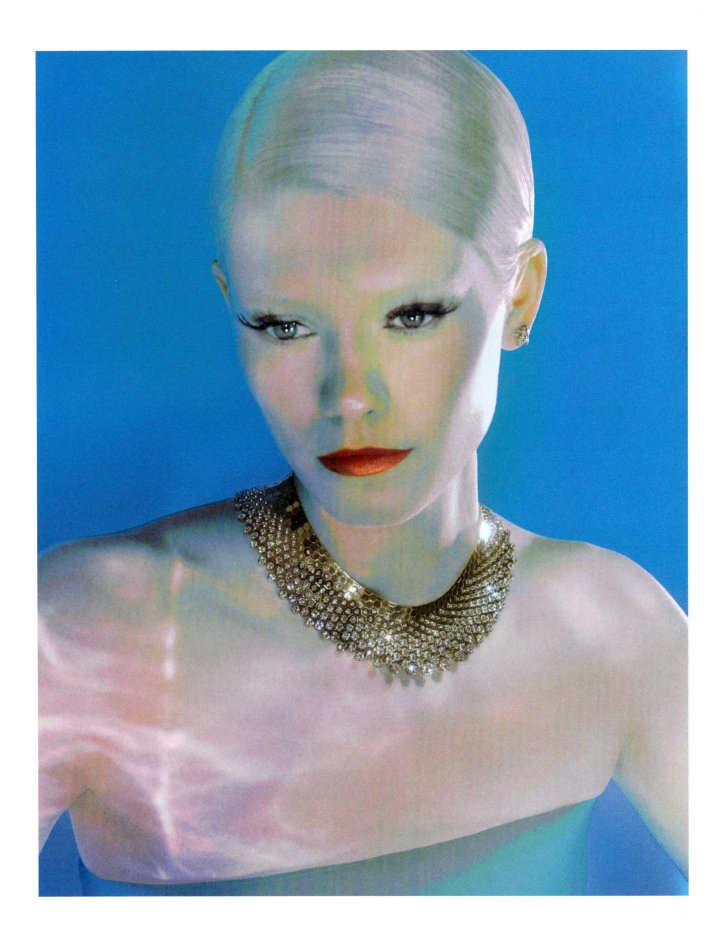

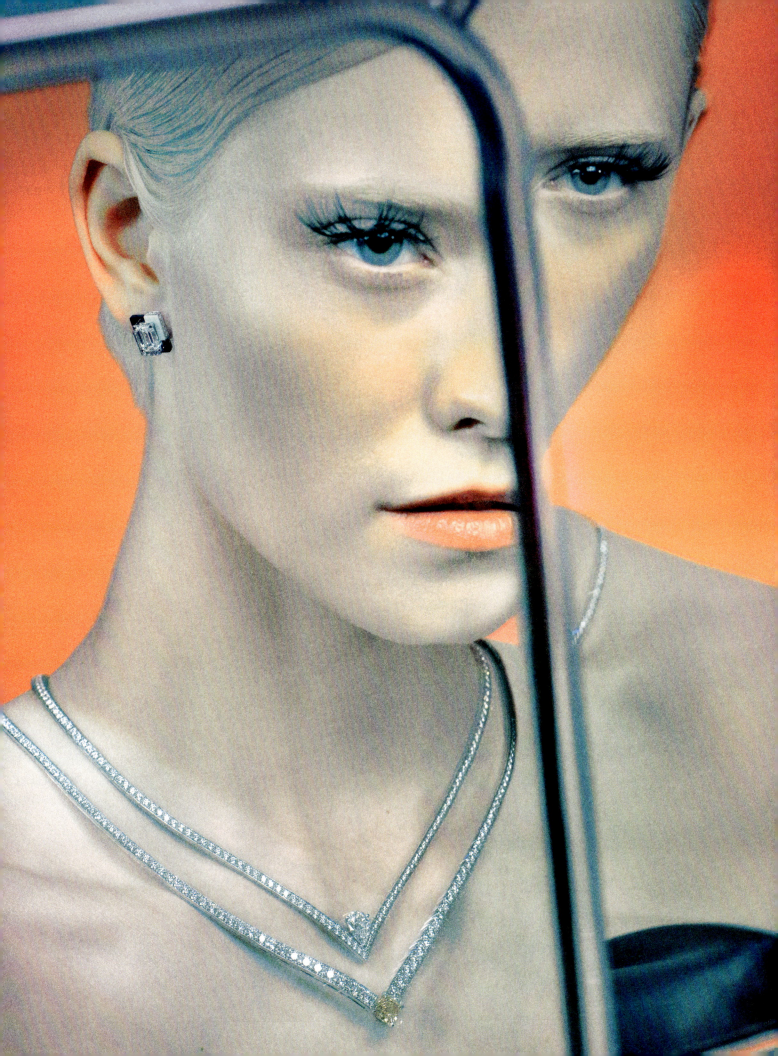

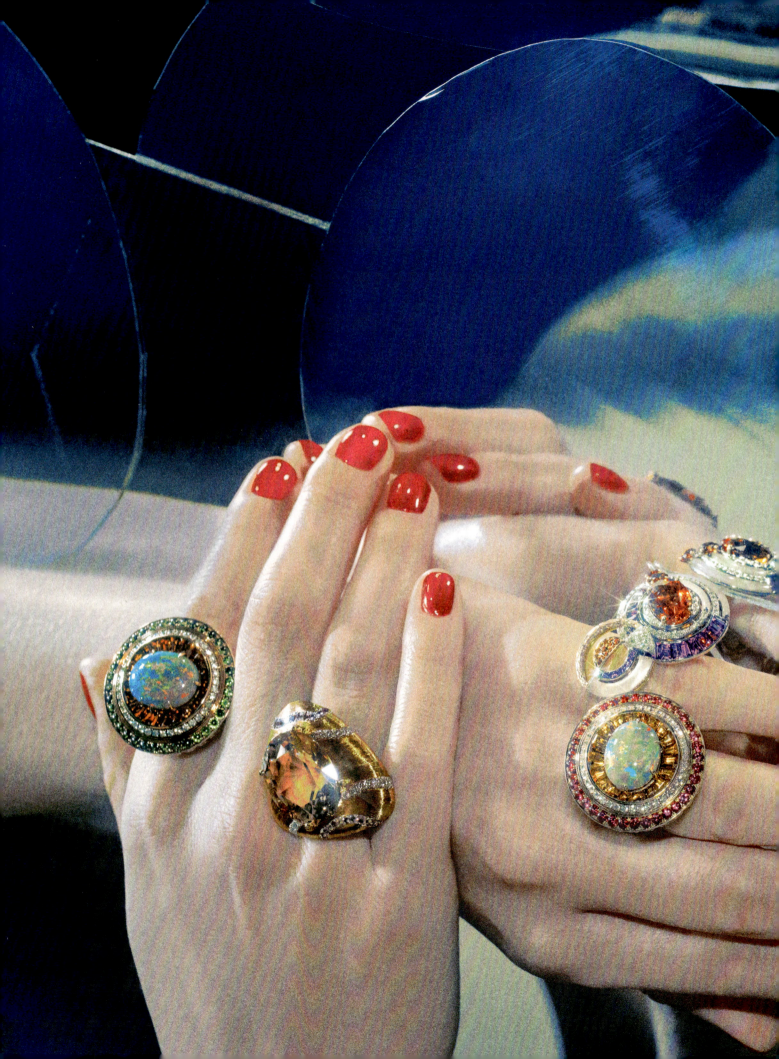

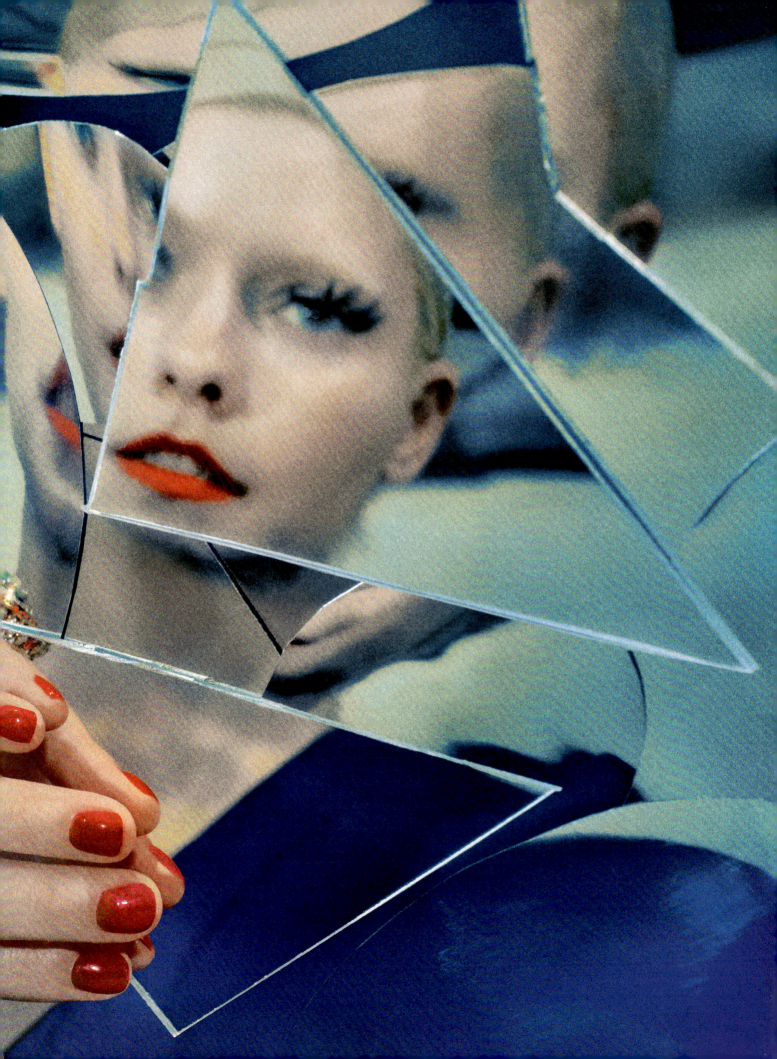

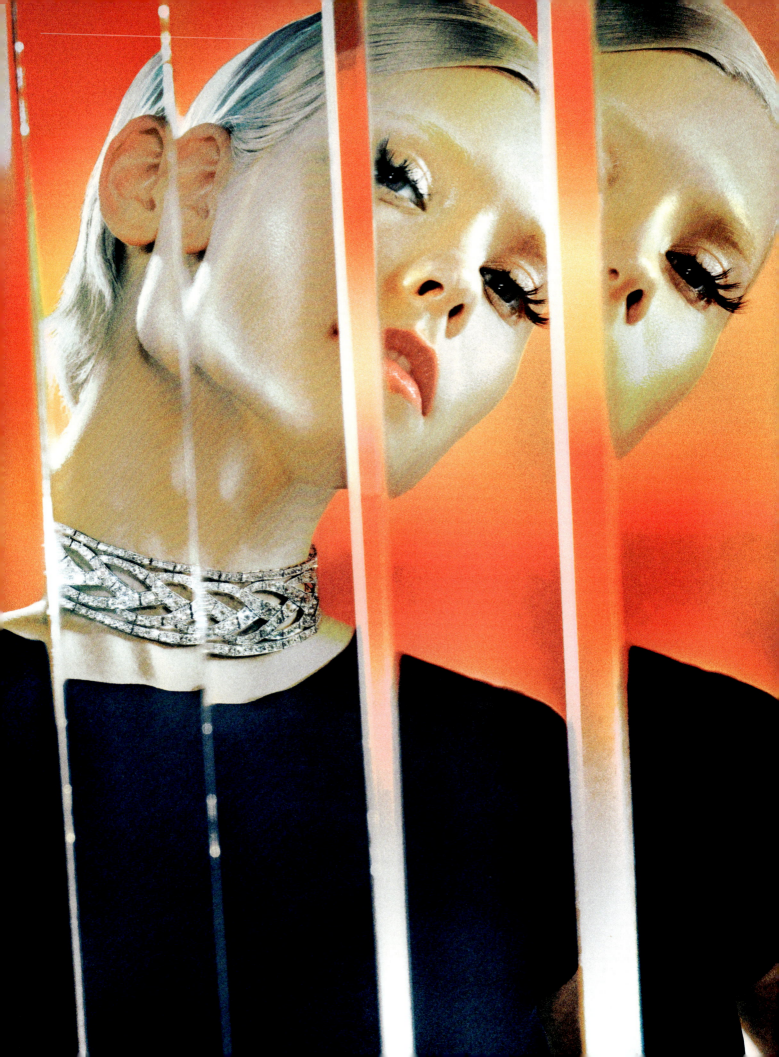

Chaumet *and* photography

Carol Woolton

Chaumet's relationship with photography has always been robust. Since its inception a consistent parade of beguiling pictures featuring the Maison's jewellery has appeared in magazines, publications and advertising images. Photography lies at the intersection of art, fashion and technique and, in the wide pantheon of camera work, jewellery is notoriously a difficult subject. I can confirm this, having spent many years in studios working with photographers trying to capture jewellery in its best light to sprinkle over the pages of *Vogue*. In many ways fashion and jewellery photography share a similar agenda. At its most basic, the role of an image is to bring details of the jeweller's or couturier's work alive on the page. The atmosphere of the photograph becomes everything as images are painstakingly crafted to produce a desired effect of covetousness. And yet, whatever the impact, beauty or artistry the resulting image might display, fashion and jewellery photography have been generally overlooked as serious artistic mediums due to their commercial nature.

…/…

It's true that jewellery photography does strive for a flawless, some might say unrealistic, result. But idealized or not, many of these pictures illustrate artistic merit individually, whilst together as part of an archive stretching back into the distant past, they take on symbolic importance. Always sparkling with prescient detail, the images chart the story of how jewellery has been represented over the last few decades. They offer a visual background of the times in which they were produced, one that infuses shifting places, trends, fashion and identities with the preoccupations and desires of the time. In addition, the cultural information included is presented with a subtle touch and engaging narrative. Light-hearted they may be, but nonetheless this archive of images does offer an authentic record of the spirit of certain periods. And occasionally an image manages to capture the current *zeitgeist* so completely, when something magical coalesces in the combination of artistry, storytelling and dynamism, that it becomes an iconic vision of the moment with the aesthetic appeal of an artwork. For the most part, the viewer only becomes aware of this in hindsight when the coherent and well-defined style of a particular age has been identified.

The following photographs tell the story of the styles and fashions for jewellery from the 1930s to the present day, with pieces worn by the "supers" of their generations such as Edie Campbell, Stella Tennant and Kate Moss photographed by an array of the best fashion photographers of their time, including Richard Burbridge, Guido Mocafico, Mario Sorrenti, Guy Bourdin. The images are reflective of the way that High Jewellery adapts to encompass women's changing lifestyles and attitudes, combined with an indefinable *air du temps* that almost imperceptibly infiltrates each decade. Take for instance the high-luxe look of a bejewelled model with a glossy blow out wearing fur exemplifying 1990s super glamour. Another image illustrates the more recent trend of men leading the brooch revival on red carpets around the world. The brooch's ability to send a subtle message has been rediscovered and, in this case, the young male model of Timothy Schaumburg wears a carnation in diamonds, with a transgressive feel, pinned to a shirt collar as an alternative white tie. Although this wide-ranging compendium provides a reference point for the general flavour of each decade, some images

The images are reflective of the way that High Jewellery adapts to women's lifestyles.

offer a closer glimpse into society itself, acting as a glittering guide to fast-changing modes and manners. In this way jewellery photography rises above the frivolity of "snapping" an object for representation in a catalogue or magazine and satisfies the grander intention of reflecting the mood and style of an era. How we live is expressed, in some part, for future generations through photography.

Photographing jewellery

Jewellery photography is a more complicated assignment than portraying almost anything else that we wear. The fluid nature of clothes allows them to be artistically draped or wrapped in a manner that's not possible for the uncompromising metallic shapes of jewellery. Although the pieces appear static, in real life they are constantly changing and catching the light with the wearer as they move. The skill and challenge for the photographer is the implication of this three-dimensional volume and sparkle to show depth and detail in the reproduction on a flat page. Vibrant colours have to be replicated as true to life as nature created, and each tiny pave-set diamond must shine as any shadow or fingerprint on metal or stone can turn even the brightest gem into a dark smudge. Other fashion items or accessories don't have a complex inner life to explore and portray, whereas the depth of a stone needs precise lighting to ignite its energy and vibrancy.

.../...

CHAUMET AND PHOTOGRAPHY

In the days before digital photography this process added hours to a photo shoot. The positioning of every individual stone under the light had to be checked using a Polaroid, the photographer warming the film shield between his or her hands, to speed up the development process. If anything needed moving however minutely, the procedure was repeated time and again until it was deemed ready to shoot. With the advent of digital photography, and the instantaneous visual examination and post-production work it allows, this laborious method was no longer necessary. Nonetheless, creating a perfect set-up in the studio still invariably requires elements to alter and change. For instance, styling has to be carefully considered. The addition of a prop shouldn't overwhelm the image nor draw attention away from the jewellery piece itself, which must be centre stage. Somehow a pack of ants swarming over a diamond, pictured by Guido Mocafico, never detract from our view of the central ring, in fact they increase our focus, by piquing our interest in the insects' object of attraction. Storytelling has to be alluded to, and, in some cases, the Maison's heritage is rightfully evoked, because an image does perform the subtle role of visual "packaging" for the history of Chaumet. For example, Tim Schirmacher alludes to the Maison's storied elegance with the addition of a winged earring and ring to a simple black silk top. A masterclass in dressing with classic simplicity. Here the agenda of fashion and jewellery are in direct contrast. Jewellery isn't created to be seasonal, unlike clothes, and therefore it's never presented as such. And constructing a visually up-to-date representation of timelessness takes considerable expertise – as well as time itself.

Photographers have cultivated an artistic approach to the presentation of Chaumet jewellery. They may create a pared-back still life background in which the piece plays the starring role draped imaginatively over a romanesco head by Araki. Other times they support a narrative running over several pages animating a fiction that's told without words. The captivating storyline by Bettina Rheims for *L'Égoïste* shows a girl ripping up papers and magazines as if she's read some upsetting celebrity gossip. Lying in bed, scantily clad, the tiara she wears is all that remains from a dazzling evening, but the smudged mascara from falling tears in the following image,

as she looks directly into the camera, tells the tale of her pain. Just what that disappointment is we are left to imagine, thus engaging with the fiction and by association, the jewellery.

Joseph Chaumet, jeweller and photographer

Chaumet has a rich and storied history, dating back to 1780, which has also provoked inspiration for imagery garnered from styles of the past. Although firmly rooted in the history of France – Chaumet was the first jeweller on the Place Vendôme – the lens through which these pieces are explored is universal. Photography has exhibited the Maison's illustrious history whilst also revealing its role as a modern innovator. When the medium was in its infancy, Joseph Chaumet pioneered a new direction, creating a photo studio in 1889 to keep a record of every piece of jewellery created.

Never mind the time it took to develop a Polaroid, the first recorded photograph of a view taken from a window in Burgundy was a long-drawn-out process. Joseph Nicéphore Niépce inserted a pewter plate, coated in bitumen diluted with lavender oil, into a camera obscura which took several days of exposure to sunlight to yield an impression. Niépce called these experiments with various chemicals and light *héliographies* or "sun writing". A decade later Louis-Jacques-Mandé Daguerre, a print maker who was experimenting with the idea of permanent images on polished silver-plated sheets of copper, which would become known as *daguerréotypes,* presented his results to the Académie des Sciences in Paris. These early experiments of a still life, Parisian scene or portrait revealed the value of imagery not only as a medium of artistic expression, but as a valuable tool for the scientific world.

Joseph Chaumet immediately recognized the potential of photography for both spheres. He became an early adopter of the art to document jewellery designs and began developing the practice of examining the inner life of precious stones for research purposes. Chaumet's interest inspired the Maison to creatively explore new

...∕...

techniques and artistic styles for its brochures and advertising campaigns. Whilst experimentation was encouraged, the photograph never failed to satisfy its core purpose: depicting women, their beauty, their elegance, and their clothes and accessories.

Chaumet in the avant-garde

It's possible to trace the changing female gaze and lifestyles through the Chaumet archives, from a time when women wore jewellery as a statement of social status or as a sign of their husband's wealth and power, to the mid-century aesthetic illustrating the idea that a carefully selected piece of jewellery added the finishing touch to any ensemble, to contemporary ideas of women using jewellery as a means of self-expression. Neither Chaumet's jewellery, nor the photography, are created in isolation. These compelling photographs therefore illustrate more than jewellery design; they encapsulate shifting lifestyles. Furthermore, societal changes, artistic movements, prevailing trends, jewellery designs and women's changing roles have all historically influenced Chaumet photography.

During the early part of the twentieth century, design chimed with the distinctive style and sensibilities of the Art Nouveau movement. At this time the decorative motif *du jour* defining much of Art Nouveau was the gesture of a long sinuous organic line with a graceful and twisting nature. It was employed in architecture, interior design, jewellery and glass, posters, and illustration. Like a force of nature, the ornamental curve began to dominate Paris, manifested in building facades and the new curved cast-iron signs, designed by the French architect Hector Guimard, that appeared above entranceways to the Metro. Art Nouveau was credited with compelling the art world into a new modern era.

Whilst nature became a primary source of inspiration for a generation of artists who were seeking to break away from styles of the past, organic lines were already a significant theme within the oeuvre of Chaumet. Wheat was one of the earliest plants to feature in Chaumet designs, witnessed by a tiara crowned with nine diamond ears

These compelling photographs therefore illustrate more than jewellery.

of wheat created in the early 1800s. The motif symbolizes harmony and unity with nature and has often decorated tiara frames, fashioned bending as if blown by the wind. Plants were depicted with trailing vines and delicate coiled silhouettes, in balanced yet asymmetrical diamond forms. These were the first artistic jewellery creations, according to the romantic codes of the Art Nouveau movement. The atmosphere drew upon elements of Japanese art, as the vision of Japonisme was widely available in the form of prints which flooded Europe after trading rights had been established with Japan. A definite sense of luxury and refinement in presentation was combined with intricate detail and a sensitivity to nature. Capturing shafts of light through colourful elements of butterflies, dragonflies and peacocks seemed to mimic the soft colours reflected in stained glass, which was a new example of creativity admired by the movement. For the first time advertising posters were accepted as art forms, such as those created by Alphonse Mucha, who was living in Paris, Jules Chéret and Henri de Toulouse-Lautrec, all of whom became known for the swooping lines of their vibrant poster art. The early style of photography also lent itself to a creative interpretation of this sense of fluidity in admiration of the beauty of nature and plentiful golden harvests. This style continues to inspire in the soft-focus image by Greg Lotus of a landscape redolent of Art Nouveau with its focus on nature, curves and a woman portrayed as a romanticized creature. There's a certain wildness in its stylized form.

The Art Nouveau movement had a further objective in featuring floral forms. They were intended to bring nature into modern life, fearing that human beings had lost touch with the natural world, a point of view which resonates with

.../...

contemporary concerns. In the ancient world wheat was a gift from the gods to mortals symbolizing life itself. More than a mere style, jewellery photography thus helped spread ways of thinking.

Recently, the Maison revisited the essence of wheat for a new generation using inspiring graphics featuring the collection *Le Jardin de Chaumet* and influenced by archival plant portraits, as well as the photographer's way of seeing things. Joseph Chaumet's scientific idea of capturing nature in a series of photographs was mimicked to highlight details of the wheat plant and bring its identity to the fore. Using the painterly technique of chiaroscuro, representing light and shadow to define the jewellery piece by emphasizing its lines and curves, the Paris-based photographer Candice Milon created a series of modern portraits highlighting the art of the line, previously so prized by the Art Nouveau movement. Exploring the links between painting and the still image, she explores the photographic medium as a dreamlike journey. The light is directed to accentuate the juxtaposition of the strength of the vertical wheat in contrast to the delicate detailing of its precious life-giving grain.

In a series of photographs created in 2023, the Paris-based Italian fashion photographer Paolo Roversi also played with light and shadow to appear to shroud a floral jewellery piece in mystery to better reveal its brilliance. The model resides in the semi-shadows, enabling the white and yellow gold magnolia set with diamonds to emerge triumphantly to the fore of the picture. In another striking image he uses the delicate feather-like line of a wild diamond *Fougère* to curl around the head, reimagining historic botanic motifs and ornaments of the past for a new audience. Chaumet's photographic focus on botany and capturing the beauty of nature seems as poignantly relevant now as it was for audiences of the late nineteenth century.

Photography and jewellery: creative and timeless reflections of a changing society

Whilst some photographs in the archives suggest the enduring nature of certain motifs, others emphasize the longevity of jewellery, which transcends fashion. Consider the Mancini-style briolette diamond hair ornament, named after Marie Mancini, the first love of Louis XIV, created to pair with the new off-the-shoulder lace gowns of the 1840s with bell-shaped skirts supported by layers of starched petticoats. The tightly corseted hourglass shape made an unforgiving silhouette. Over a century and a half later the ornament shines in a fashion-forward image adorning the tousled hair of a model, in direct contrast to the period for which these pieces were first created. In another portrait by Julia Hetta the smile and cheeky upward glance of a young model expresses the fun of wearing an exquisite heirloom jewel insouciantly pinned to her topknot. The photograph perfectly reflects the notion that jewellery always expresses, but is never limited by, the spirit of its time, viewed from the perspective of a contemporary artist.

I imagine that Joseph Chaumet would have been one of the first to embrace digital photography when it swept through the 1980s, revolutionizing the field and relegating film-based models to the background. New high-resolution digital cameras with specialized macro lenses, in combination with advanced lighting set-ups, allowed for greater precision and control which was especially helpful for capturing the minute details of jewellery creations.

Originally the details of Chaumet's notable stones were picked out in paint with as much brilliance as possible in early portraits. The impasto technique became popular to portray the texture of rich fabrics, or details of a fold in silk or sparkle of a diamond by applying the paint in thick layers, spread in a way that the strokes of the brush would trick the eye into believing the gem was emerging from the canvas. Artists such as those working in the studio of Baron Gérard painting Empress

.../...

Joséphine or in that of Robert Lefèvre, who portrayed Empress Marie-Louise, faced the same challenge as modern photographers to bring jewellery to life with a sense of depth and three-dimensional texture using brushwork. These painterly skills, using lead white pigments, could be considered as precursors to modern lighting practices. They aimed to produce the same result as Roversi's brilliant white and yellow gold magnolia set with diamonds did centuries later, erupting from the picture.

Empresses and aristocrats were painted wearing sumptuous silks and lavish parures reinforcing the association between jewellery, wealth and social status. This connection was also expressed using photography into the early part of the twentieth century. The German-American photographer Horst P. Horst pictured Catharina "Toto" Koopman, the muse to couturiers Mainbocher and Rochas, wearing a sleeveless silver lamé gown with a headdress of flowers and several wide diamond bracelets decorating both wrists. This was an era when women enjoyed being pictured wearing their notable jewels for the public to see. Russian-born photographer Baron George Hoyningen-Huene pictured Lady Abdy in a striking portrait in 1929 for *Vogue*, showing she had no qualms wearing a pendant necklace mounted with an astonishing 40-carat pear-shaped diamond. Nor did these women appear worried about pressing work commitments. Contrast the different lifestyle portrayed in the photograph by Rankin of a *Class One* watch. With the watch placed over one of the model's eyes, the message is clear; she's busy and keeping an eagle eye on the time is important to her. A reference to the popular 1990s feminist phrase "girl power", which became a mainstream cross-generational political slogan, is visible in the image by Ellen von Unwerth of a diamond tiara-topped model looking victorious seated next to her fit-looking male boxing opponents displaying signs of bruising and black eyes. The image is suggestive of the ancient practice of a wreath or crown being bestowed as a prize on the victor of athletic games. It resonated with girls fighting back to change the established notion that girlhood was a state of frivolity and dependence.

When the modernist approach to design of Art Deco began, it paved the way for a new design style in photography. Marcel Chaumet understood the prevailing trends and started producing avant-garde advertisements. The new qualities of modernism were echoed in bandeaux worn low across the brow of fashionable newly cropped hair. One illustration of the time features a model immersed in a setting that conveys a feeling of speed, in tune with the energy and dynamism of the new aesthetics. Using Kodachrome, colours were also explored, adding a new dimension to photography and allowing the vibrant palettes of precious stones to be true to life.

In spite of fast-paced innovation, the tradition persisted that well-known and aristocratic women wore tiaras as a signifier of birth and rank. Edwina, Countess Mountbatten of Burma, and the Countess of Bessborough were photographed for magazines wearing dazzling ancestral Chaumet tiaras and evening gowns. At this time the genre of fashion photography was gaining prestige through the work of photographers such as Edward Steichen and Cecil Beaton, who rose to prominence creating iconic images of society's bejewelled lifestyle. Tiara-topped peeresses swept into the *Vogue* studios in London to be pictured by Cecil Beaton in preparation for King George VI's coronation in 1937. Beaton also turned his artistic hand to illustrations for the magazine suggesting the correct dress code for the coronation; a pale pink satin gown and coat with sable bands and sleeves, with a sun-ray diamond fringe Chaumet tiara to complete the costume.

Viewed in retrospect these images brought the grand aristocratic lifestyle to a dramatic fin de siècle crescendo. During the world wars Chaumet's female clients were leading independent lives and advancing their careers with increased opportunity and reflecting the changing status of all Western women. From a social and cultural perspective photography was beginning to mirror the transformation of changing conventions. Tiaras weren't to be banished as a ghostly adornment of a bygone age, but the previous preoccupation with convention and who wore them disappeared. In the photographic oeuvre of Chaumet tiaras were evocative of a new era for modern

.../...

women as photography began to emphasize their superb design and decorative ornamentation. Crown-like tiaras fashioned from dynamic spirals of rose- and brilliant-cut diamond stars were pictured to highlight their curves, precise craftsmanship, and the hundreds of hours spent on their construction at the bench. They began to be pictured worn with an egalitarian sense of freedom illustrating their future as a stylish addition to the jewellery collection of any girl or family. In one image by Guido Mocafico a tiara is pictured with a humorous nod to its erstwhile expression of privilege, worn by a Queen Elizabeth II lookalike. Always appreciated for their beauty, the imagery of tiaras began to explore their potential and a new, more modern way of wearing them. And when the fashion style of "grunge" emerged, tiaras worn alone with their instantly recognizable heritage of elitism, provided the perfect vehicle to create a non-traditional subversive look worn to suit a young girl's agenda challenging conventional tastes and ideas. These photographs reveal something of the ties that bind the story of jewellery to changes in our cultural life, as tiaras shown though the Chaumet lens expressed a certain individuality for independent and strong-minded women.

The French-Argentine actress Bérénice Bejo was pictured wearing a bandeau tiara with a foliate motif in the 2015 film *The Childhood of a Leader* and photographed by British photographer Tom Munro, with the piece secured on the back of her head. Other "props" used in some cases remained essentially the same as during the height of the Belle Époque, such as a silk gown worn with a tiara, with the resulting photographs styled by editors to have a distinctly modern impact. The series of photographs taken by British photographer Richard Burbridge of model Stella Tennant wearing the Bourbon-Parma tiara for Chaumet's 2003 advertising campaign has become emblematic of its time. The images capture a young woman with tousled hair in the action of breaking free of any type of restriction. Girls were no longer prisoners of the accoutrements of a certain mannered beauty. These pictures made clear that individuality of expression was the paramount factor in any jewellery choice.

During the mid-twentieth century, with the advent of cinema lighting using strobes and soft boxes, the quality and versatility of jewellery photography

Tiaras expressed a certain individuality for independant and strong-minded women.

improved. Compositions were influenced by Hollywood glamour. Artists, ballerinas and actresses were drawn to Chaumet to purchase jewellery pieces as a measure of their success. The singer and actress Yvonne Printemps was photographed by Sasha in a beguiling movie star pose, with her Chaumet II-carat cabochon emerald cuff given to her by her playwright husband Sacha Guitry, brought to the fore of the picture. These photographs resonate with a society that was embracing entertainment, post-war optimism and the allure of celebrity culture.

Jewellery sets the tone for photography

Sometimes Chaumet photography has been influenced by the jewellery designs themselves. During the turbulent social milieu of the 1970s radical new gold pieces were emerging from the workshops by artistic designer René Morin who was exploring new goldsmithing methods. His *or sauvage*, a textured gold playing with its nuances, created a new sensational modern style which the oldest jeweller on the Place Vendôme expressed through avant-garde images. Chaumet photography chimed with the youth-driven idea of breaking away from established norms with a revolutionary visual aesthetic.

The photographs shone with an abstracted rawness, similar to the fresh new attitude of gold pieces that were matt in places with an exposed lustre in others, producing a play of contrasts. Hammered, braided and woven gold pieces followed, as well as others with highly reflective surfaces, all designed by Pierre Sterlé. Full-colour

.../...

pictures of the gold pieces appeared in magazines through inventive hazy, dreamlike sequences featuring original angles and abstract compositions reflecting the Maison's creative experimentation with the metal itself.

Recently, the experimental fashion and fine art photographer Elizaveta Porodina returned to this progressive and alternative style. She blurred the lines of surrealism using models with a hypnotic gaze and extreme shadow and light to recreate a 1970s mood and spirit. Golden mirrored surfaces of necklaces chiming with the erstwhile disco era were pictured on smoky-eyed models redolent of photographs that had appeared in French *Vogue* during the period, with their predecessors wearing magnificent golden Chaumet collars. The smooth and shiny appearance of the gold is reflective of Porodina's boldly contrasted lighting.

Abstract expressionism with its extreme layers gave way as the twentieth century came to a close, in favour of a new literal and objective approach characterized by simple forms. Casual fashion dominated and, in particular, the clean lines of minimalism came into focus. The principle was perfectly illustrated in 1998 when the *Fidélité* rope necklace appeared in *Vogue*, photographed in London by Jenny van Sommers, who set the necklace like a loosely knotted necktie on a plain black background highlighting the diamond modernism in a pared-back composition. The *Fidélité* featured in many other shoots illustrating how one great design can appear differently styled to suit the distinct vision of photographers. In one image the necklace is pictured worn by a model wearing black leather gloves with a street-style punk atmosphere whilst another shows the necklace luxuriously styled on a model in a setting where the piece itself becomes a disco ornament.

The following pages illustrate the versatility of jewellery, which can be paired as successfully with the 1990s trend for athleisure wear as the pop culture references of maximalism in the 2000s. In 2010, High Jewellery became an official part of the Paris couture calendar. Jewellery and fashion came together to celebrate their shared heritage as art forms with a new dynamic synergy revealed on runways and photographic shoots for magazines around the world. The ability to demonstrate rich

textures, bright colours and the refined threads of jewellery on film, evoking the idea of couture and craftsmanship, continues to be a glittering thread running through Chaumet photography. And picturing High Jewellery also makes subtle references to a French origin and something crafted by the equivalent of artisans working in ateliers. Consider the still life close-up by Sabine Villiard to show the texture and intricate needlework of an embroidered pink dress set against two pink gemstone couture rings. Or the unpretentious background of macaroons — by Toby McFarlan Pond — whose colour and texture allow the spectacular and brightly hued rings to take centre stage.

In many ways we can trace over the following pages how fluctuations in both fashion and technology influence photographic style. By the turn of the millennium street-style photography became popular, a phenomenon that gained momentum with fashion editors and bloggers circulating images on websites and global social networks. As the future looked to the use of smartphones, technology and social media, Chaumet responded to the new style by showing Sarah Harris, Deputy Editor and Fashion Features Director at British *Vogue* and a prominent influencer, matching her minimalist attire with jewellery pieces.

Capturing the allure of jewellery and how to wear it remains the objective of these images but once again it's possible to see how prevailing ideas and thoughts are translated visually as the modern concern for the environment dominates. *Attrape-Moi* spiderweb designs, featuring precious-coloured gem bodies and diamond wings draw attention to nature, mirroring society's focus on ethical concerns, which were also reflected in Chaumet's *Save the Bees* campaign, supporting the efforts by the French organization Terre d'Abeilles to protect bees and nurture hives. Chaumet photography is subject to more fundamental changes on the broader socio-cultural landscape and the visual "packaging" of the Maison through the medium changes to suit the modern mood. A lovely image expressing the moment sometimes is no longer enough. Now complex and multi-faceted stories must be included in addition to remaining in a permanent dialogue with the arts and fashion of the time. Narratives need to reso-

···/···

nate with the new generations who are seeking a deeper connection to the brand and want to know the story behind each jewellery piece including craftsmanship, ethical practices and gemstone history. More recently images have highlighted responsible practices aligned with these contemporary values of sustainability. Joseph Chaumet's photographic research to understand the details of stones is subtly referenced by the contemporary spirit of Chaumet imagery fashioned to reassure expectations that the origin and source of each stone has been examined in depth. The spirit of our time requires this openness and inclusivity in the creation of a jewellery piece. Particular pictures shared by the Maison can make viewers feel as if they've entered the atelier and maybe stood in the same place as Joseph Chaumet as he watched a piece come to life on the workbench.

Paradoxically, whilst the research required is forensic, the demand for individuality, escapism and fantasy also increases. Enlivening the artistry, glamour and romantic mystique of gemstones will continue to challenge photographers, editors and stylists tasked with and imaginatively reinterpreting the role of jewellery in our lives as it continues to evolve in a variety of ways. Although the archive acts like a glittering timeline depicting changing atmospheres and surroundings, to some extent it also demonstrates how the photographic process essentially remains unaltered. The jewellery continues to take centre stage. The time needed to produce one idealized image of a piece is still considerable, whilst the studio process continues to adapt to ever-changing elements of techniques and fashion. As this book illustrates, the results are never static. The images remain relevant, informing a part of our story now as well as in the past, and there will be more ahead of us in a surprising range of new styles, shapes and configurations. The photographic process is always moving and in flux, relying on a light source to flicker its way into the future with all the quixotic mystery and longevity of a diamond itself. ❖

Antho
logy

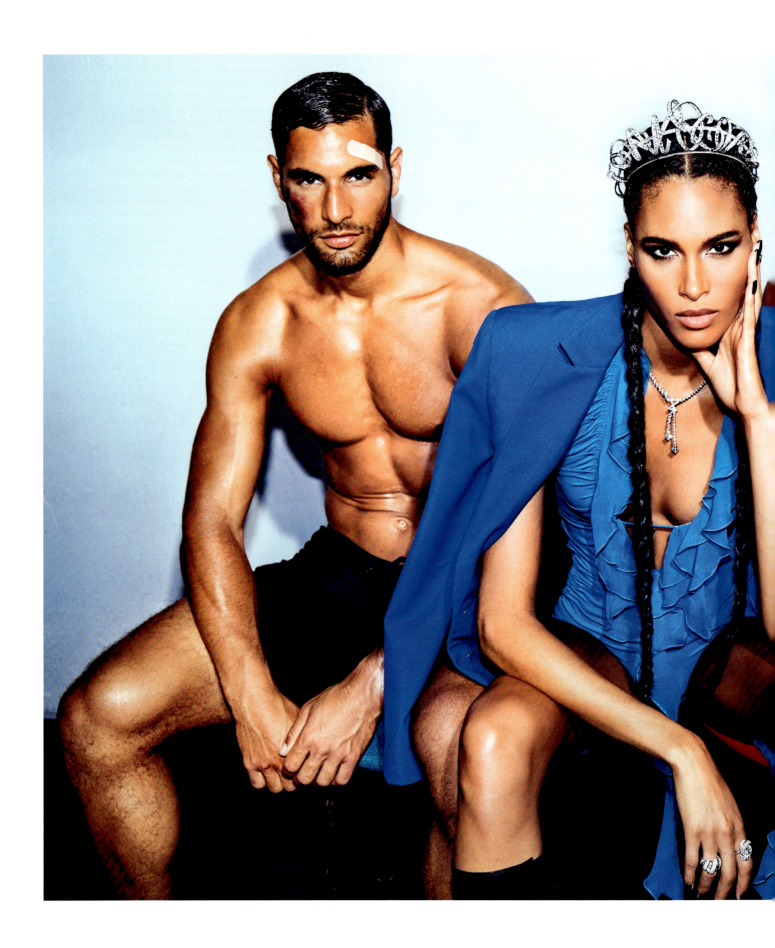

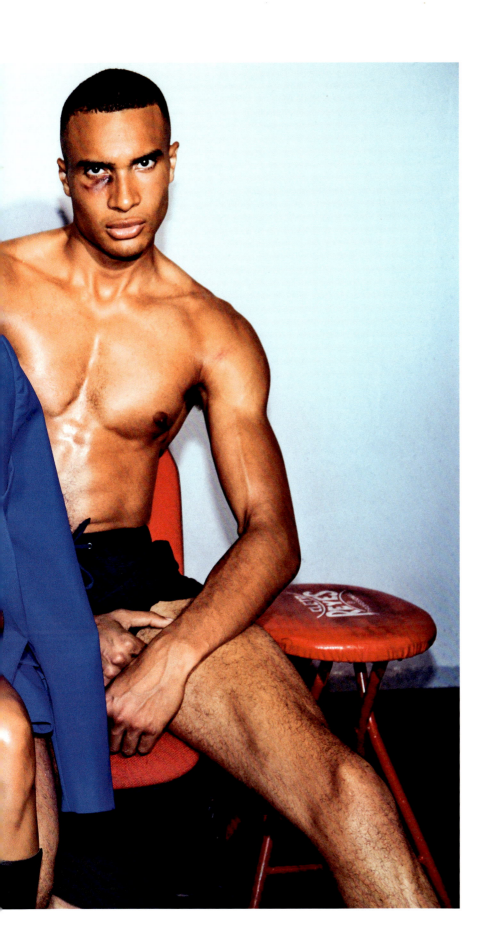

Ellen von Unwerth
Harper's Bazaar
2022

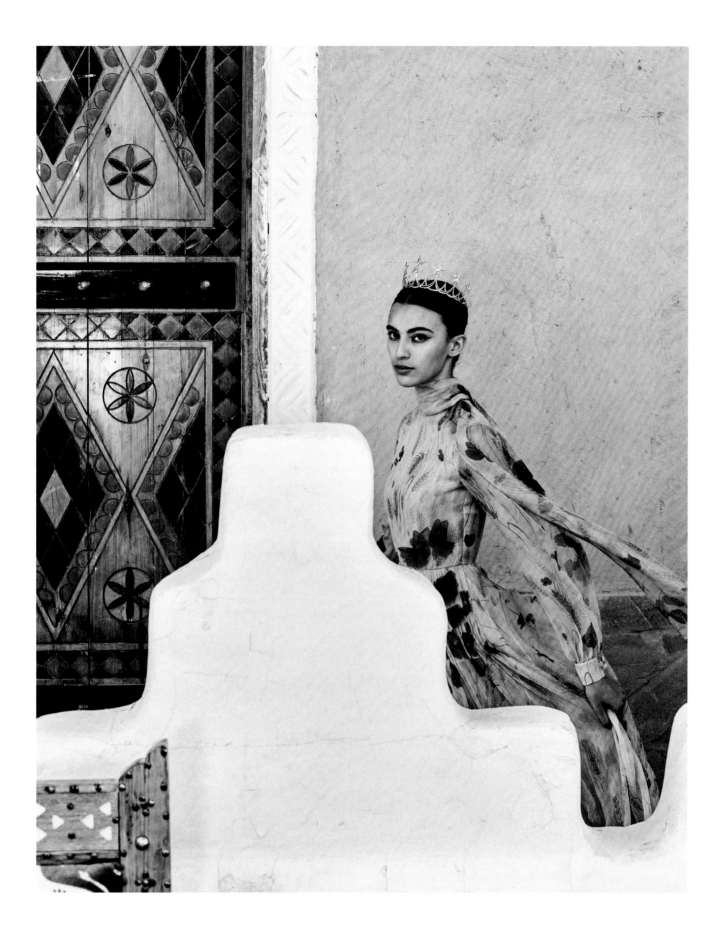

Philipp Jelenska
Vogue Saudi Arabia
2022

Paul Morel
Grazia International
2022

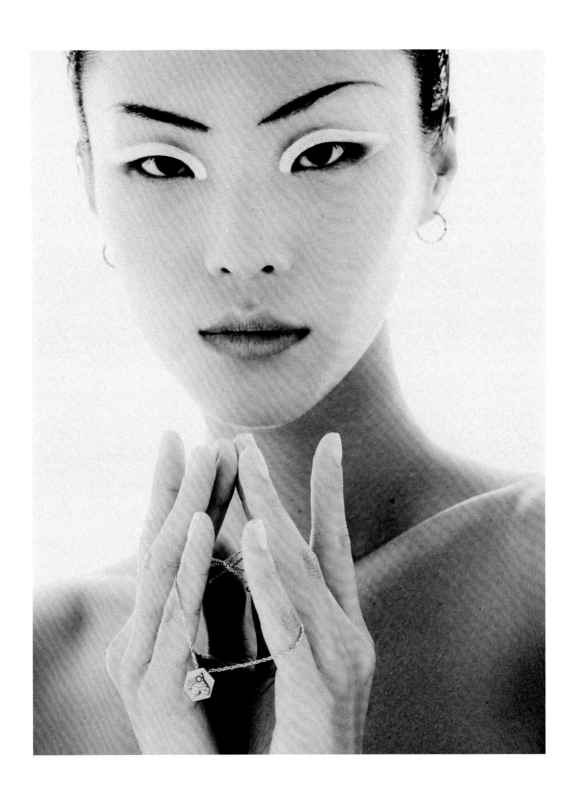

Blandine Chabani
Numéro
2022

Lachlan Bailey
Vogue Paris
2021

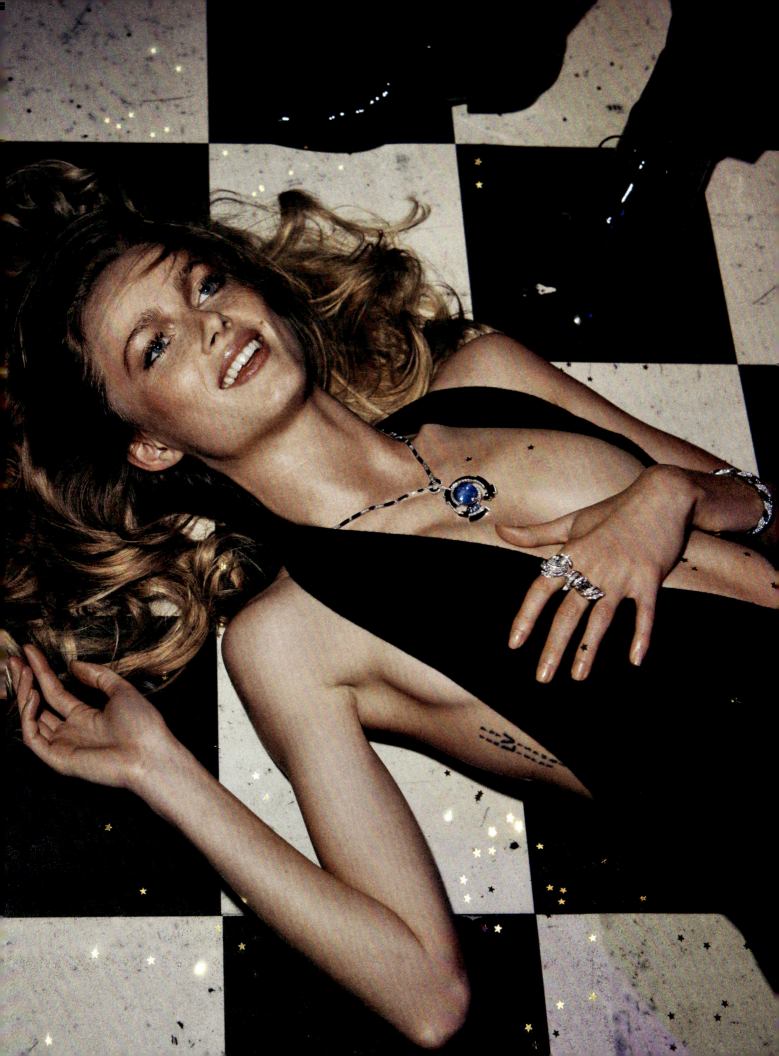

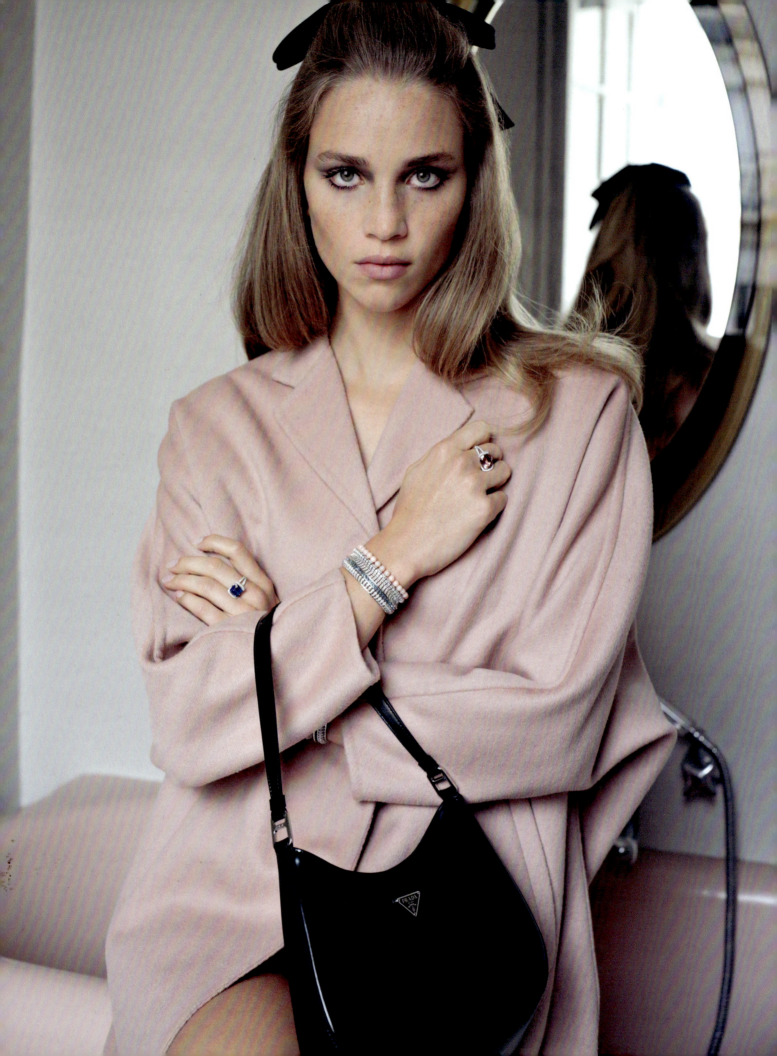

Nathaniel Goldberg

Vogue Paris

2020

Valentin Giacobetti

Vanity Fair France

2020

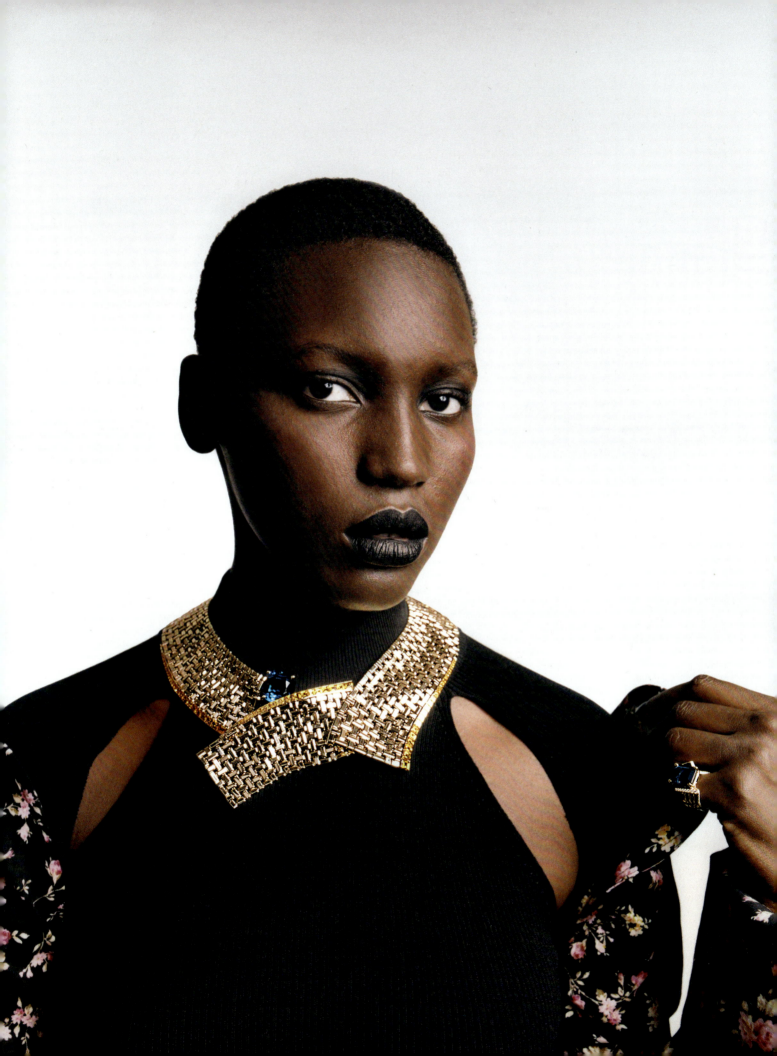

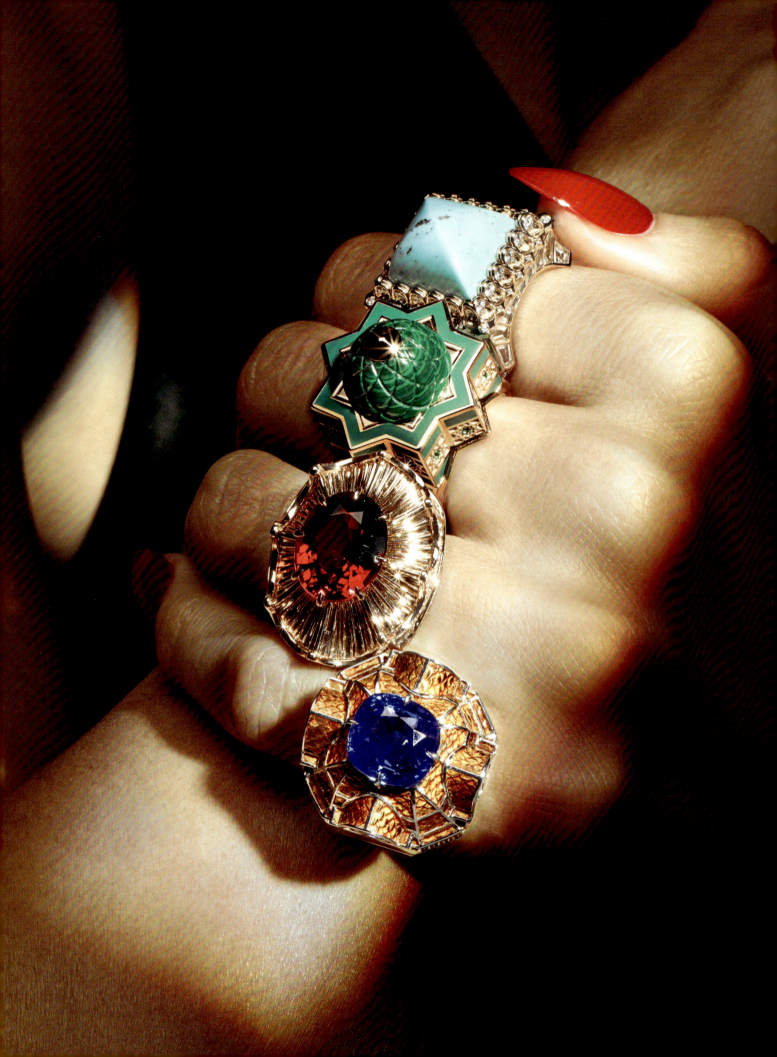

Gregory Harris
Vogue Paris
2020

Charles Negre
Vanity Fair France
2018

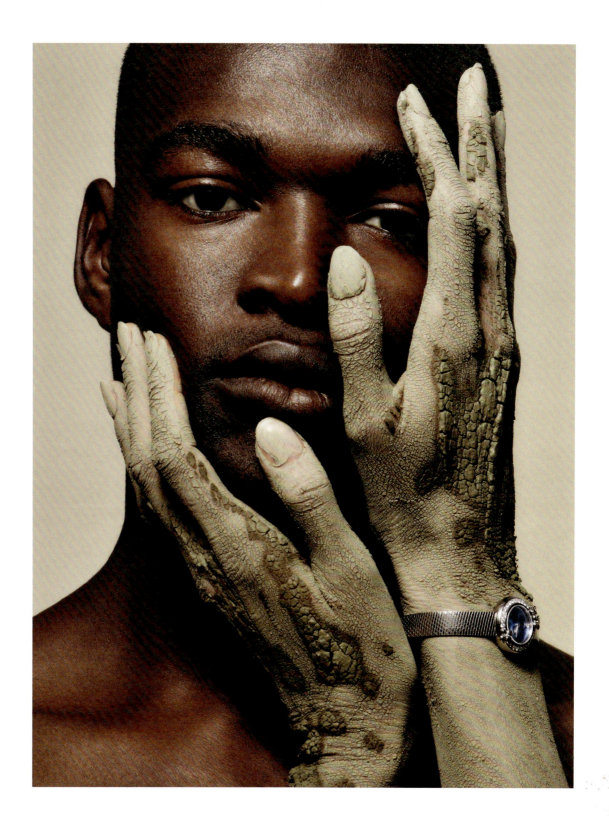

Inez Van Lamsweerde
and Vinoodh Matadin

Vogue Paris

2020

Following pages:

Toby McFarlan Pond

Numéro

2019

Brigitte Niedermair

Numéro

2018

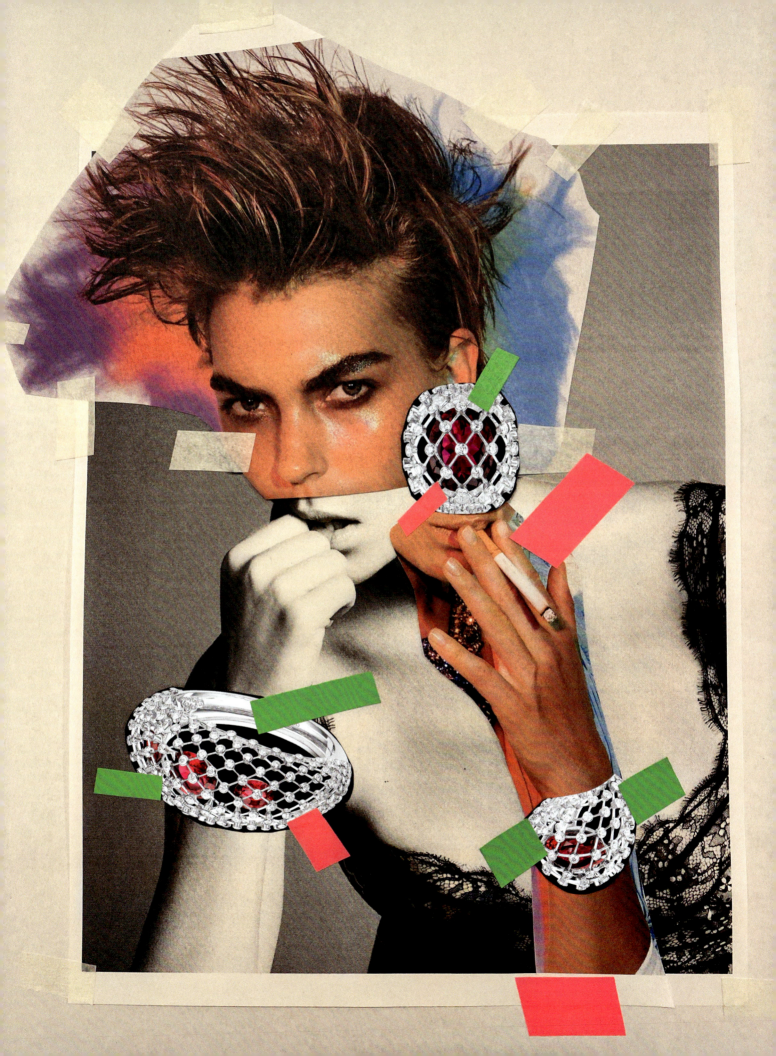

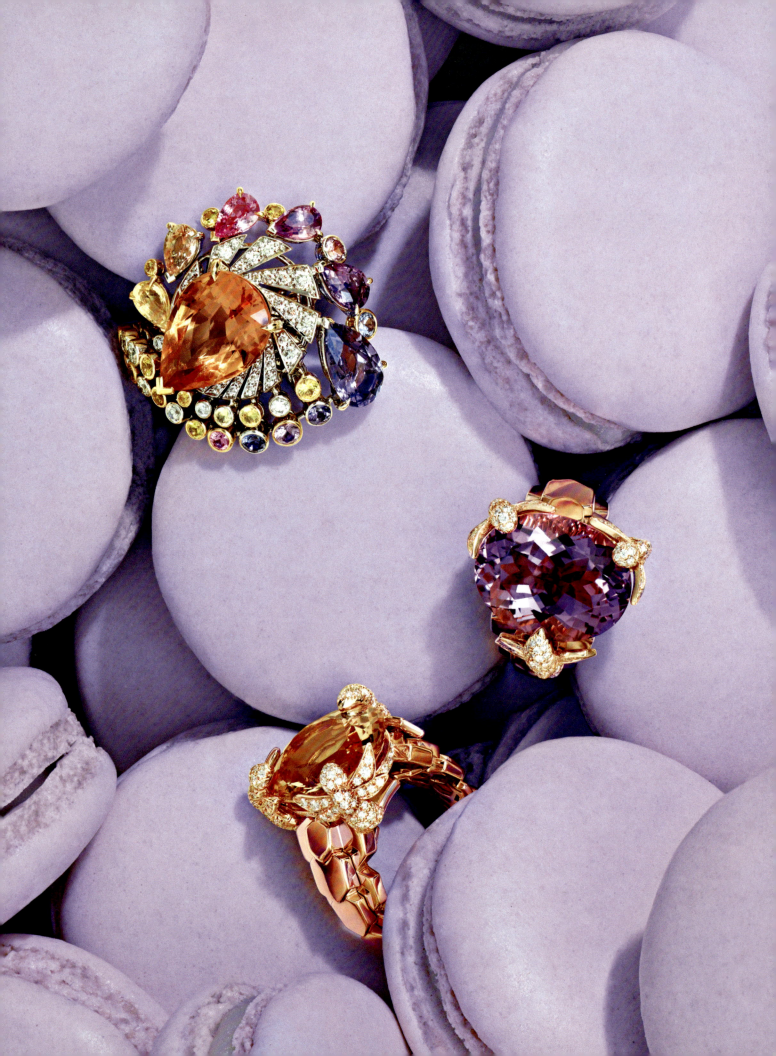

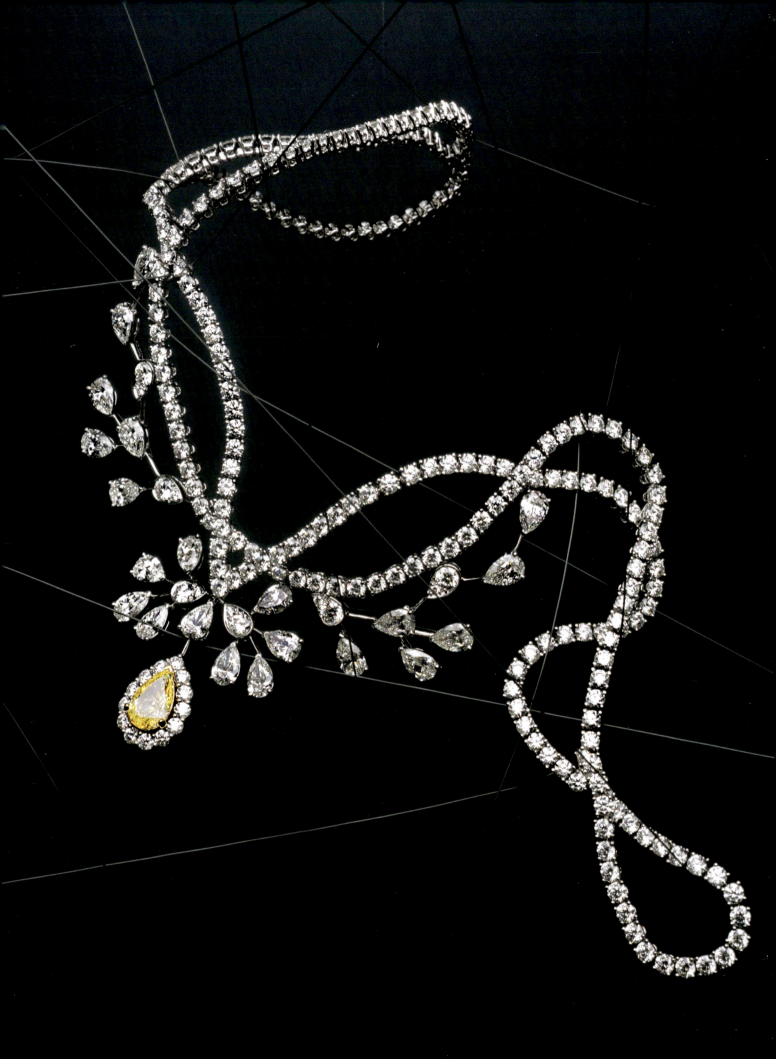

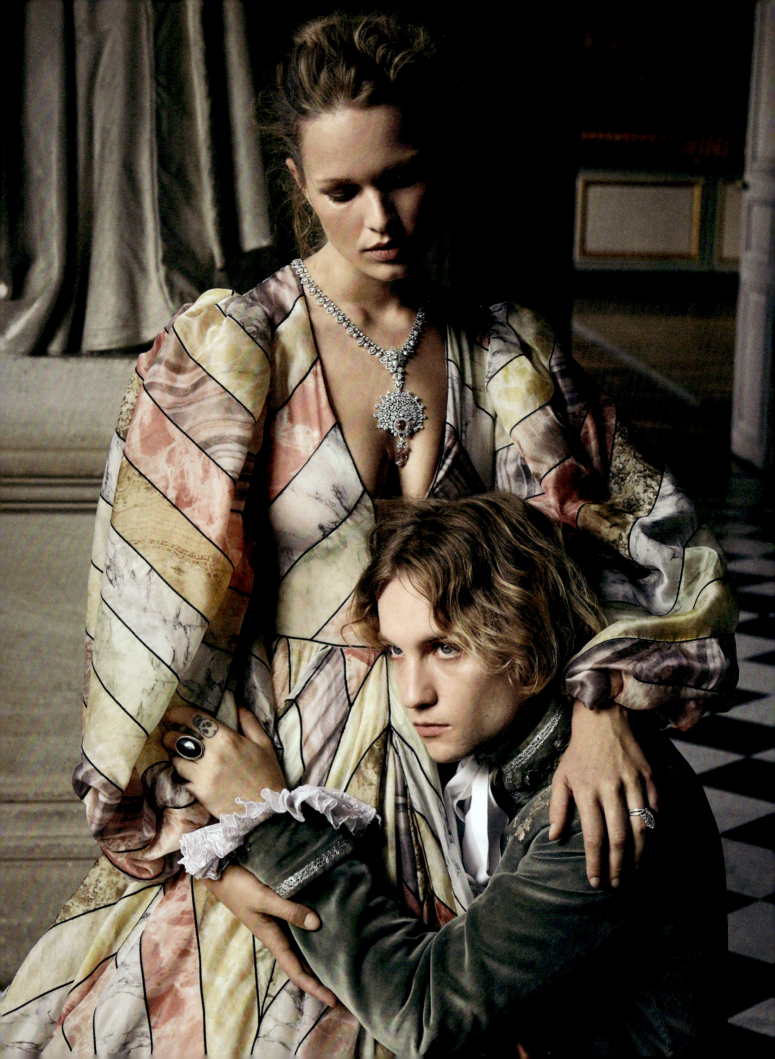

Charlotte Wales
Vogue Paris
2019

Jenny van Sommers
Numéro
2012

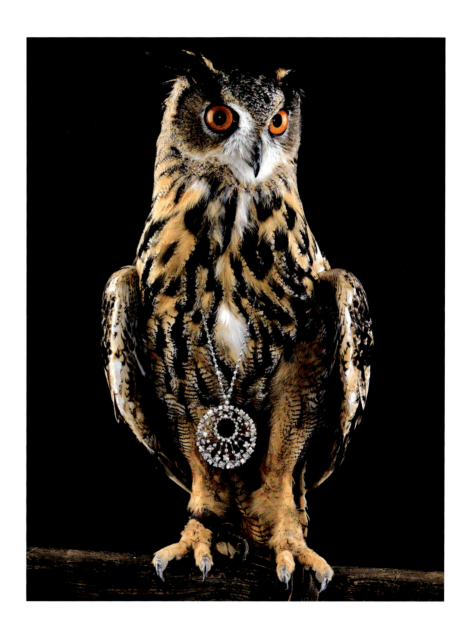

K. T.

Citizen K France

2014

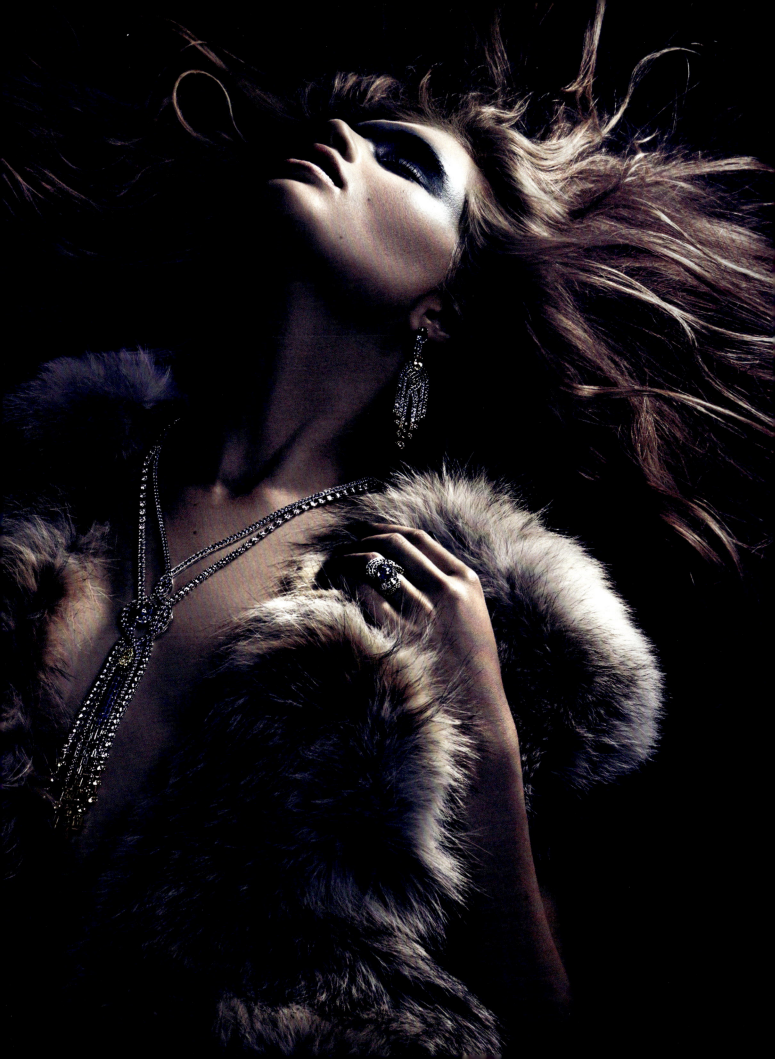

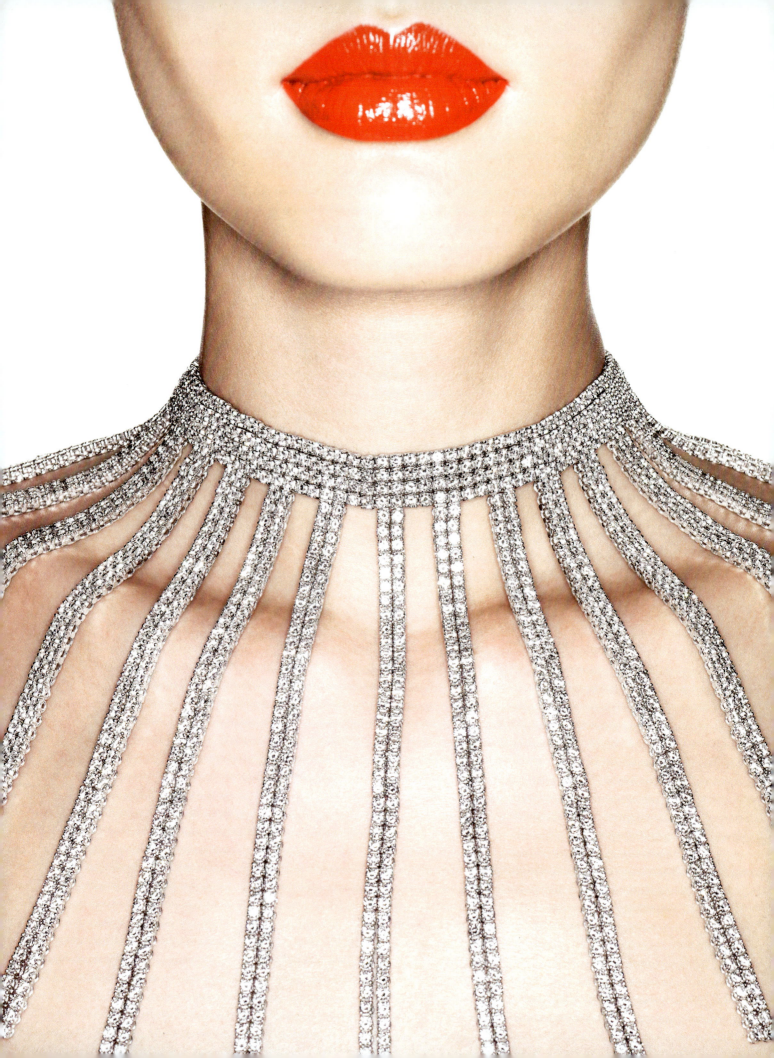

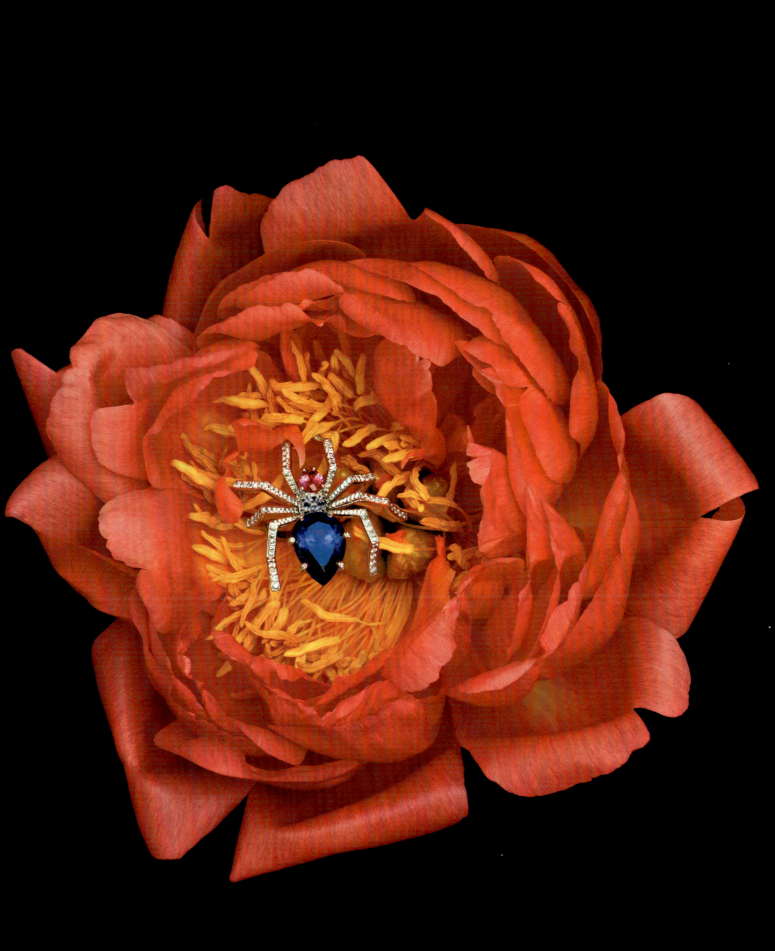

Previous pages:

Eric Maillet
Vogue China
2013

Toby McFarlan Pond
Numéro
2019

Mikael Jansson
Vogue Paris
2018

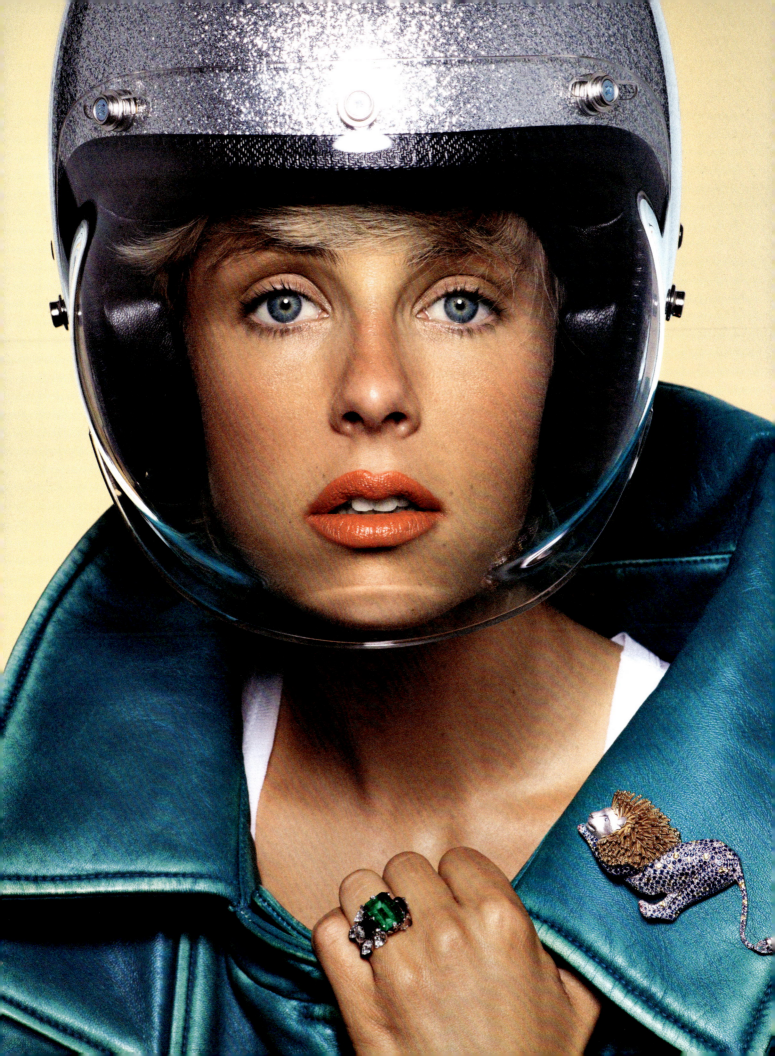

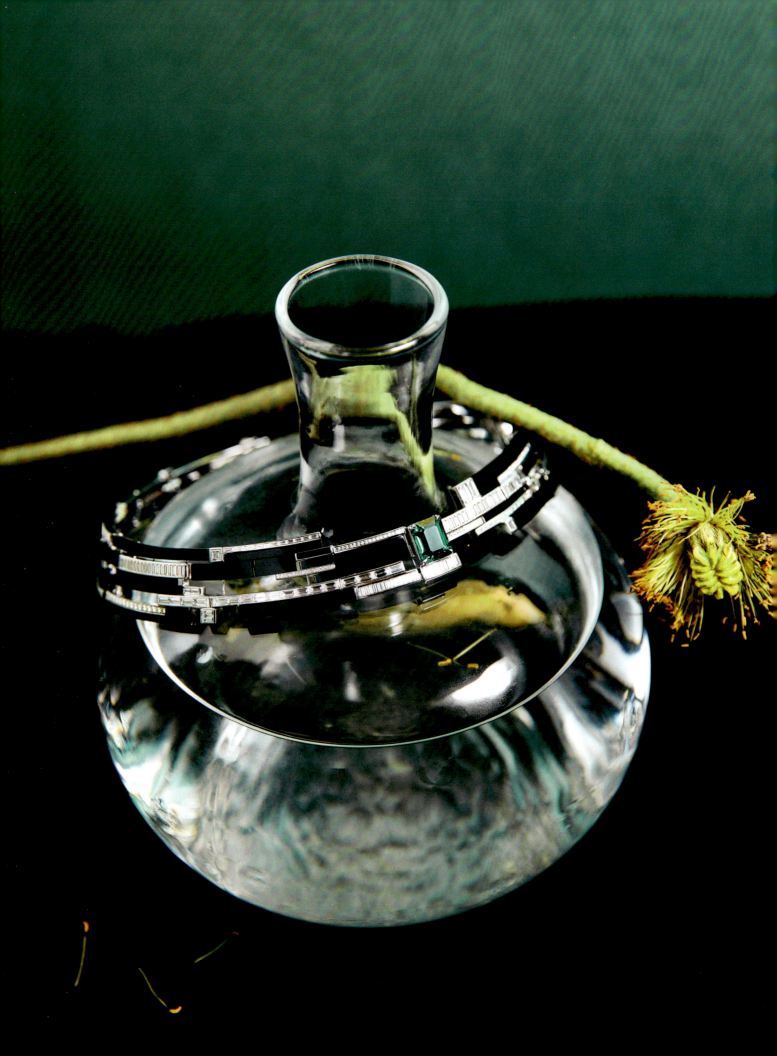

Mathieu Trautmann

*Marie Claire
Haute Joaillerie*

2021

Sabine Villiard

Bolero Suisse

2017

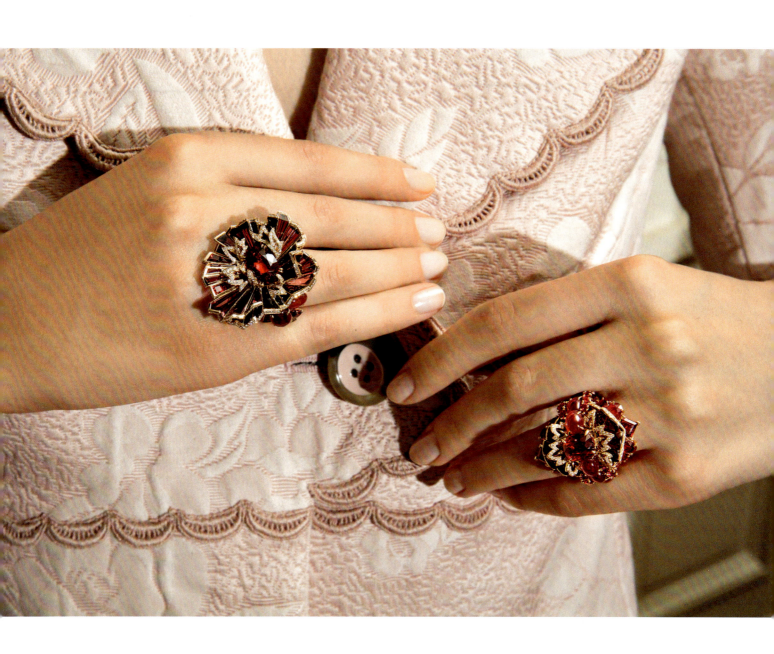

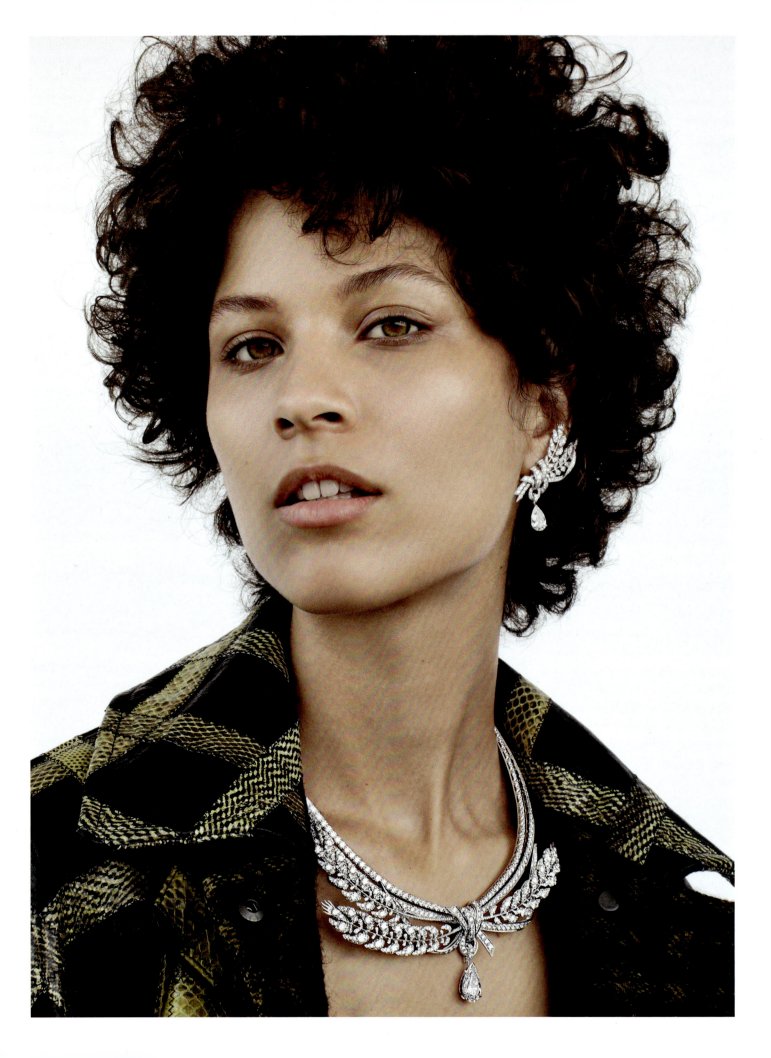

Amy Troost

Vanity Fair France

2016

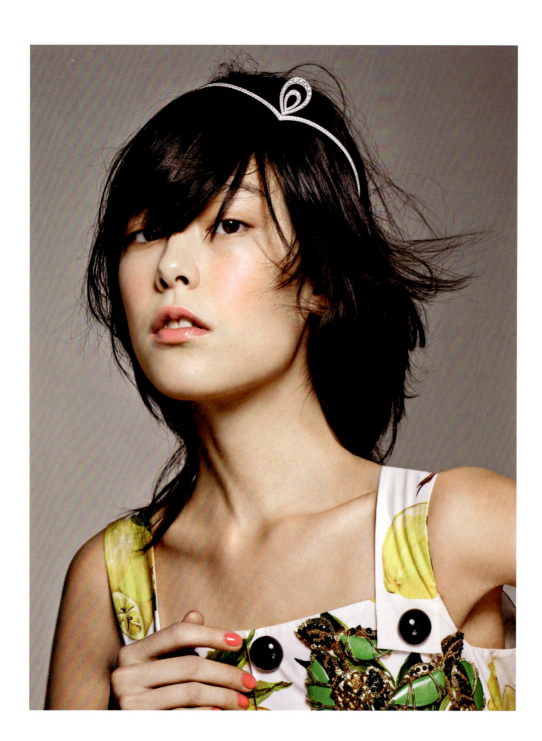

Jem Mitchell
SKP Magazine
2016

Emma Tempest
L'Express Styles
2015

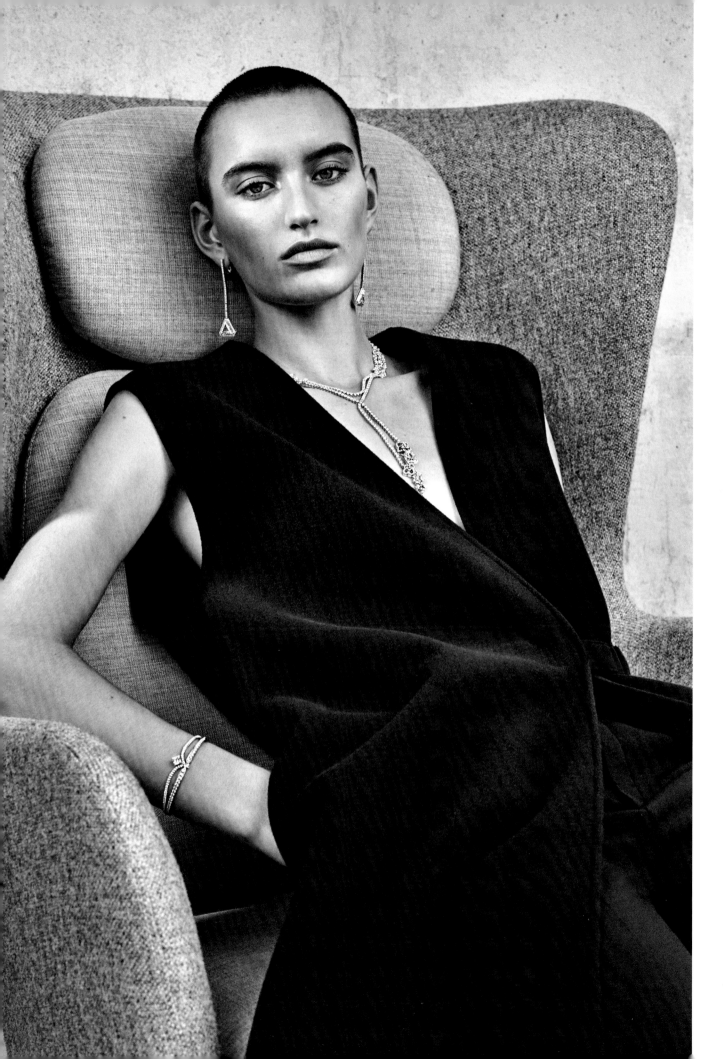

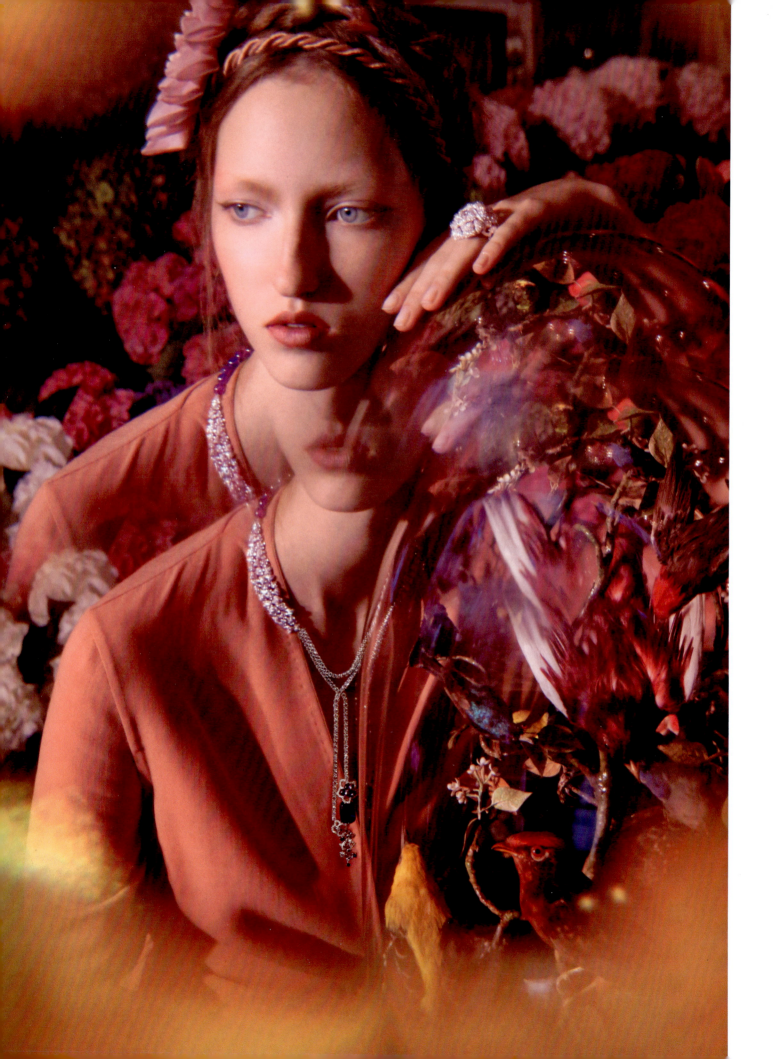

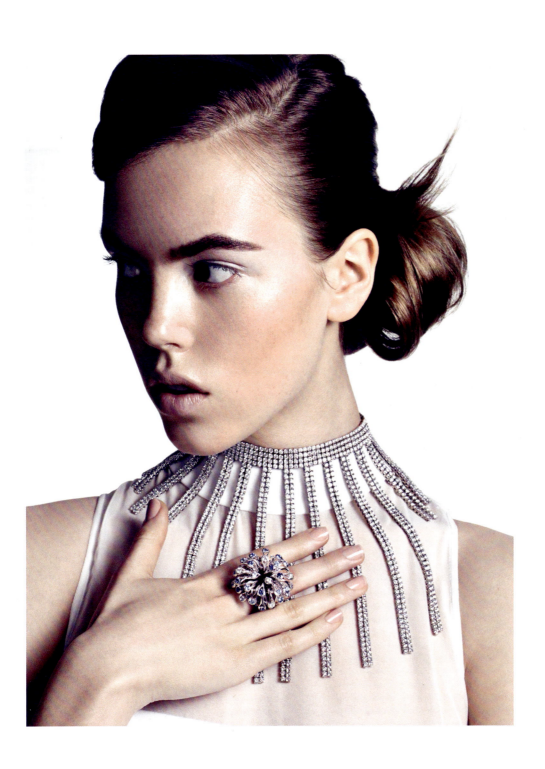

Greg Lotus
Vogue Gioiello Japan
2016

John Akehurst
Vogue Gioiello Japan
2014

Tom Munro

The Childhood of a Leader
(movie by Brady Corbet)

2016

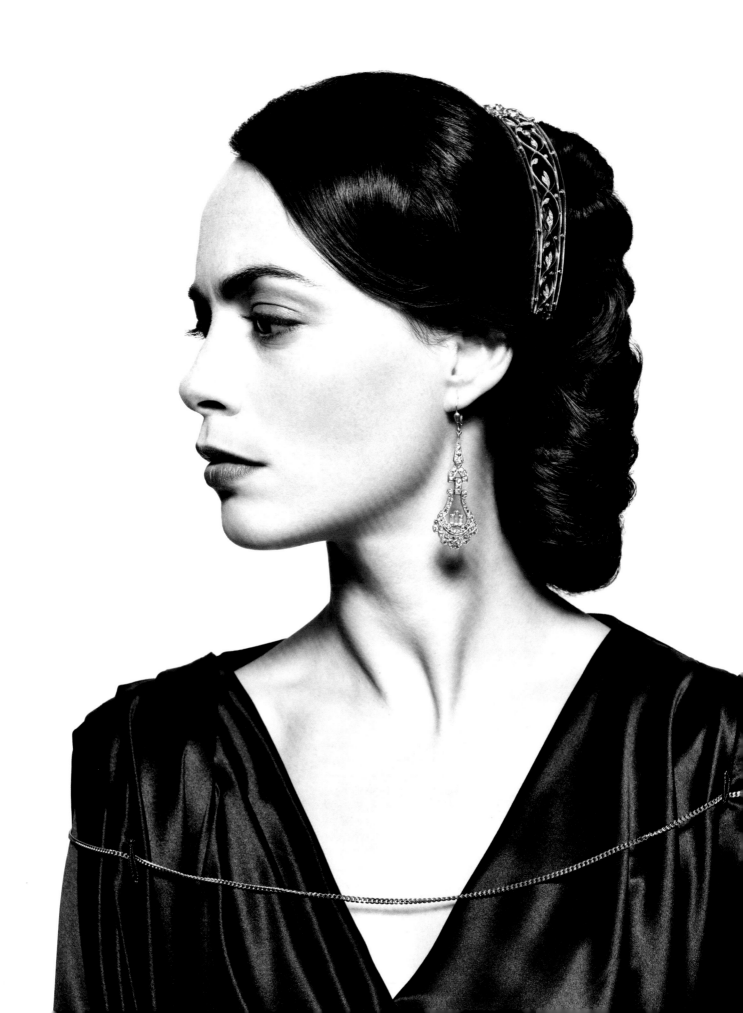

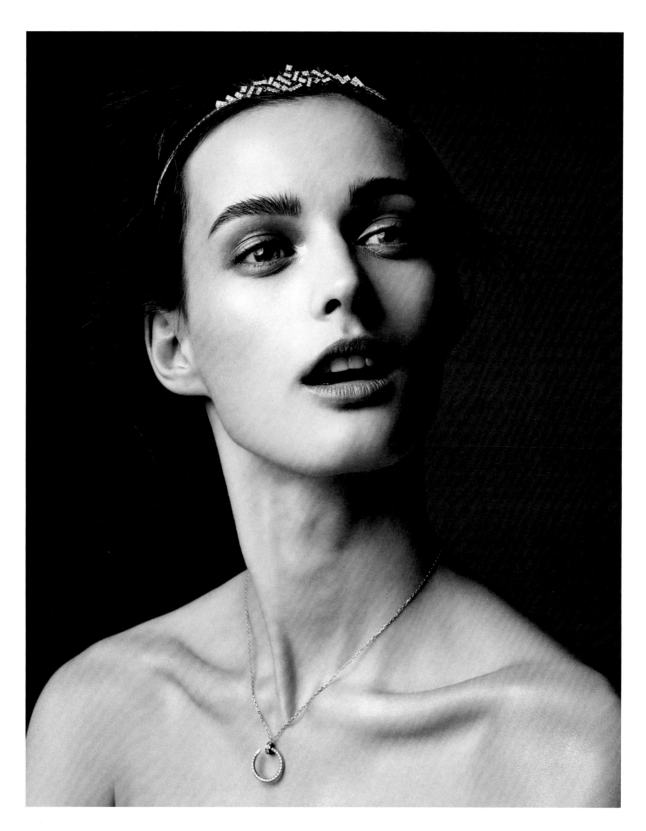

Paul Wetherell
Telegraph Magazine
2014

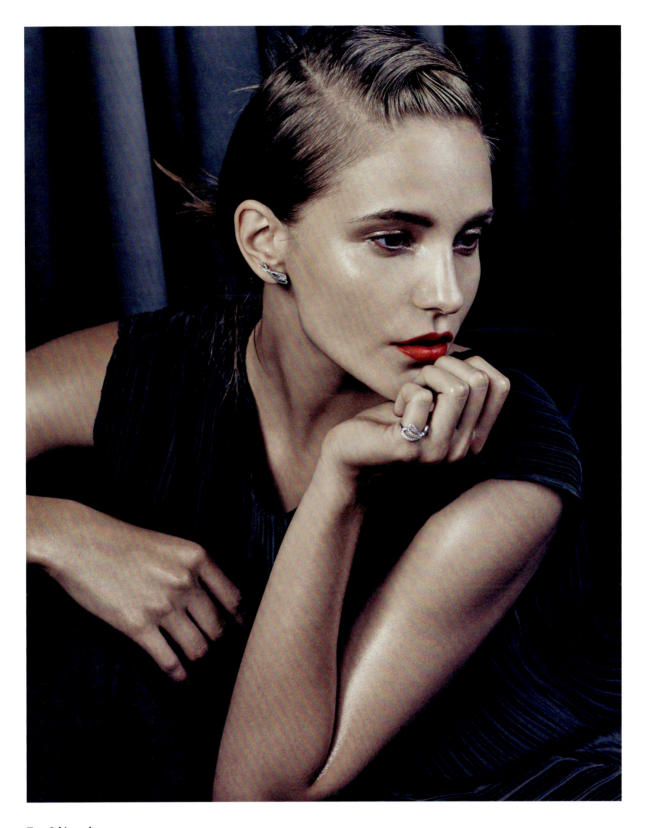

Tom Schirmacher
Harper's Bazaar Japan
2015

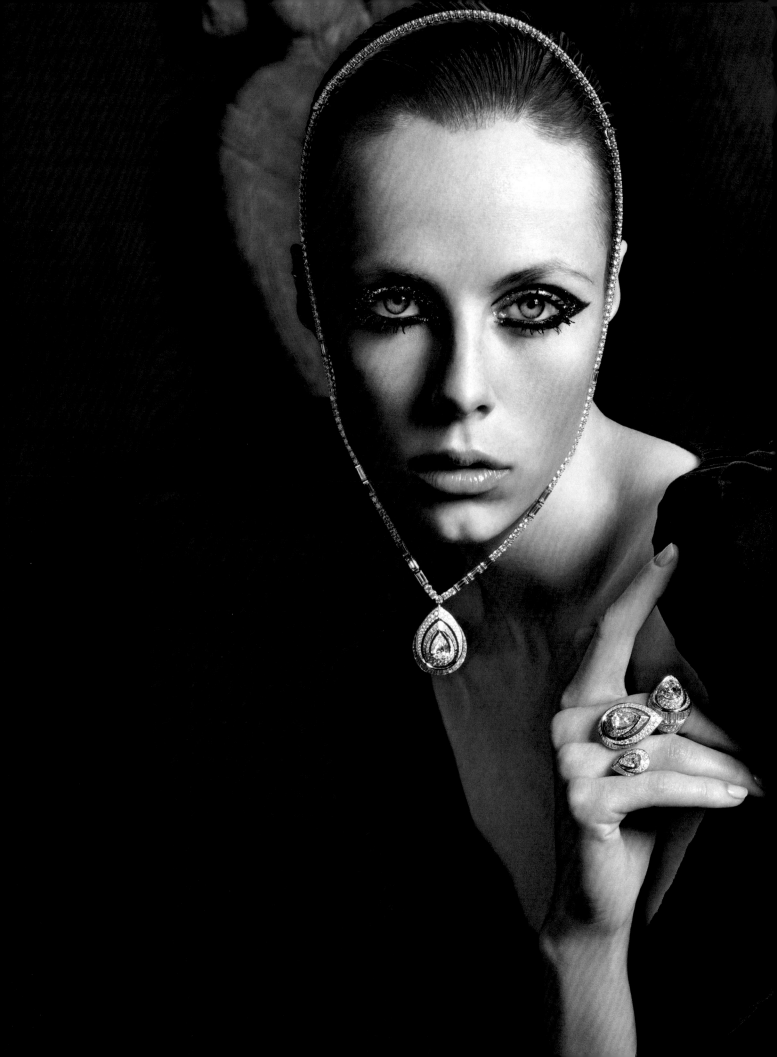

Inez Van Lamsweerde
and Vinoodh Matadin

Vogue Paris

2015

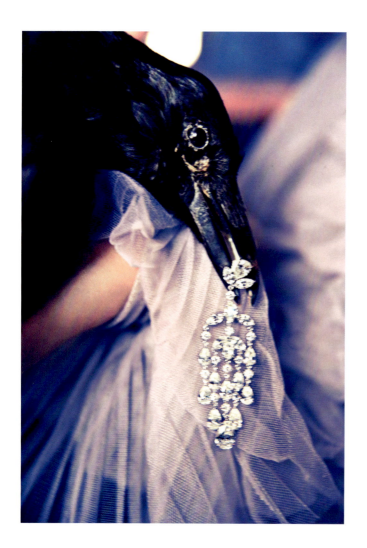

Ellen von Unwerth
Vogue Russia
2014

Thierry Le Goues
Revue des modes France
2014

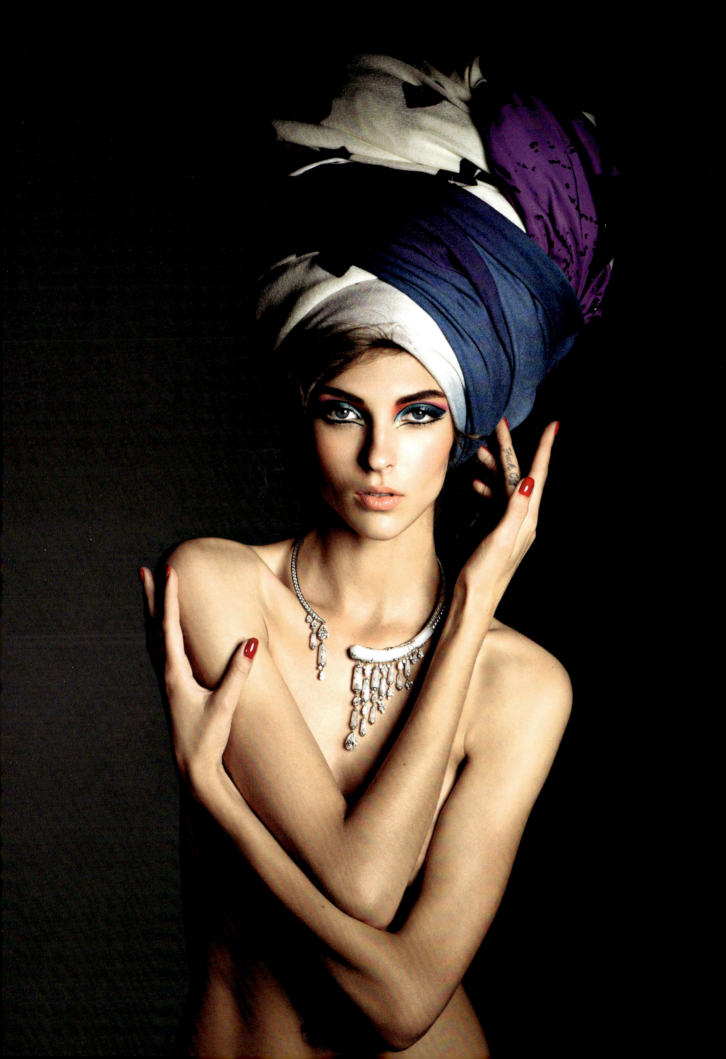

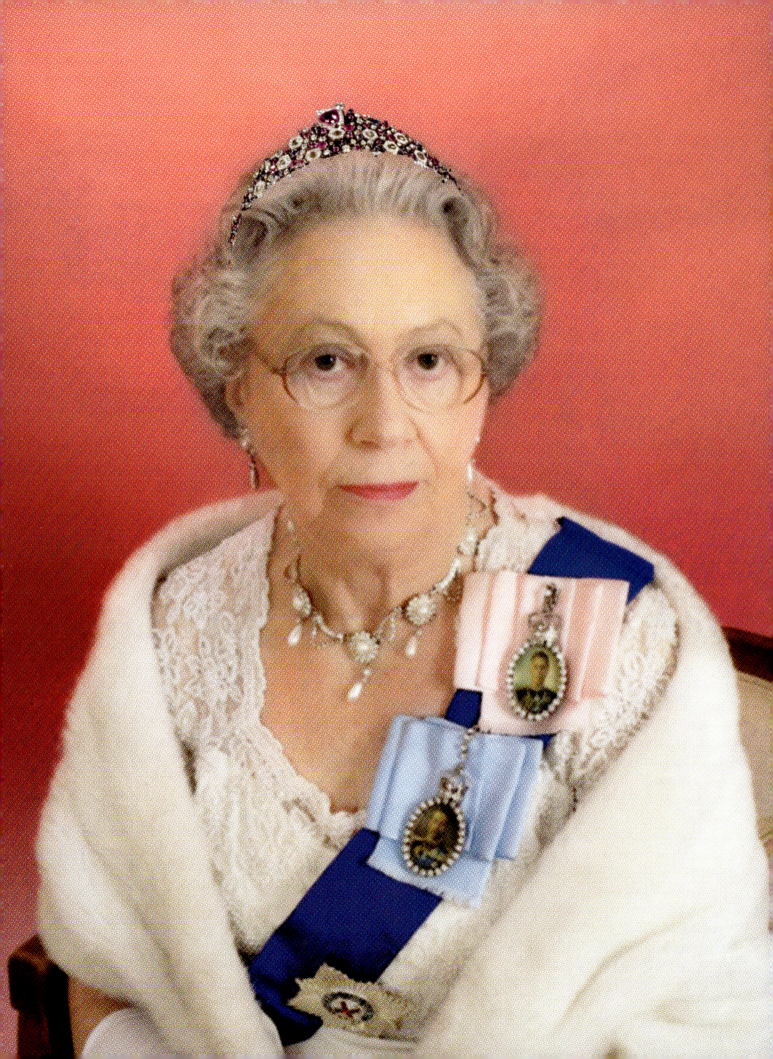

Guido Mocafico
Numéro Royalty
2013

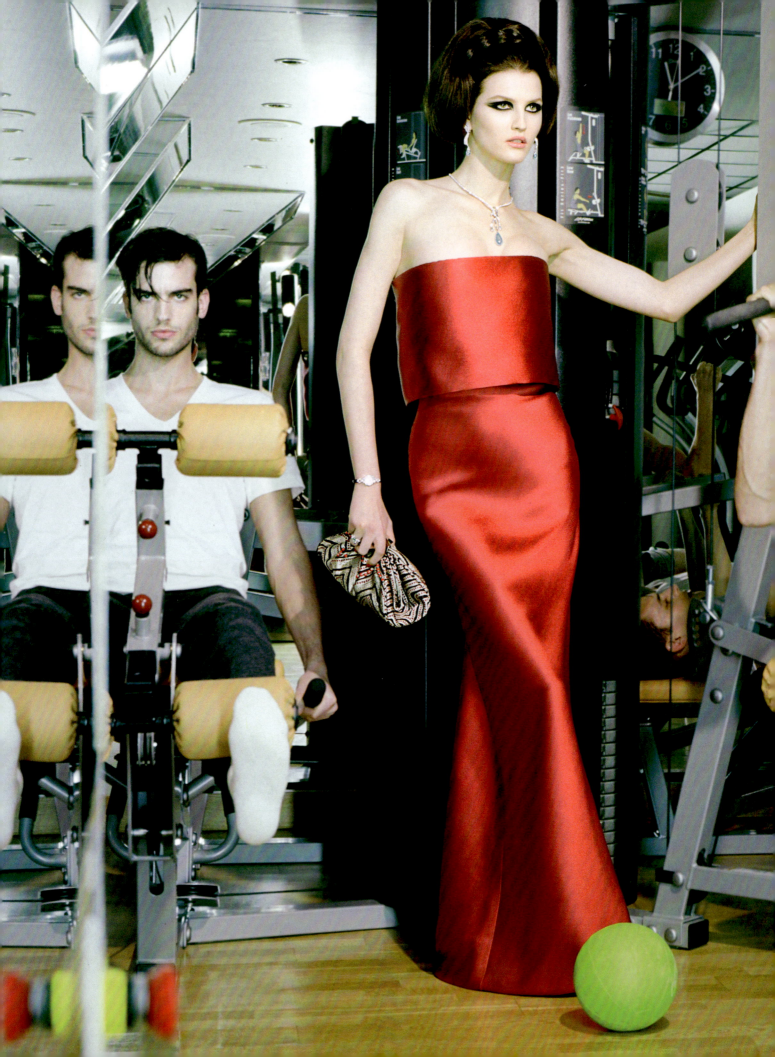

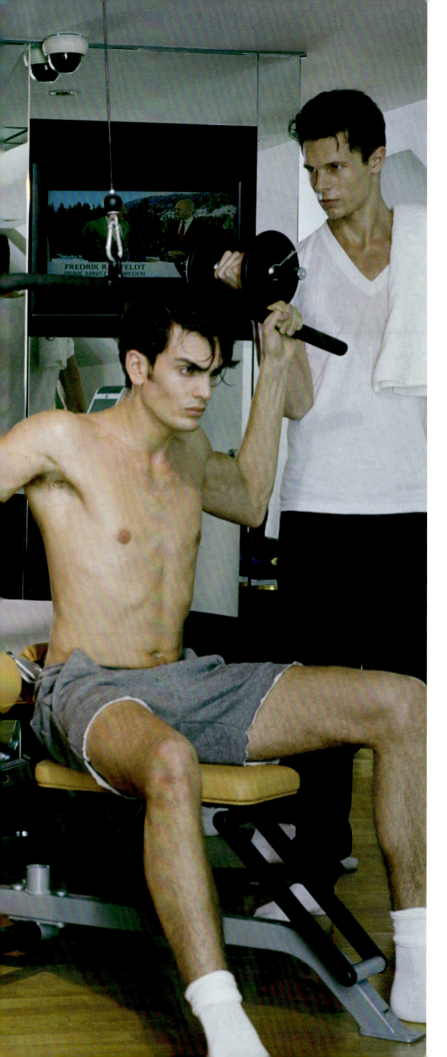

Miles Aldridge
Vogue Italia
2013

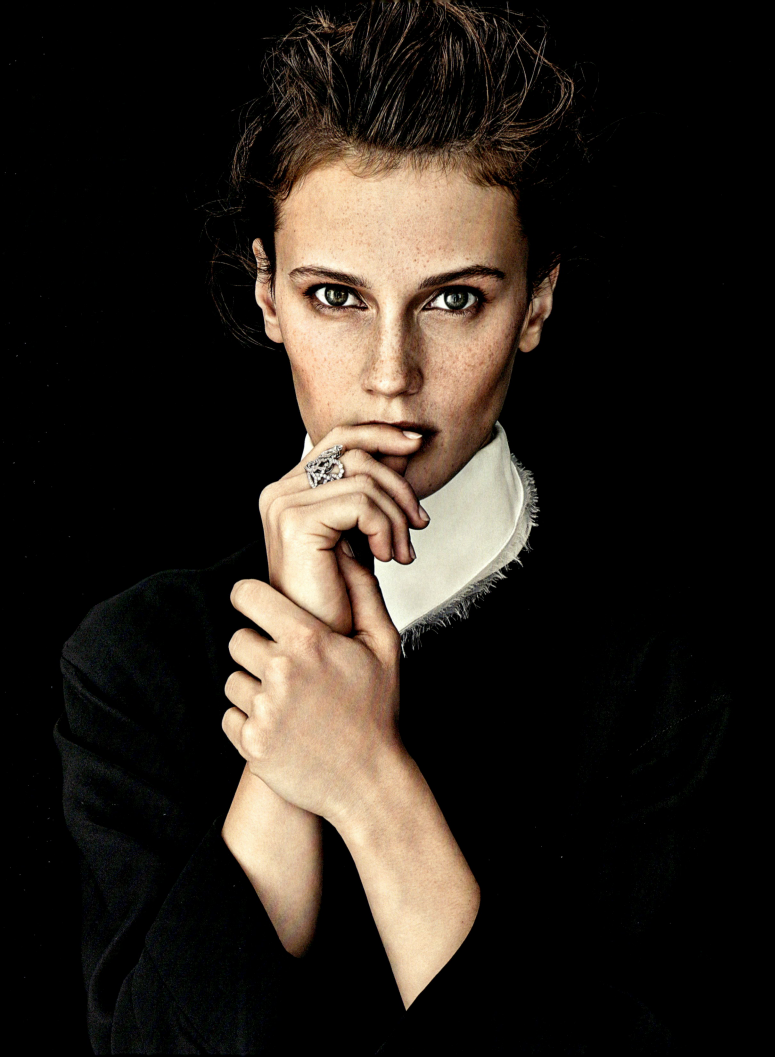

Andreas Sjodin
Elle France
2014

Walter Pfeiffer
Vogue Paris
2012

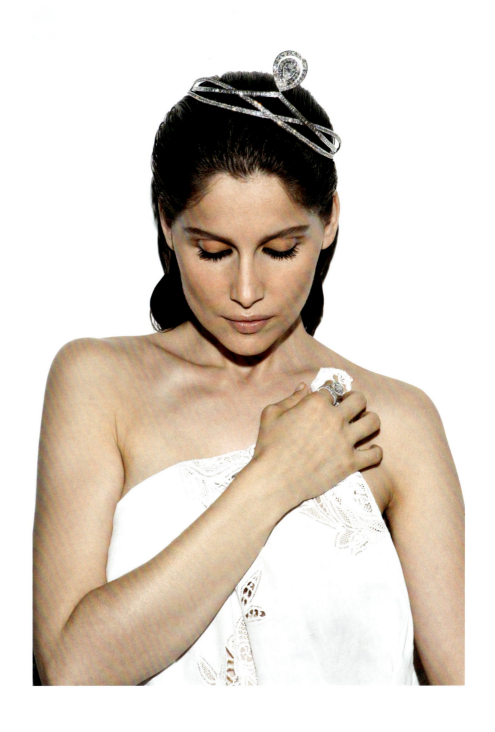

Ben Hassett
Numéro
2011

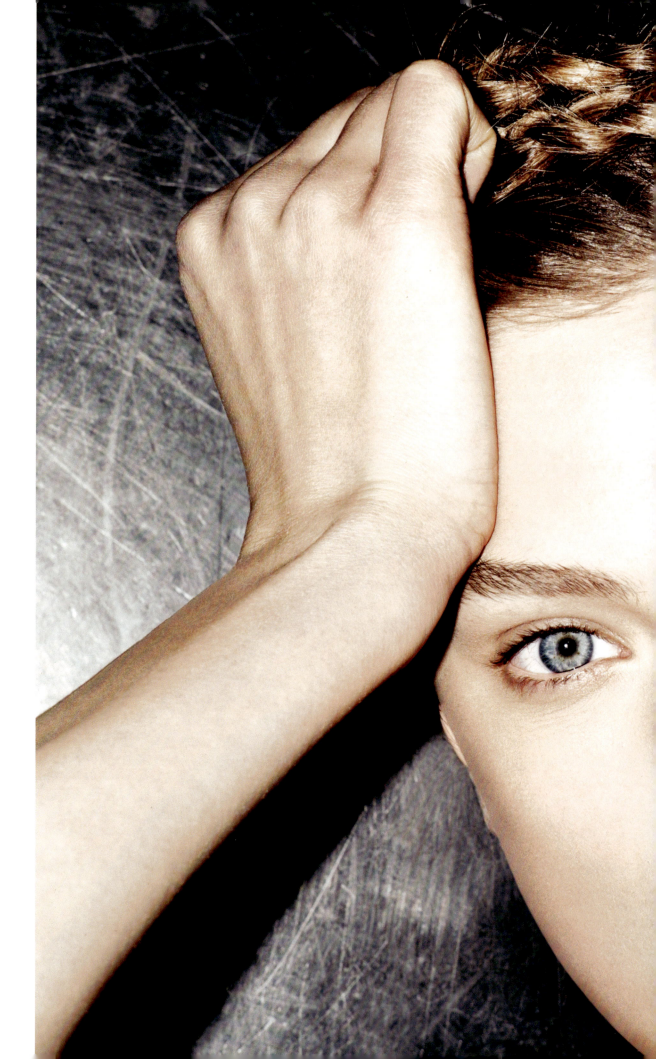

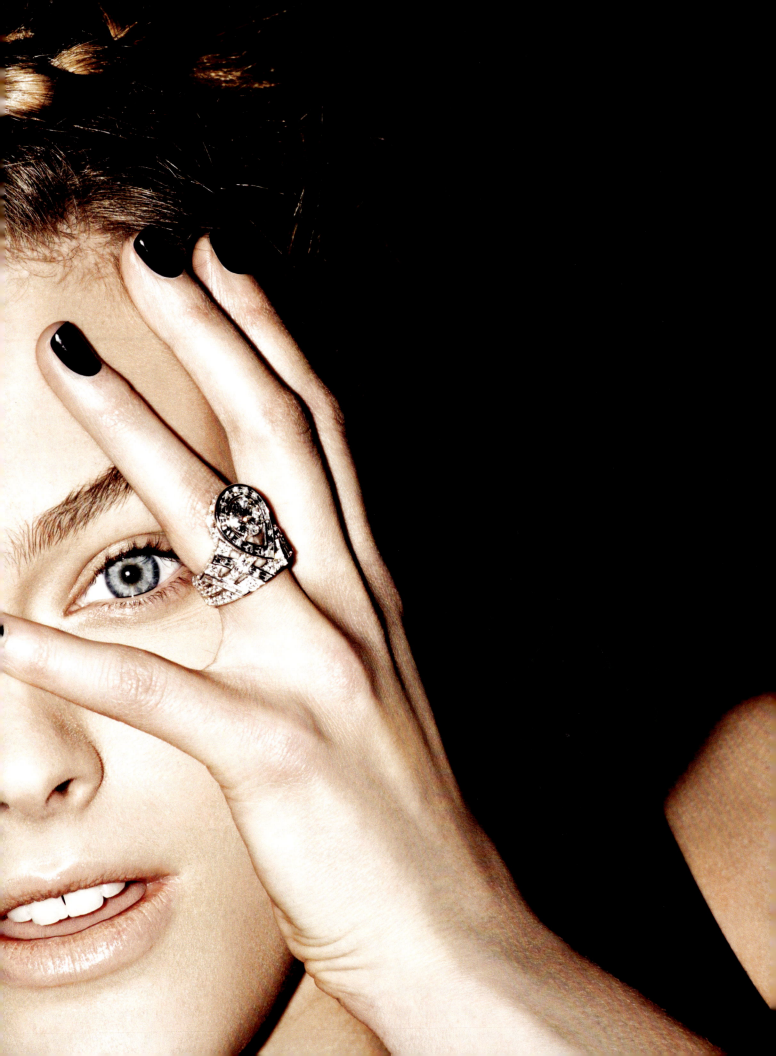

Liz Collins
Numéro
2011

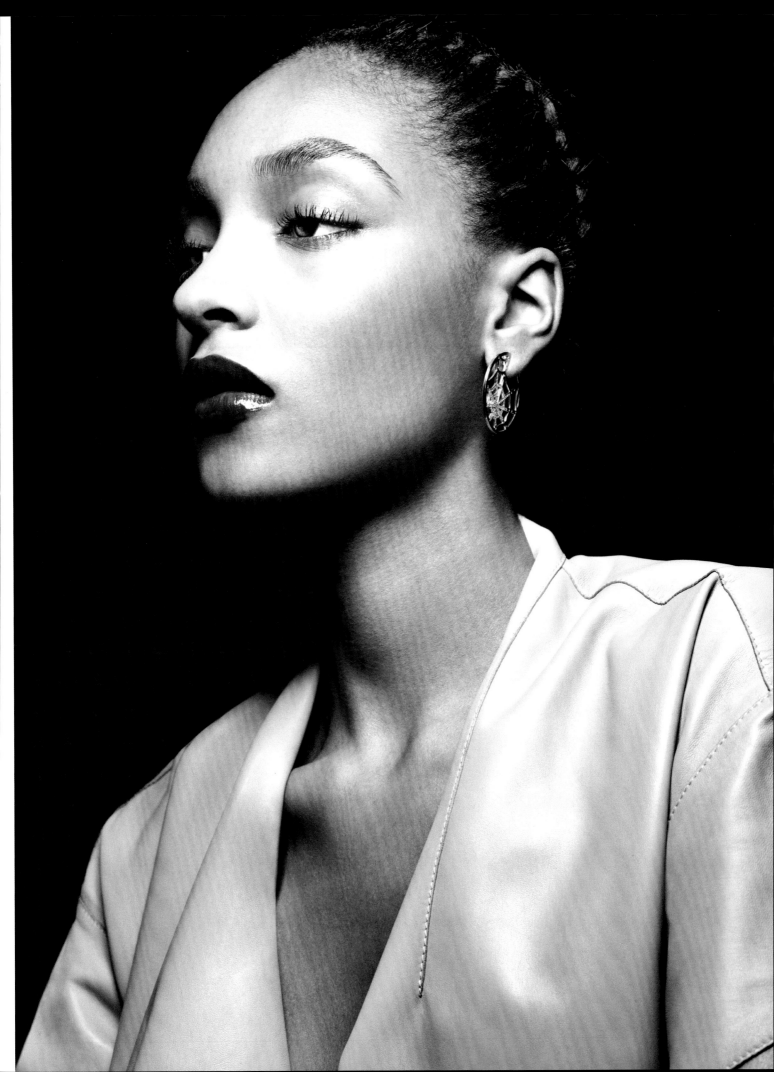

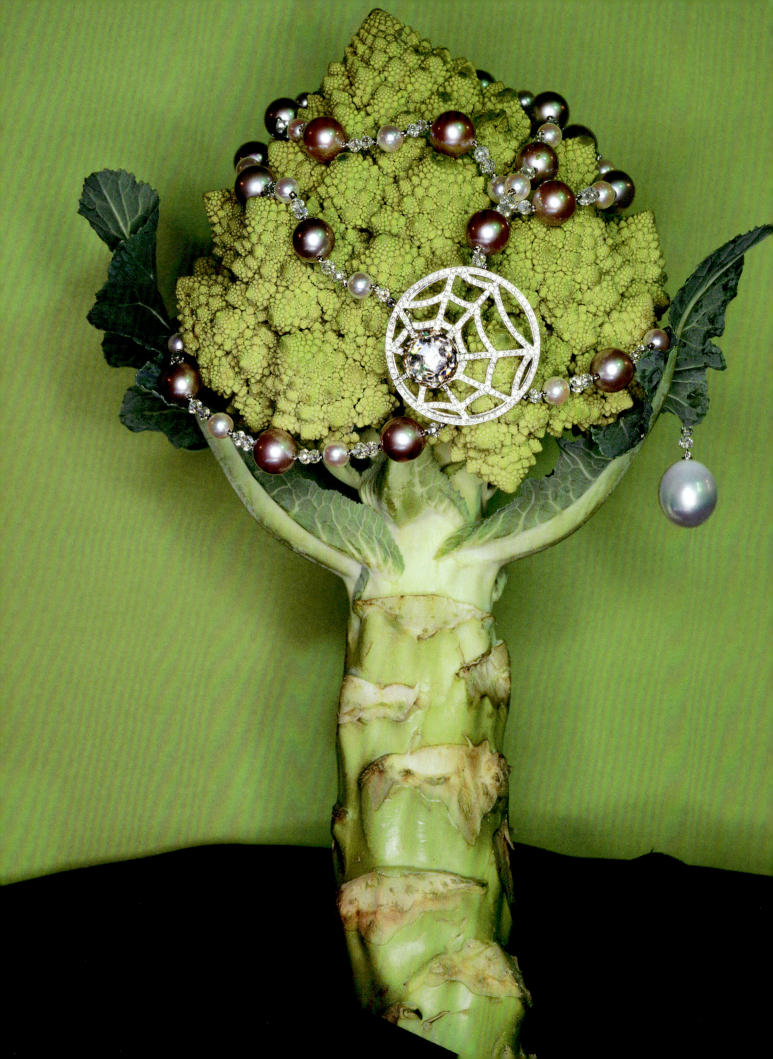

Nobuyoshi Araki

Untitled from
Yami No Hana
(Flowers of Darkness)

2008

Luciana Val
and Franco Musso

Numéro

2008

Following page:

Richard Burbridge

Ad campaign

2003

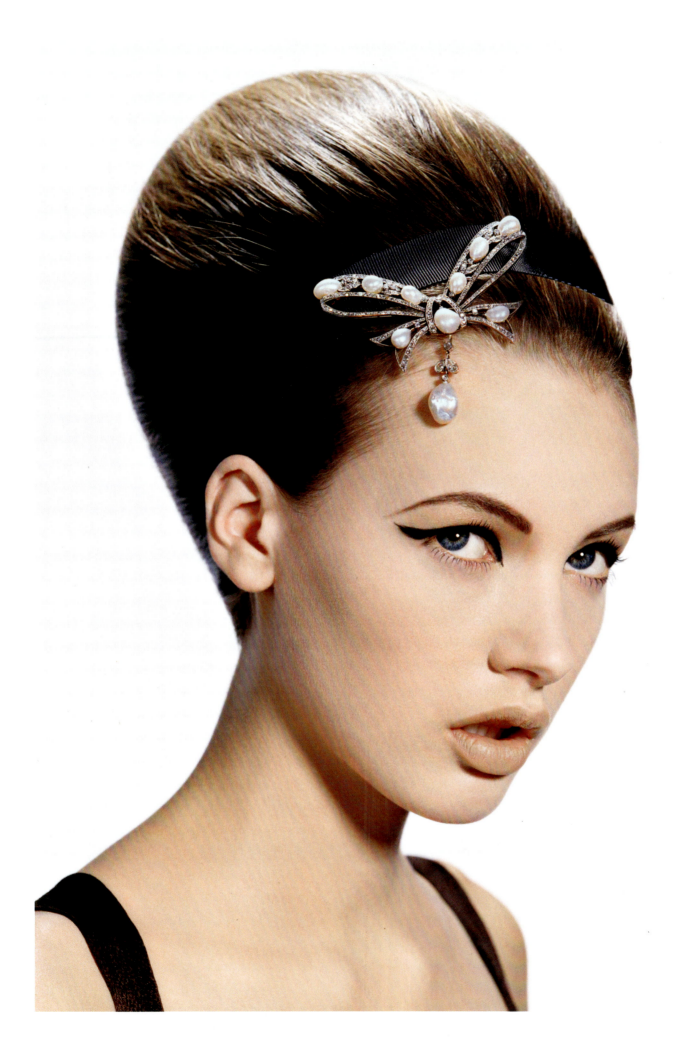

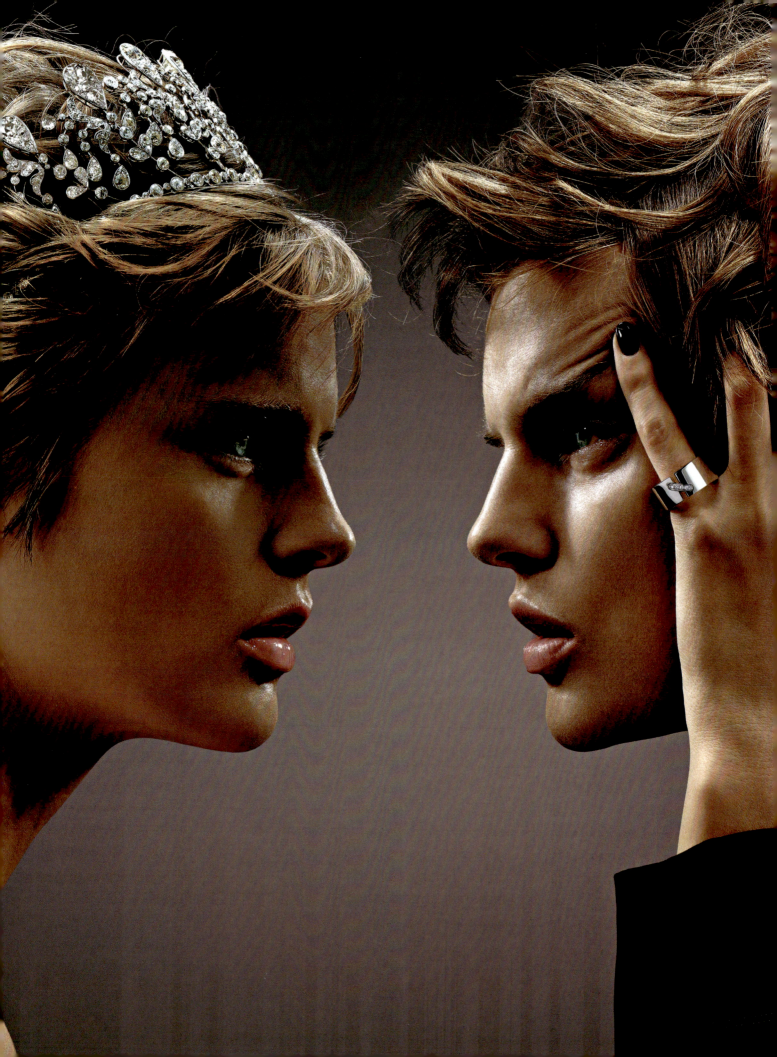

Shared
pers
pectives

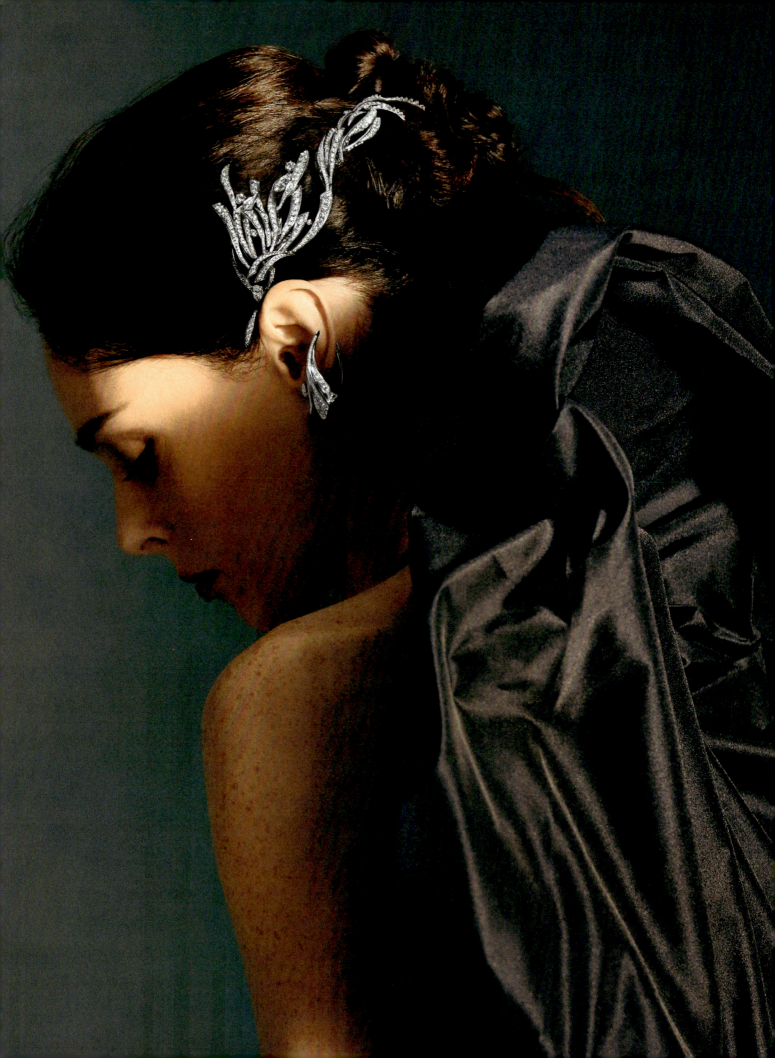

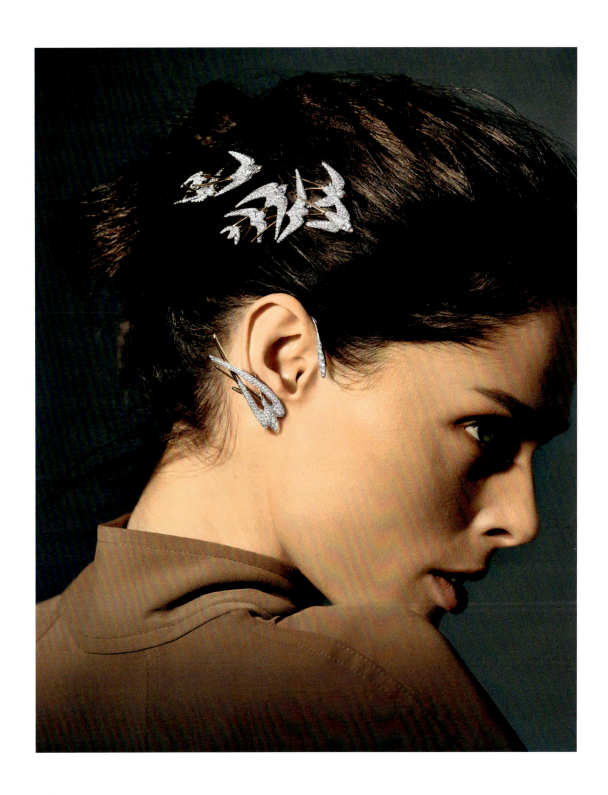

Robbie Lawrence

2023

Elizaveta Porodina

2023

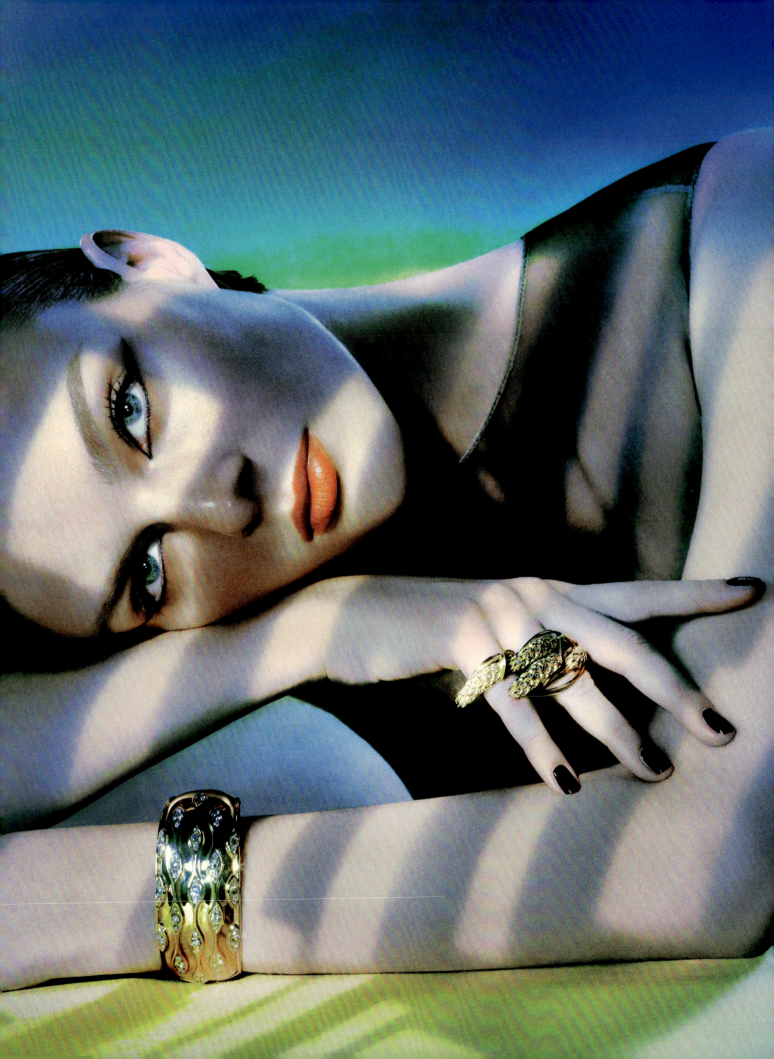

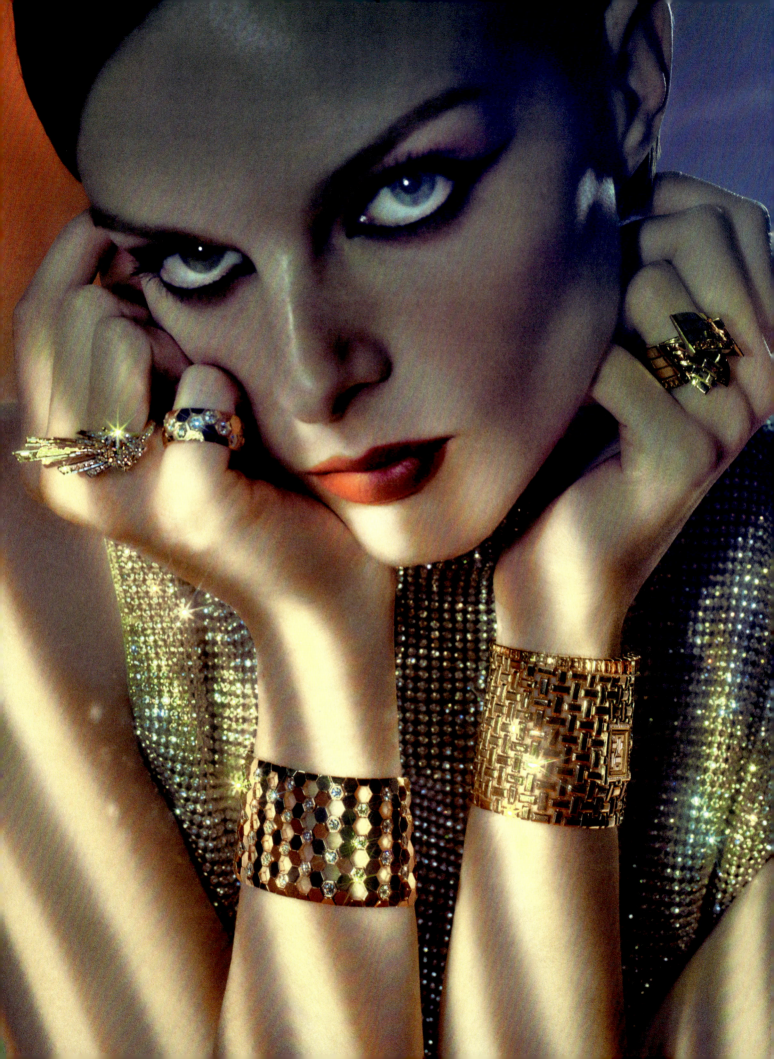

Elizaveta Porodina

2023

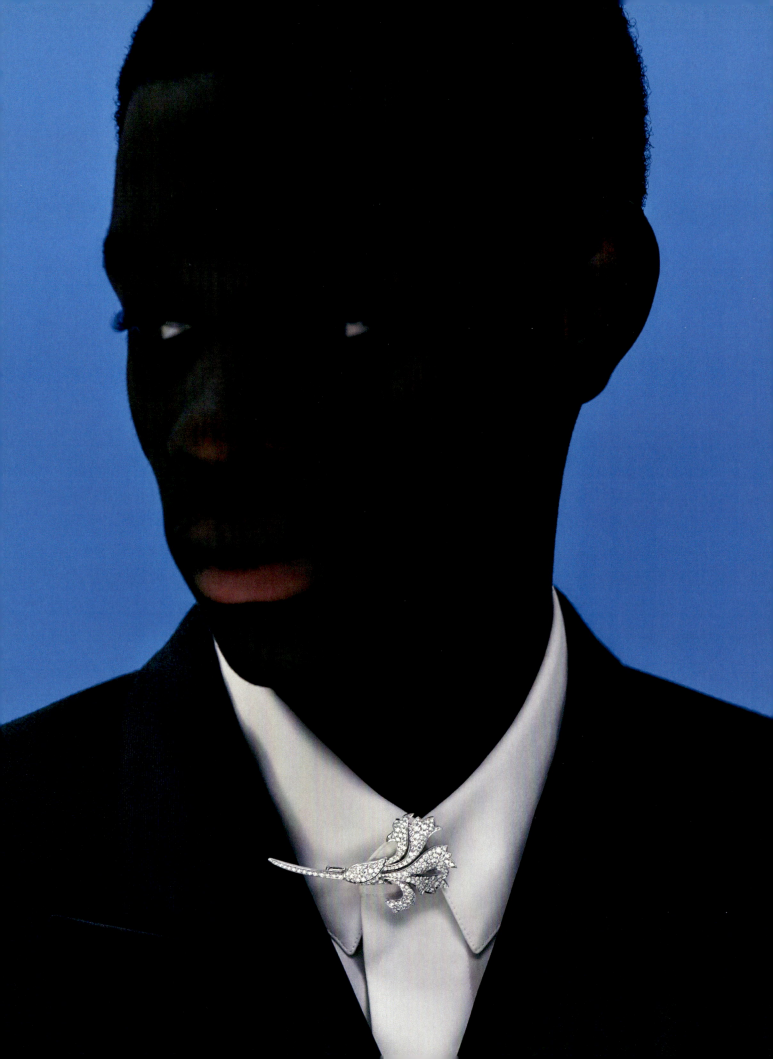

Timothy Schaumburg

2022

Following pages:

**Maurizio Cattelan
and Pierpaolo Ferrari**

2020

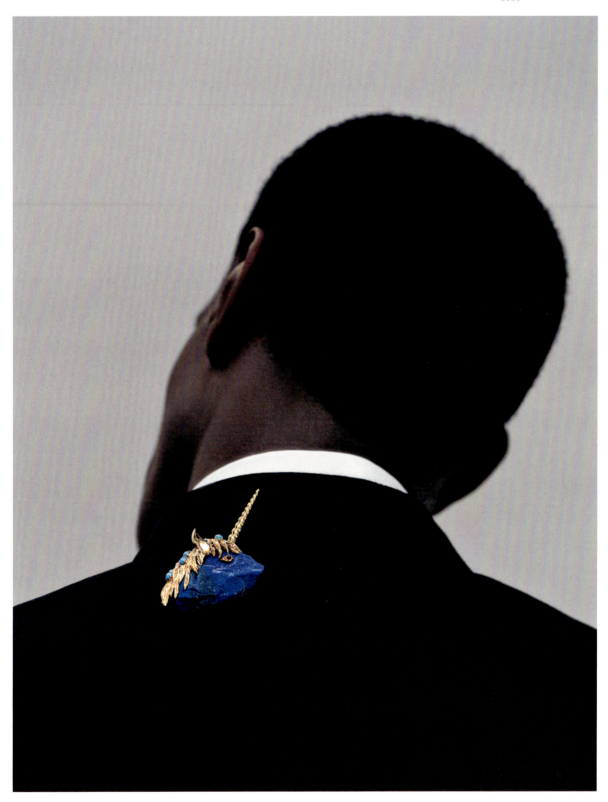

SHARED PERSPECTIVES

105

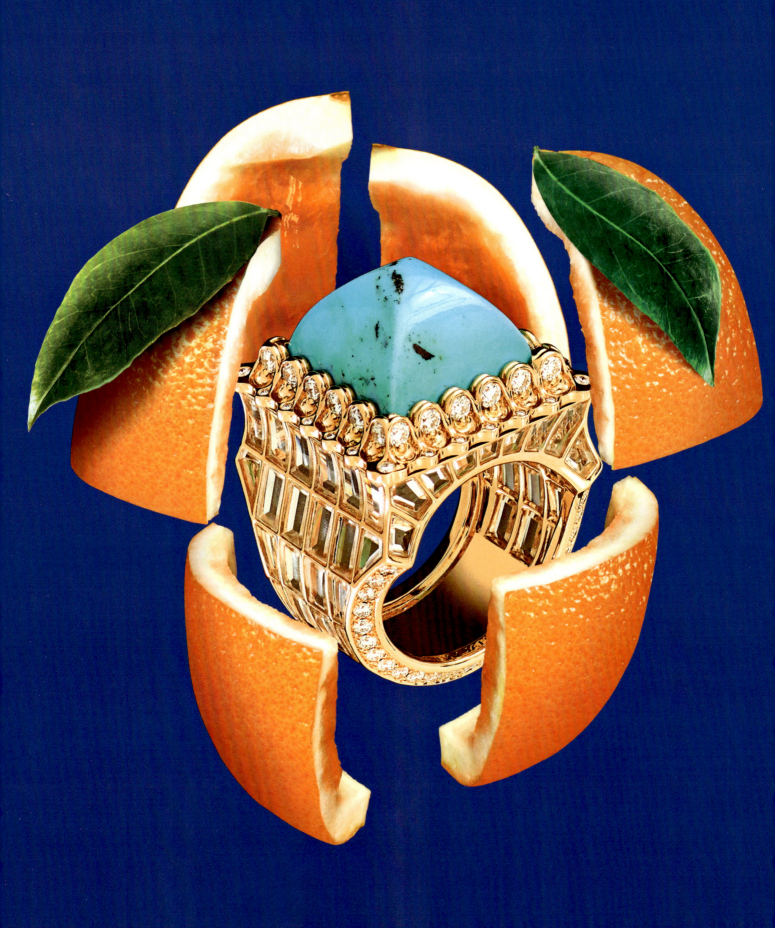

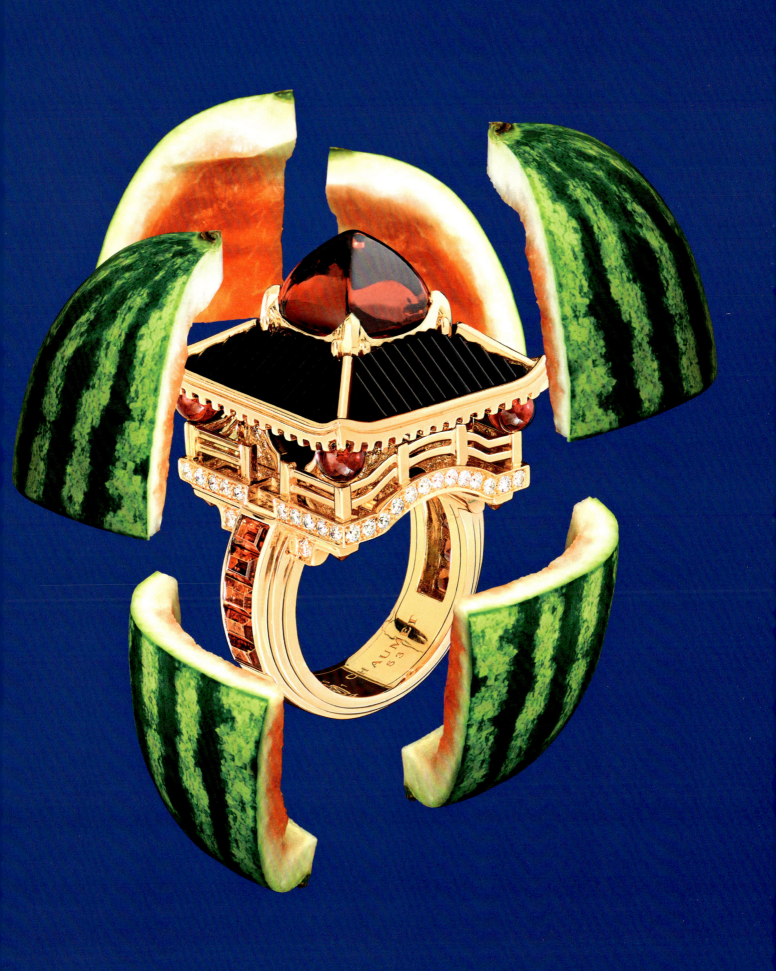

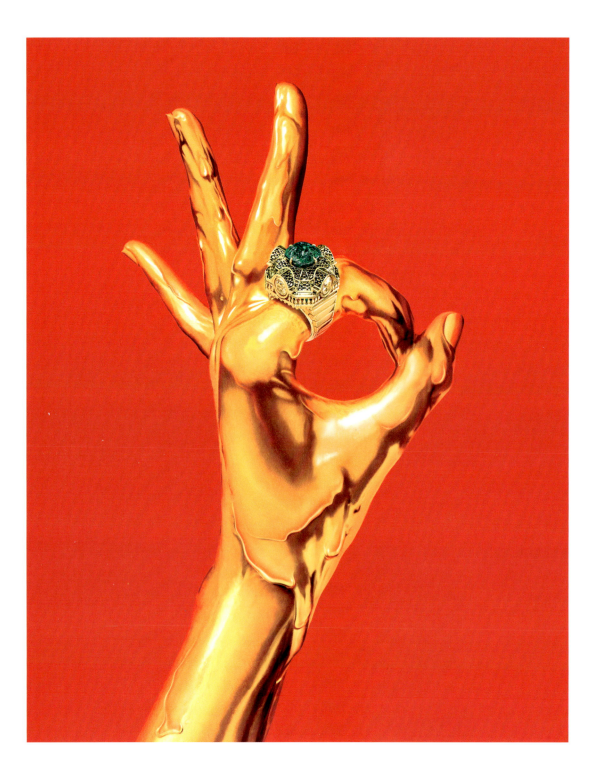

Maurizio Cattelan
and Pierpaolo Ferrari

2020

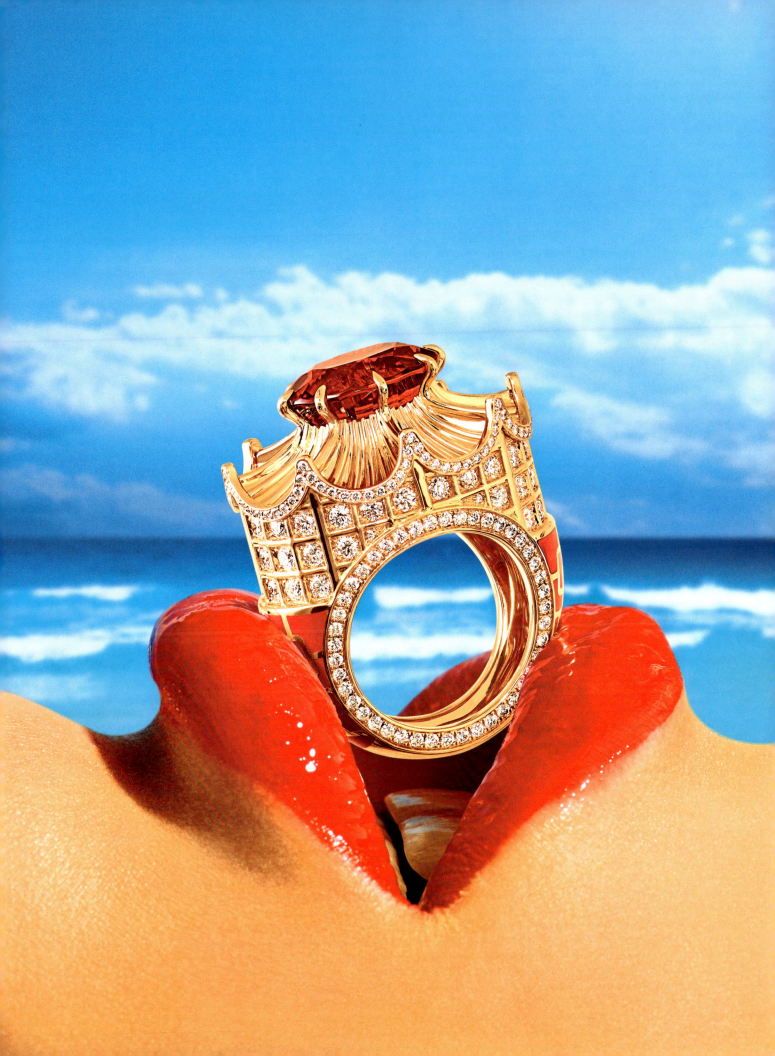

Cédric Bihr

2022

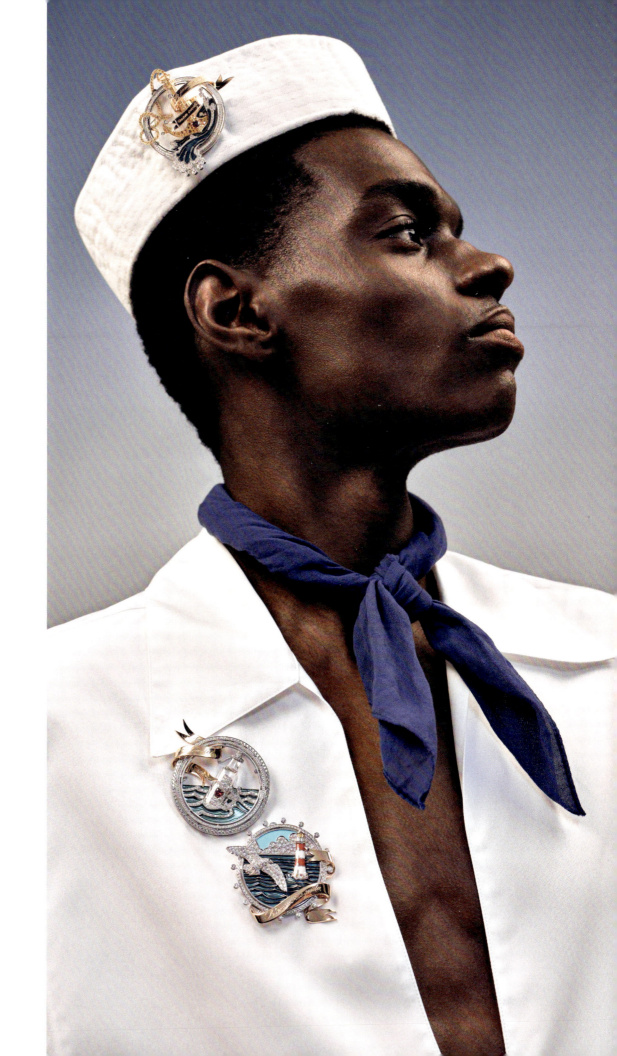

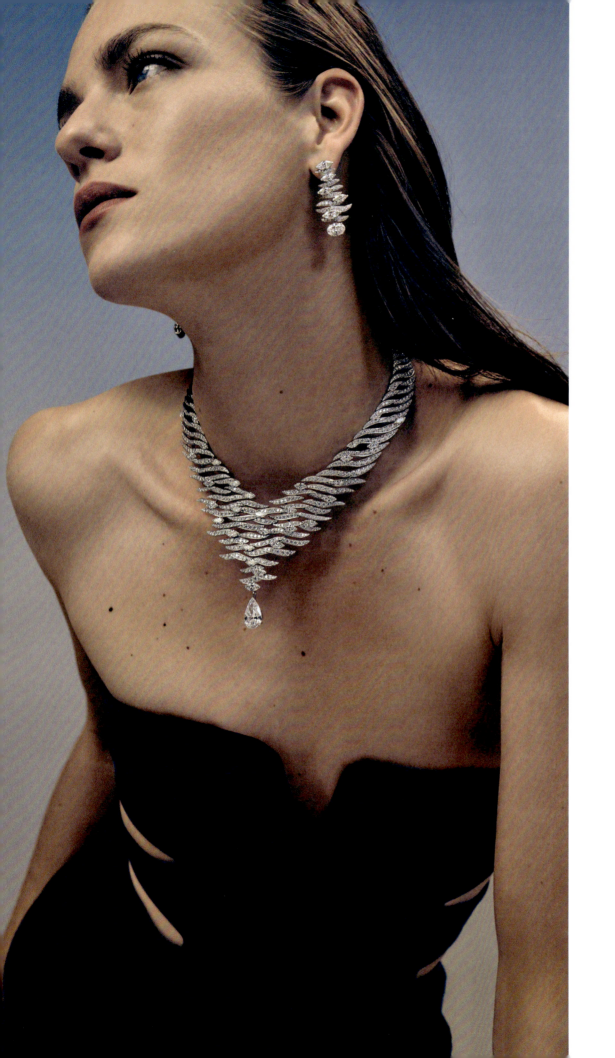

Cédric Bihr
2022

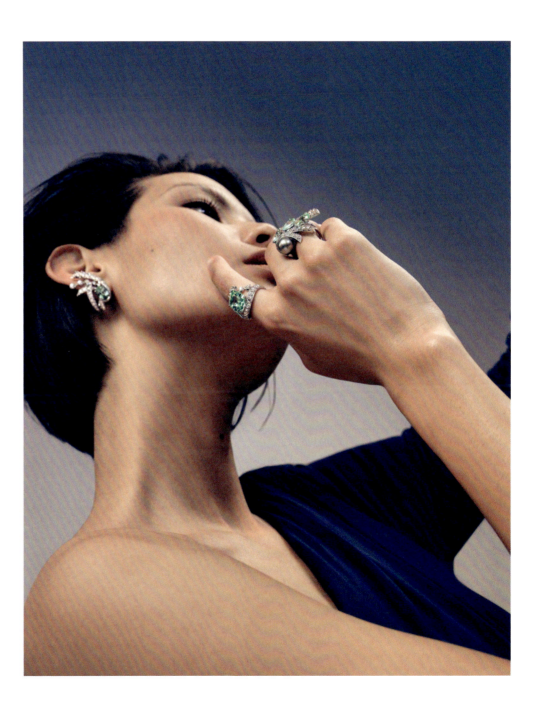

Julia Hetta

2019

Following pages:

Julia Hetta

2018

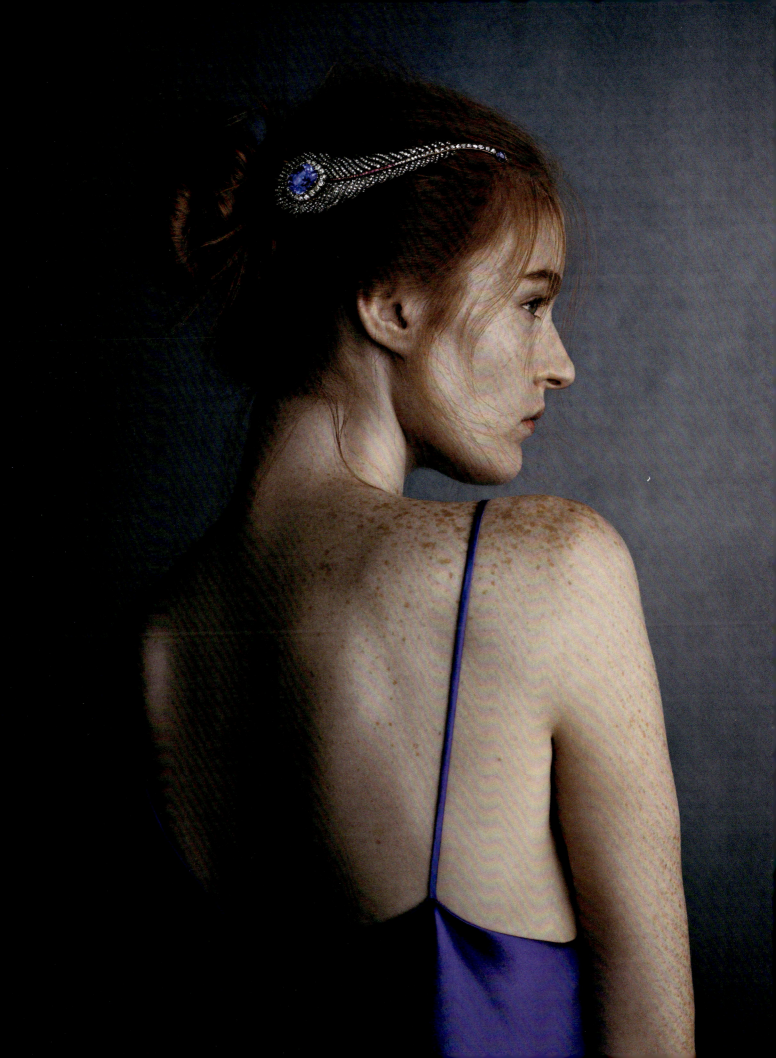

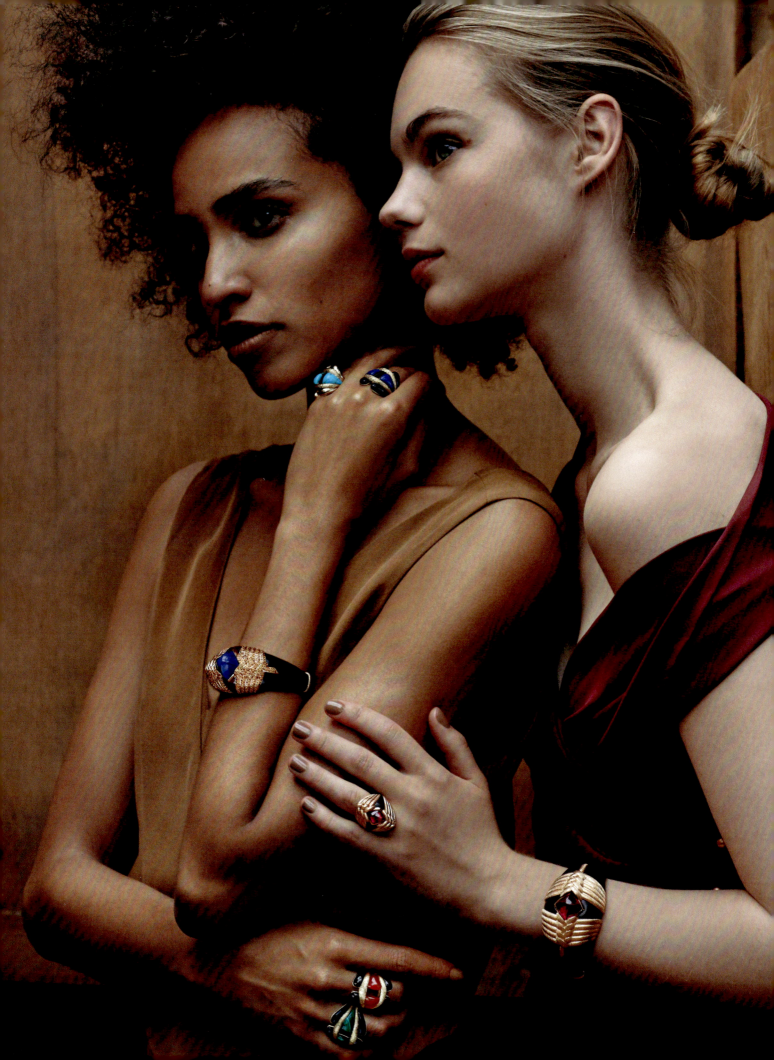

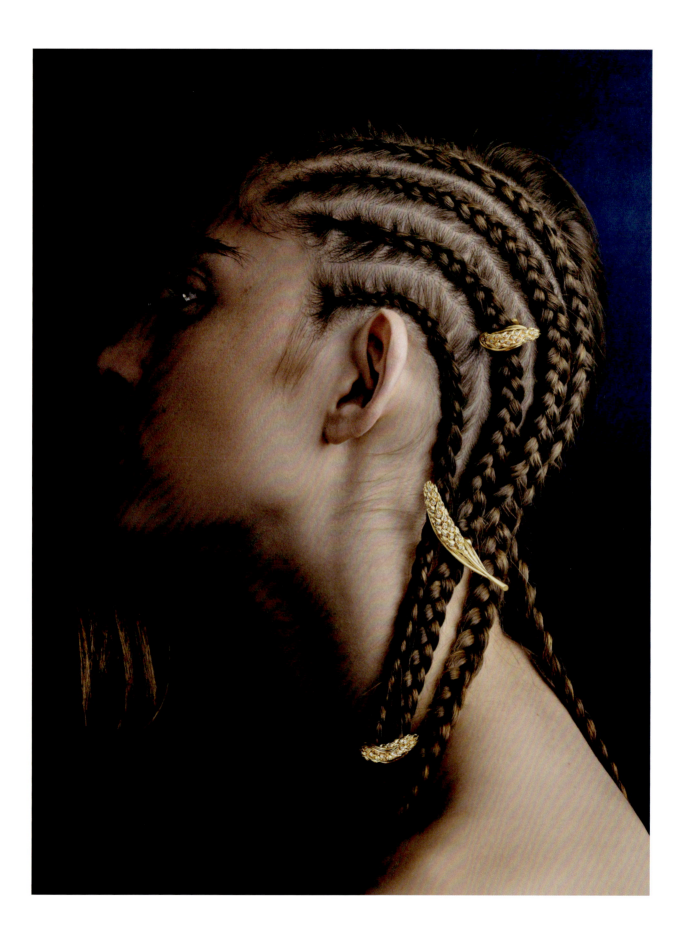

Julia Hetta
2019

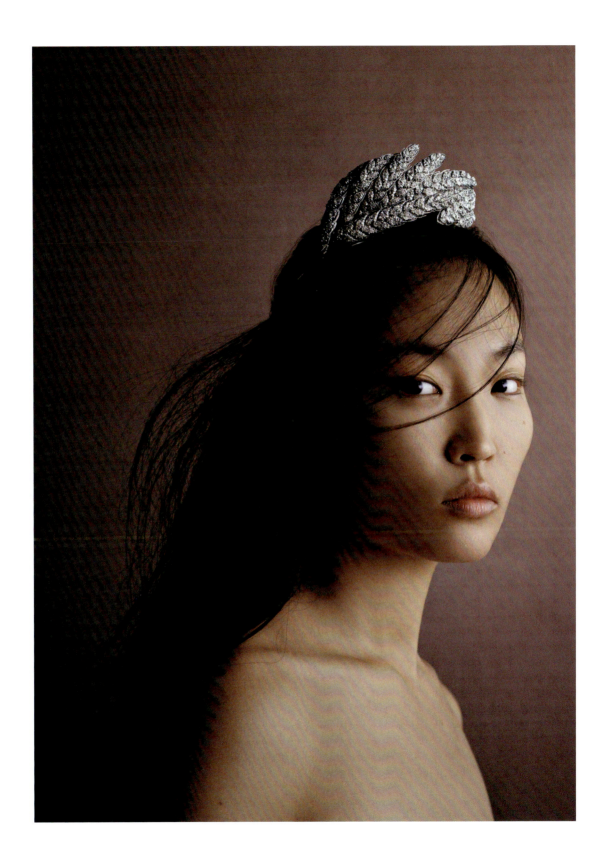

SHARED PERSPECTIVES

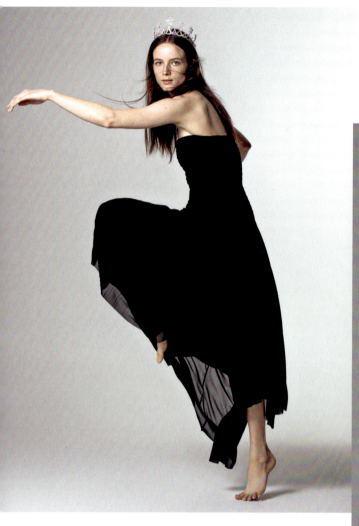
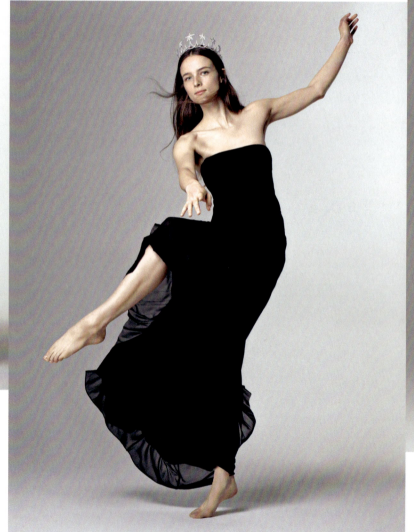

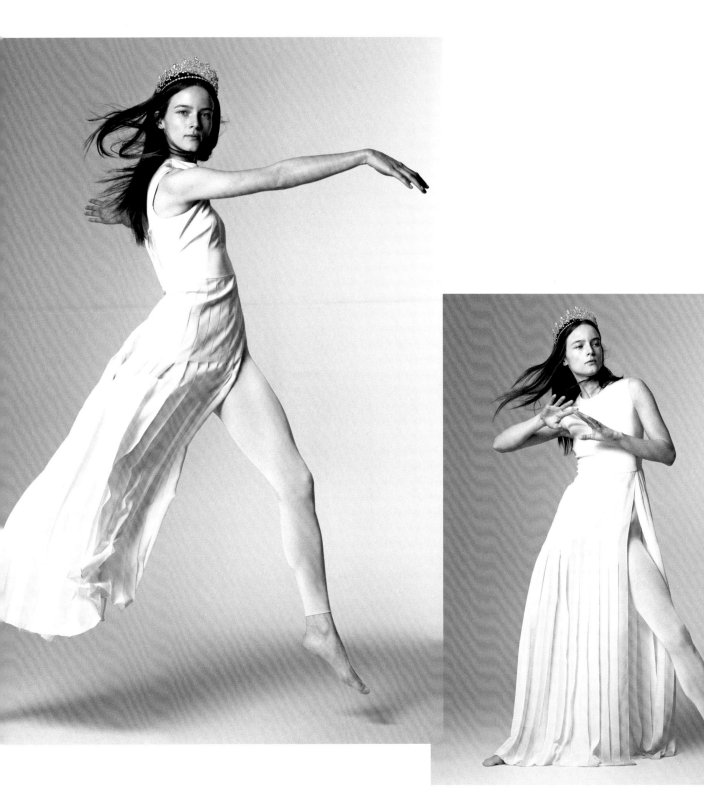

Julien Martinez Leclerc

2021

SHARED PERSPECTIVES

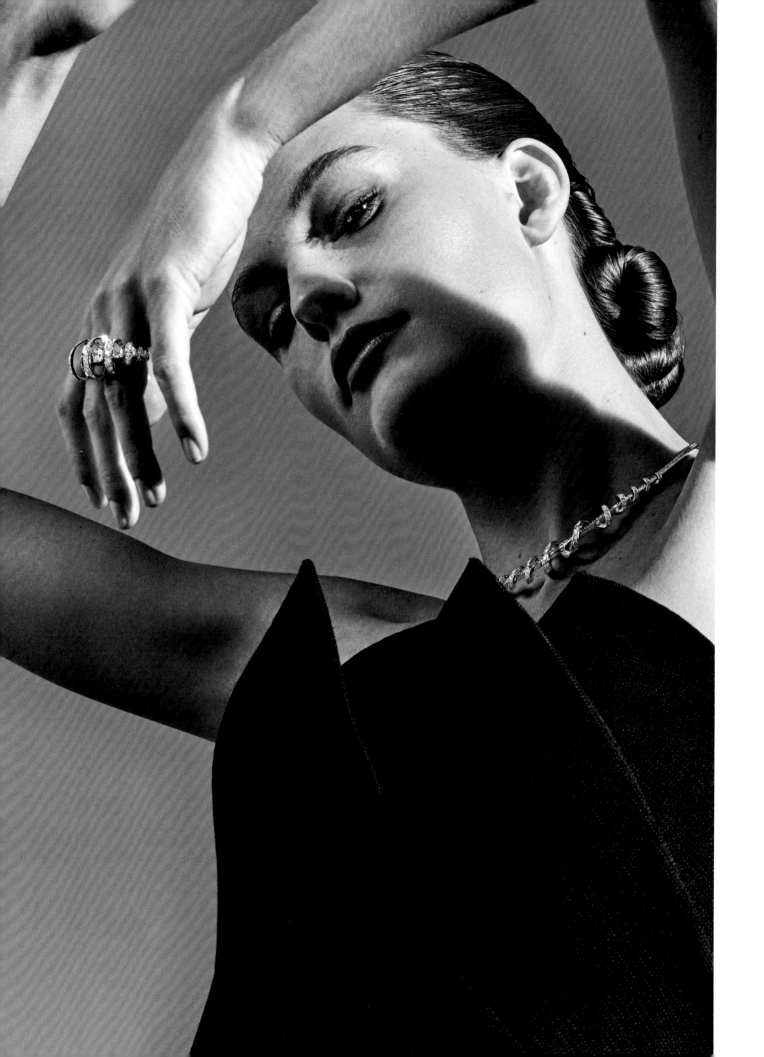

Mélanie Lyon
and Ramòn Escobosa

2021

Julia Noni

2022

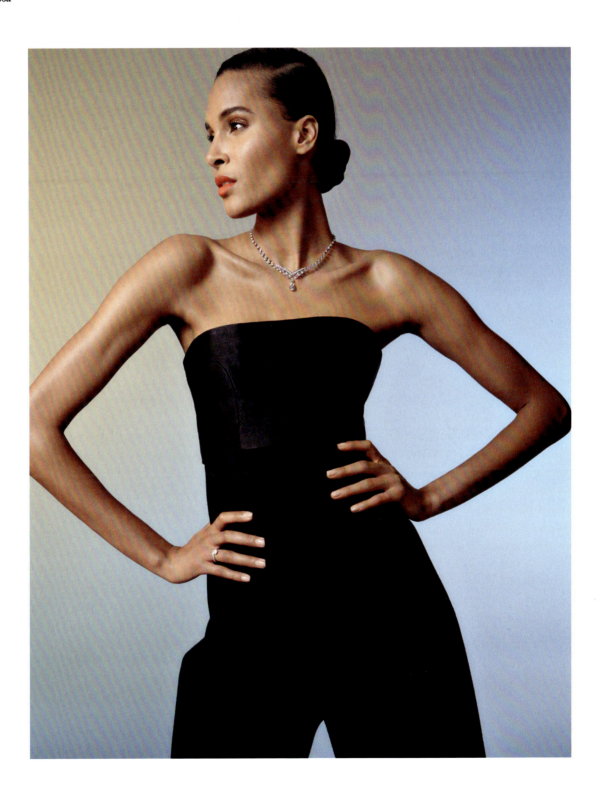

SHARED PERSPECTIVES

123

Sofia Sanchez
and Mauro Mongiello

2016

Following pages:

Richard Burbridge

2021

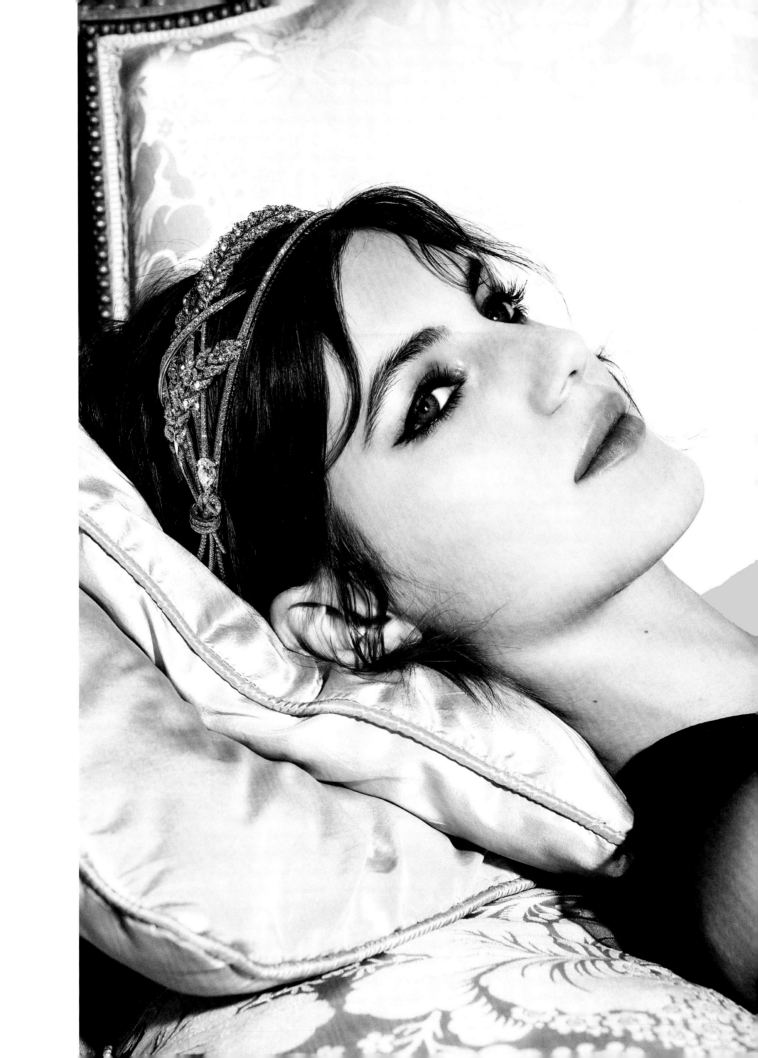

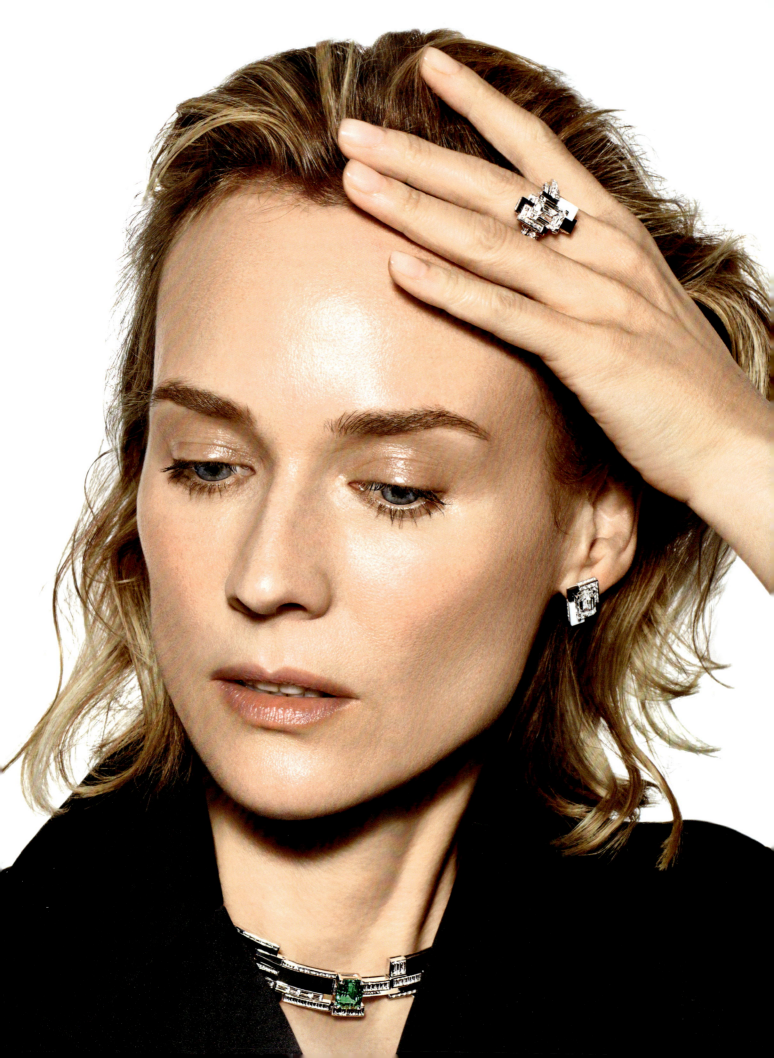

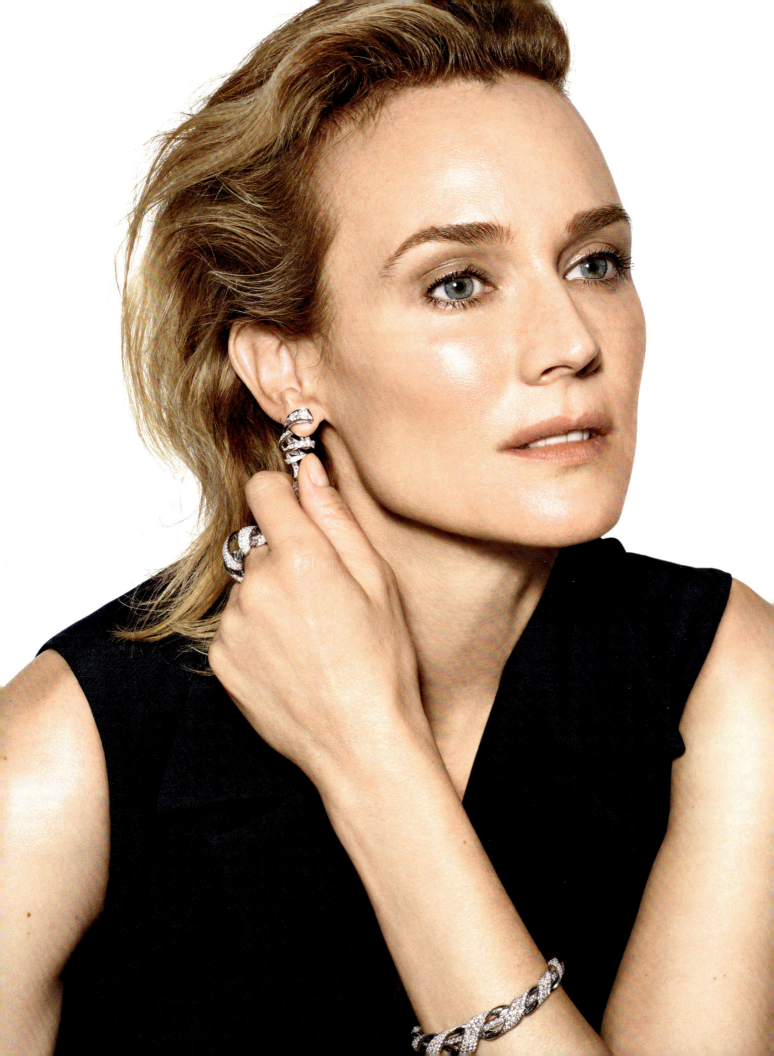

Karim Sadli

2019

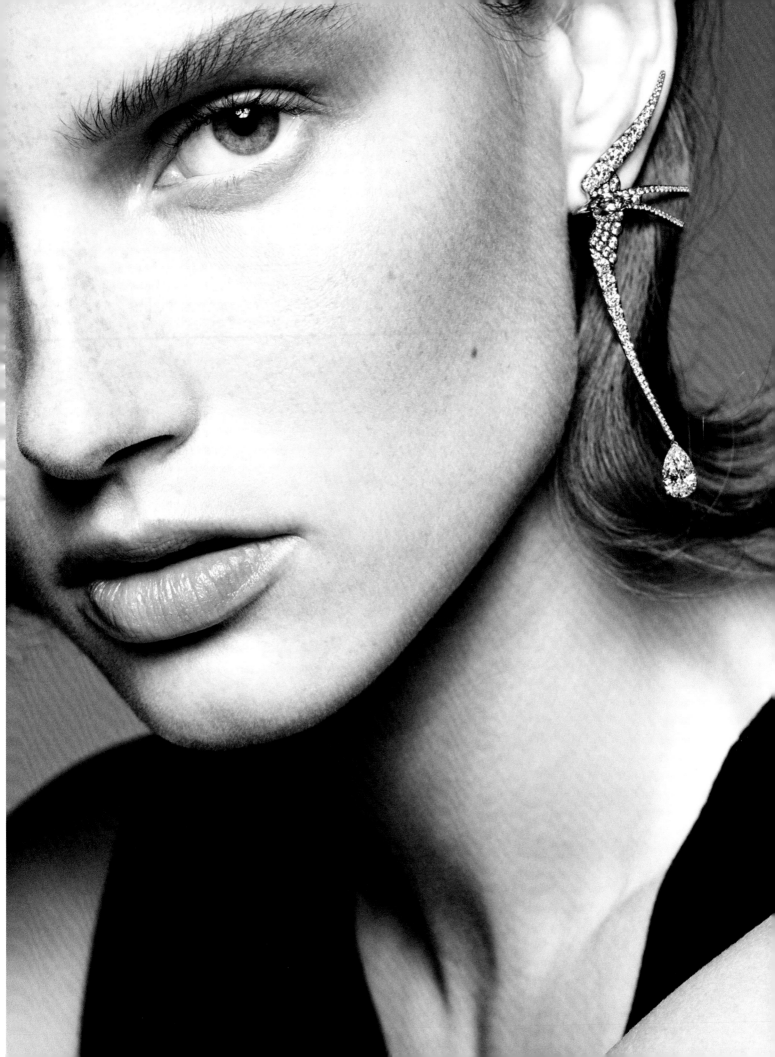

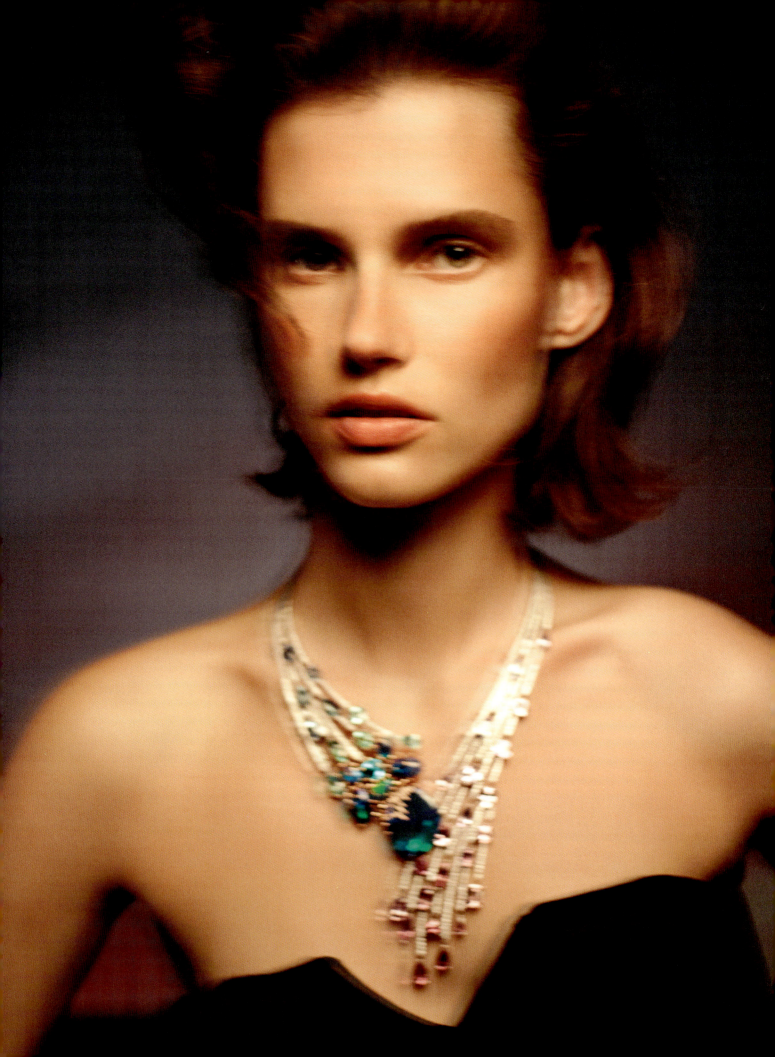

Karim Sadli

2019

Viviane Sassen

2022

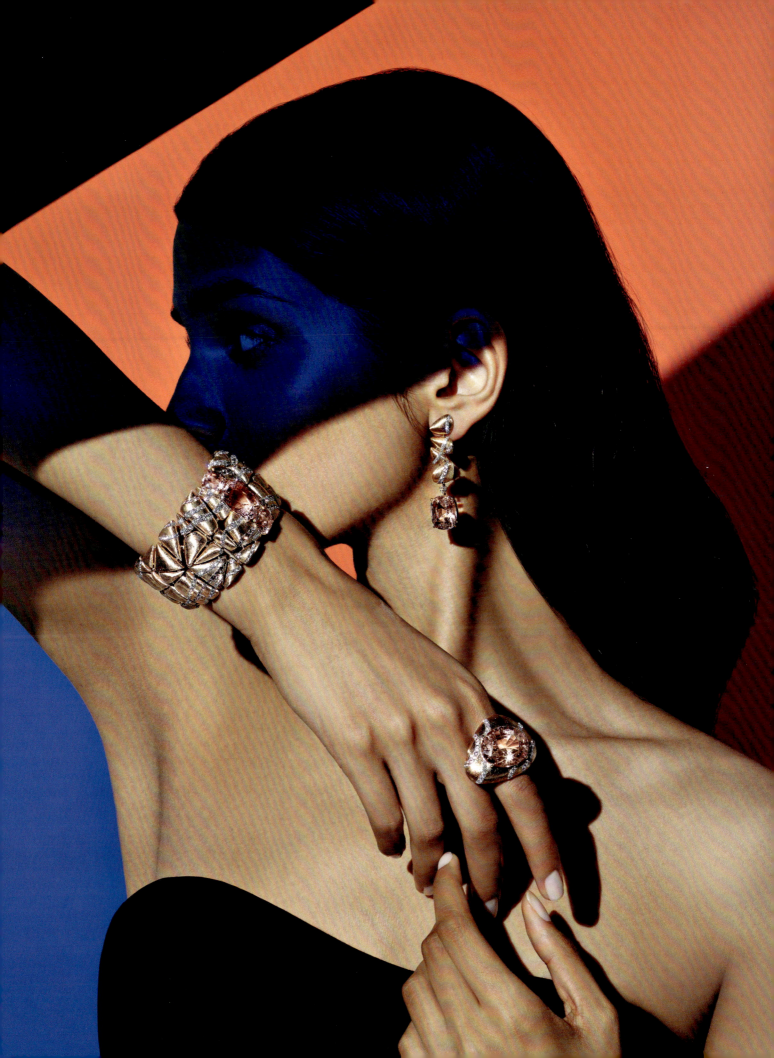

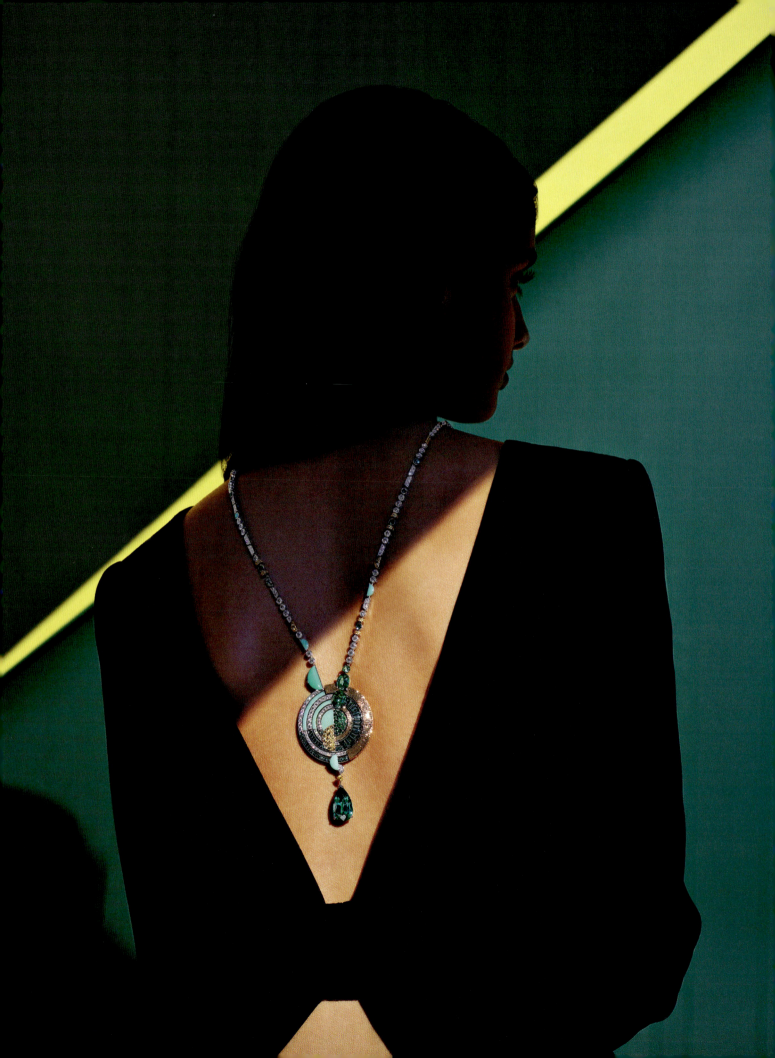

Viviane Sassen
2022

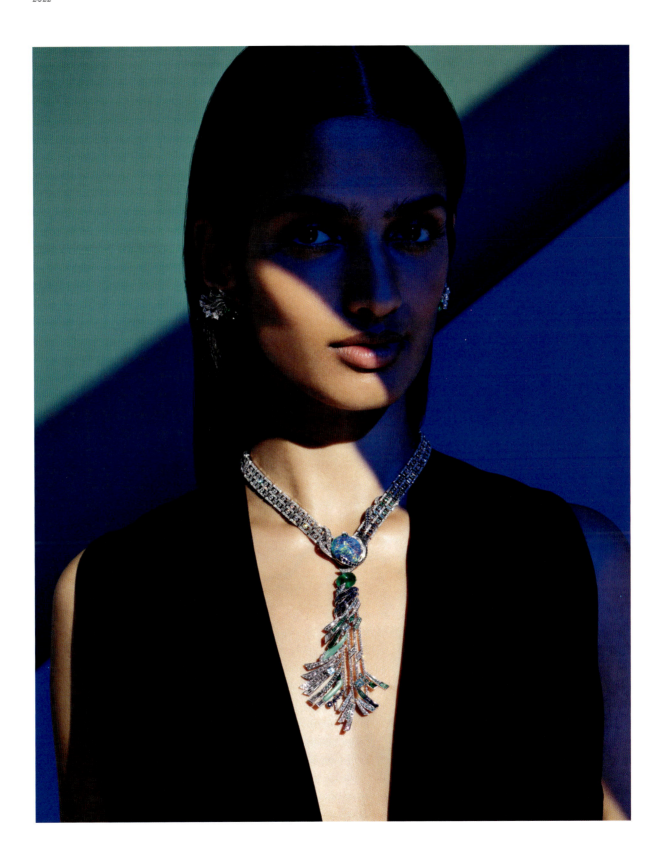

Cédric Bihr
2023

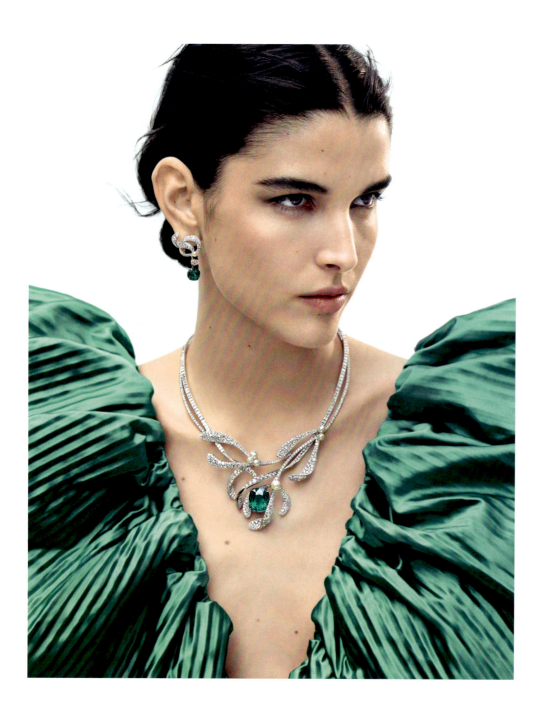

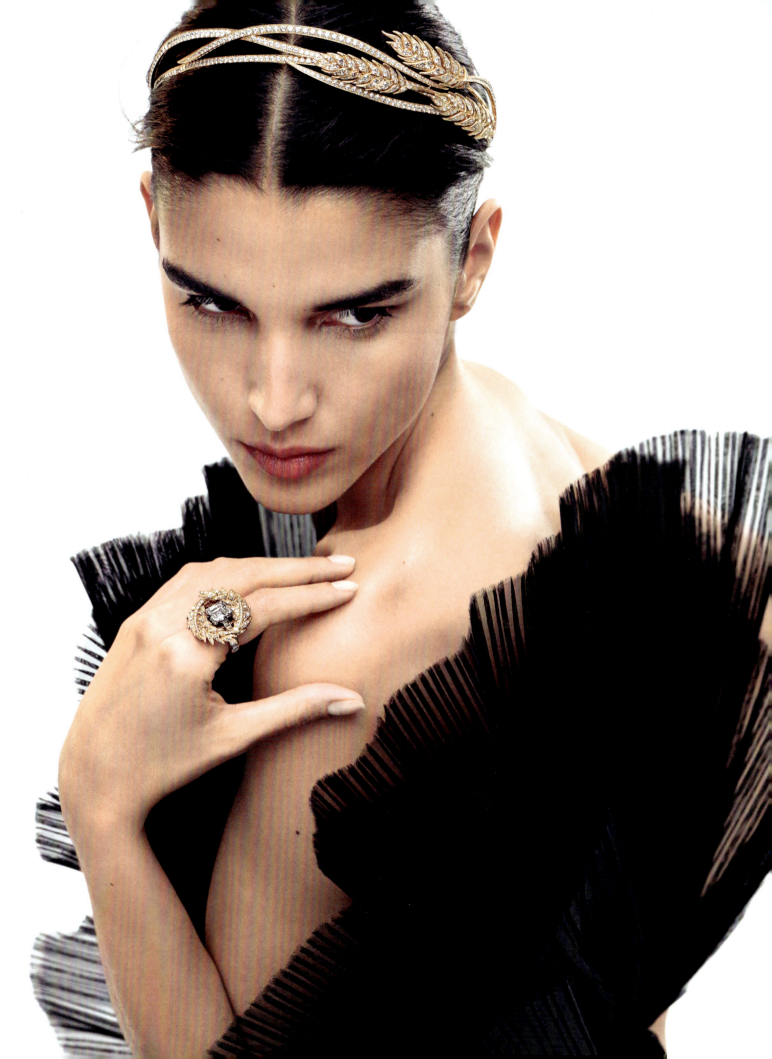

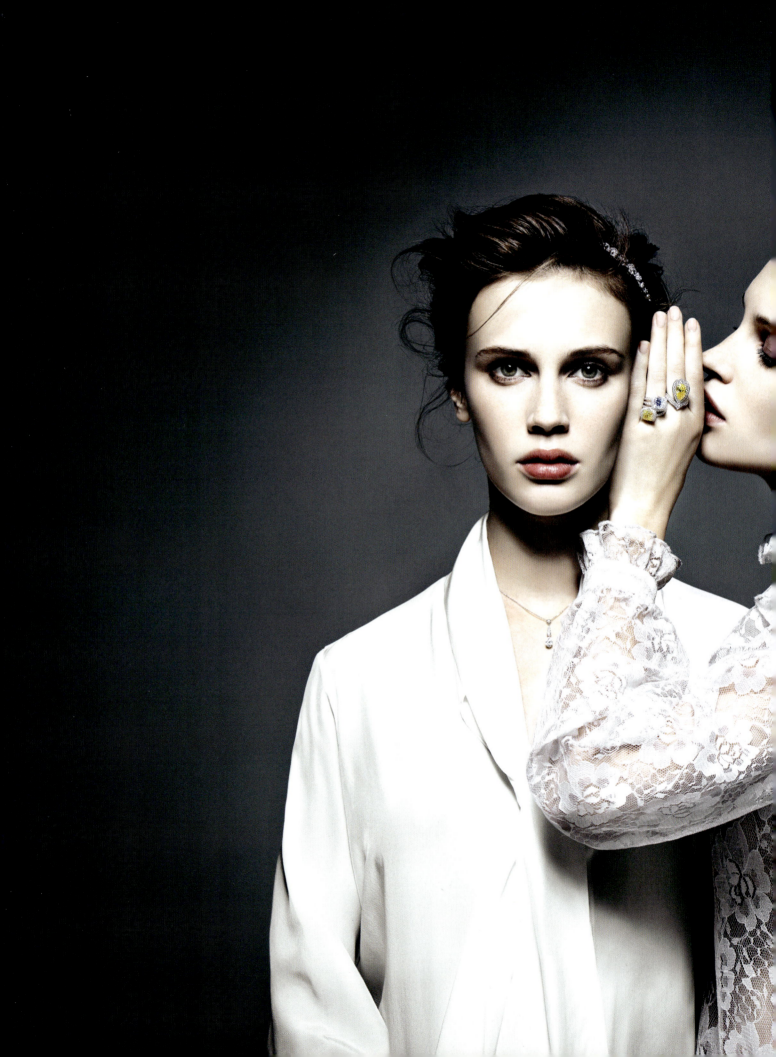

Mario Sorrenti

2014

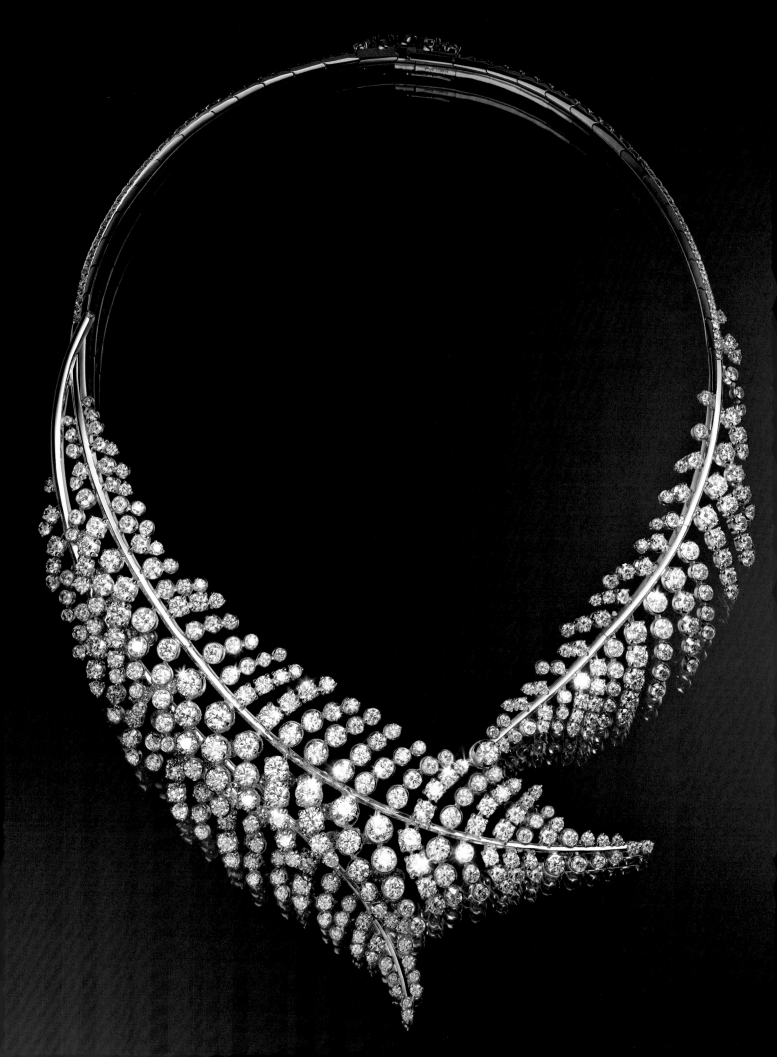

Laziz Hamani
2023

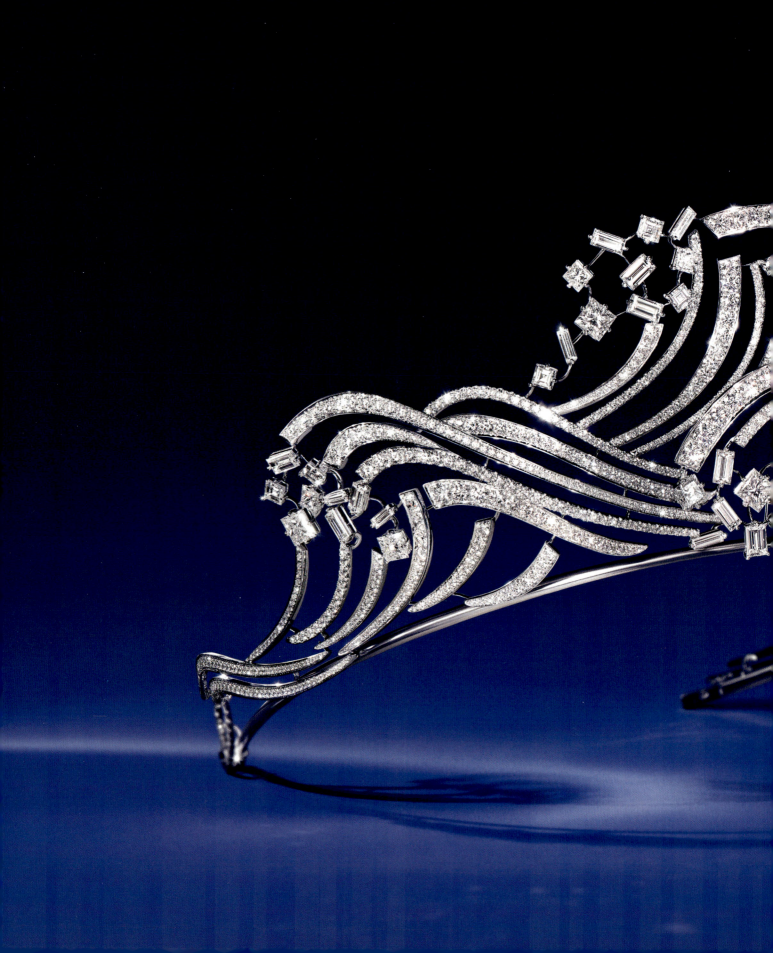

Maud Rémy-Lonvis
2022

Julien Claessens
and Thomas Deschamps

2022

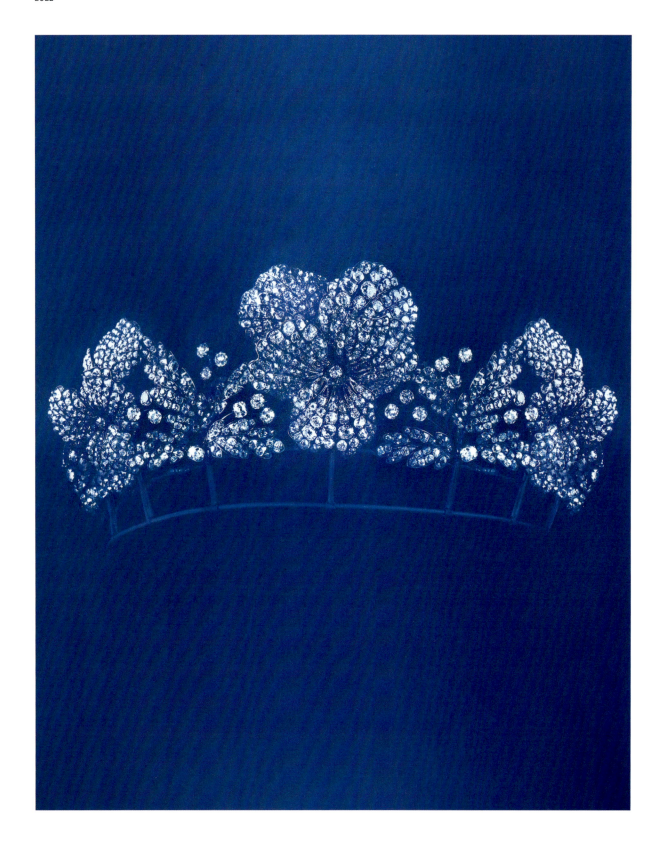

Jewellery under the lens, from still lifes to jewels *as* worn

Sylvie Lécallier

I t is perhaps due to his love of detail that Guy Bourdin is considered one of the greatest of all fashion photographers. Each time he goes a bit further, never capturing the same photo twice, always outdoing himself. He never repeats his work, leaving that to others.[1] This is certainly a powerful tribute to the star photographer of *Vogue Paris*. Beginning in the 1960s, Bourdin expressed his talent across the Beauty pages, then edited by Françoise Mohrt, the heart and soul of the magazine, in terms of volume as well as creative quality. A demanding perfectionist, highly skilled in the fragmenting of bodies, Bourdin made a successful foray into jewellery photography. Deep reds dominate his images: lip gloss, nail polish and scarlet fabric vie with the gemstones and precious metals for attention. But he seems to have felt that naked flesh was the ideal backdrop to bring out the true beauty of jewellery. Worn right next to the skin, each piece acquires a sensual, almost animal, dimension: jewellery takes on its own bodily form.

Interpreting the way in which a jewellery piece is worn and bringing into view the object's most minute details are the photographer's ultimate objectives: showcasing

.../...

1. "C'est peut-être par son amour du détail que Guy Bourdin s'est placé parmi les grands photographes de mode. Parce qu'il va chaque fois plus loin, qu'il ne refait jamais la même photo, qu'il se dépasse. Il ne s'imite pas: on l'imite." *Vogue Paris,* May 1966, p. 107.

the piece's vitality and desirability, admiring the technical feats and artistic prowess that brought it into being. Jewellery raises genuine challenges for photography, which must not only capture each piece's features, but also its soul. It is in the lineage of its visionary founder and the bold inventiveness of artists like Bourdin, Richard Burbridge and Mario Sorrenti that Chaumet has renewed its bond with photography over the last few years by seeking out the most demanding creatives for a vast project: casting its historic and contemporary jewellery collections in a new light and reinventing the Maison's heritage.

STILL LIFES

A masterful **exercise**

Creating a still life in a studio would seem to be the most obvious choice for photographing a jewellery piece. Outdoor photography introduces a number of constraints and involves a certain element of risk, especially given the precious nature of the objects. Working in the studio eliminates obstructive factors – notably by ensuring perfect control over light – as well as unexpected circumstances. Sealed off from the outside, the studio offers not only a safer setting for the photo shoots, but also one that sparks imagination. It is a theatrical space. In his New York studio, Erwin Blumenfeld enjoyed photographing accessories, jewellery and beauty products. He felt freer there to express his creativity and pursue his experiments, both during the photo shoots themselves and in his laboratory. As if shielded from the spirit of the times, photographing jewellery is less akin to fashion shoots than to the art of capturing beauty or the creation of still lifes. It is characterized by an obsession with detail and requires deft mastery of lighting, reflections and shadows, as well as the rendering of colours and materials.

In the fashion magazines of the early twentieth century, in-text photographs of jewellery pieces are featured, depicting them laid out flat and viewed from above.[2] But jewellery photography acquired greater visibility beginning in the 1930s. Roger Schall, in particular, became known as a specialist in this field, at the same time raising its profile as an exercise requiring great skill and creativity. Using silk or satin fabrics whose brilliance echoed that of the gemstones and precious metals used in the pieces, he made the most of the delicate shadows playing on surfaces in his black and white photographs, revealing myriad subtle grey tones.[3] When Edward Steichen decided

2. *Les Modes*, January 1919, p. 5.
3. See the *Vogue Paris* issues of January 1934, May 1936 and January 1937.

I find the idea, and the photographs come along naturally.

to turn to fashion and advertising photography in the 1920s, he embraced new technical challenges. The use of artificial light became central: *Then, gradually, I added lights, one at a time, until, in the later years of my work for* Vogue *and* Vanity Fair, *there were lights going all over the place.*[4] By then, Steichen had no equal when it came to the dramatic use of lighting to enhance reflections, lines and shadows. Among his fashion photographs, some of his most iconic images are of small objects: accessories, footwear, lighters.

Today, several photographers honour this creative tradition of studio photography and still lifes. Many of them work in colour, notably in shades of blue, Chaumet's colour, embracing its entire range from deep and saturated to light and bright. For the *Torsade* and *Diadèmes* collections, Maud Rémy-Lonvis plays with bluish backgrounds and drop shadows to make the precious jewellery pieces seem to float. Philippe Lacombe makes the reflections of pendants dance over mirrored backgrounds. Laziz Hamani concocts a special blue for the *Le Jardin de Chaumet* collection. There is an endless stream of visual variations, images within images, connections or contrasts to be created with other forms, colours and materials, or between the pieces of a single collection. *I mostly develop concepts*, says Guido Mocafico. *First, I find the idea, and the photographs come along naturally.*[5] He humorously scales up the effect of different versions of the *Liens* ring as a pop-inspired wallpaper motif.[6]

A world in movement

In their series from 2022, Julien Claessens and Thomas Deschamps turn to one of the oldest photographic printing processes, cyanotypes, and seize on their signature colour, that of the intense and deep pigment known as Prussian blue. Moreover, they decide to represent jewellery pieces as if they were flora, following the lead of

...∕...

4. Edward Steichen, *A Life in Photography* (New York: Doubleday, 1963), p. 100.

5. Philip Utz, interview with Babeth Djian and Guido Mocafico, *Mocafico/Numéro*, Volume 1 (Göttingen: Steidl, 2016).

6. *Rendez-Vous,* nº 2, 2017, p. 78 to 87.

nineteenth-century photographers like the English botanist Anna Atkins (1799–1871), an avid collector and illustrator of natural specimens, who used cyanotypes to reproduce algae and ferns. For the catalogue of the exhibition *Végétal - L'École de la beauté (Botanical – Observing Beauty),*[7] the duo of photographers created detail shots of jewellery motifs (bees, scarabs, oak leaves and acorns, etc.) by using macro lenses, like scientists observing nature at close range.

In light of its history, Chaumet takes pride in its powerful harmony with nature and its photographic commissions often involve the mineral and vegetal worlds, presenting textures and organic materials. To magnify Chaumet's naturalistic creations, Simone Cavadini positions the jewellery pieces on backgrounds of moss or tree trunks.[8] In her still lifes, Julia Hetta also sets jewellery against natural materials. She plays with contrasts between exotic woods, the roughness of materials and the brilliance and sparkle of gemstones and precious metals to photograph pieces in the High Jewellery collection *Les Mondes de Chaumet.* Known for recreating the light effects and composition as practised by the old masters through her photographs, the Swedish photographer studied painting and drawing in her youth: *[My teacher] taught me the importance of looking at light and shadows. We drew and painted for hours and hours, [and] I learned to see how light can sculpt.*[9]

Erwan Frotin's photographs are also distinguished by their sculptural approach, the result of joining his interests in botany and colour theory with his deep connection to nature. *For me, nature is an infinite and constant spectacle of expressions of life and matter, in their various states of appearance, transformation and disappearance,* says the photographer.[10] He thus places the jewellery pieces on small sculptures shaped in organic, flexible and curved forms. Coloured in the same shade as the background, they draw attention to their volumes and movements and seem to dialogue with the range of tones and delicate composition of the jewellery pieces, to give life to captivating and fanciful creatures. Humour and candour are also key elements of Maurizio Cattelan and Pierpaolo Ferrari's still lifes. In his photographs, the artist flirts with kitsch and the absurd to better revisit the codes of fashion and fashion advertising. He whimsically

7. Marc Jeanson, *Végétal - L'École de la beauté,* catalogue of the exhibition at the École des Beaux-Arts, Paris, 16 June – 4 September 2022 (Paris: JBE Books / Chaumet, 2022).

8. *Rendez-Vous,* n° 4, 2019, p. 81 to 92.

9. Laird Borrelli-Persson, "Meet Julia Hetta, the photographer who captured Karl Lagerfeld's work for the Met catalog", *Vogue,* 5 April 2023, https://www.vogue.com/article/meet-julia-hetta-the-photographer-who-captured-karl-lagerfelds-work-for-the-met-catalog.

10. "La nature est pour moi le spectacle infini et incessant des manifestations de la matière et de la vie, dans leurs divers états d'apparition, de changement, de disparition." Erwan Frotin, interview with Anaïs Viand, "'FLUX', ou comment exprimer sa vérité", *Fisheye,* 18 May 2022, https://fisheyemagazine.fr/article/flux-ou-comment-exprimer-sa-verite/.

plays with rings set with gemstones, which he includes in his pop and colourful universe of collages, transforming the jewellery into fruits and other delights.

As we have seen, the photographers selected by Chaumet reinterpret jewellery, working on its poetic or even playful dimension, distancing it from fashion to better celebrate it.

JEWELS AS WORN, A PHOTOGRAPHIC PERFORMANCE

From fashion to jewellery

Beginning in the Second Empire, it became clear that there was a natural alliance between women's fashion and jewellery accentuated by plunging necklines and the short-sleeved bodices of crinoline evening dresses. High Jewellery was considered as closely related to Haute Couture and the two were paired in publications such as *Les Modes* and *L'Art de la Mode*: *Fashion, which is truly a masterpiece of harmony, is increasingly giving space over to jewellery, with pieces now created specifically to accompany certain ensembles.* [11]

Worn with sophisticated attire, ball gowns or evening wraps, jewellery pieces were indispensable accessories for all elegant ladies. To bring out their charms, in the 1930s Harry Meerson paired Chaumet bracelets with a white satin negligee or a seemingly simple black dress by Jeanne Lanvin.[12] Horst P. Horst played on the complementarity between a sublime mink cape by Revillon partially left in semi-darkness and a Chaumet bracelet that sparkles in the light.[13] While lamés, brocades or satins reflect the light, the sobriety of a black garment brings out the brilliance of a brooch or a bracelet. For his part, François Kollar managed to shroud both the clothing and the face of the model in darkness to highlight only the necklaces, bracelets and earrings. Silhouettes were rarely if ever shown: the body was fragmented (a bosom, a hand, an ear) to frame the precious object.

This elegant approach to handling fashion and jewellery is also found in the work of Karim Sadli. With his minimalist aesthetic and his sophisticated use of light, he clearly draws inspiration from the great photographers of the 1930s. The simplicity of his framing as well as the choice of solid color backdrops and black garments

.../...

11. "La mode, qui est vraiment un chef d'œuvre d'harmonie, fait une place de plus en plus grande aux bijoux qui sont maintenant créés spécialement pour accompagner certaines toilettes." *Les Modes,* 1 April 1927.

12. *Femina,* October 1936, p. 30.

13. *Vogue Paris,* November 1937, p. 37.

lend even greater intensity to the presence of his models, on whom the jewellery pieces find their place quite naturally. The same is true of the magnificent brooches on haloed silhouettes set against a white background, immediately calling to mind Kollar's black and white images.

In her graphic compositions with their pure and bright tones staging a battle between shadow and light, Viviane Sassen also chooses to dress her models in black garments that give form to geometric flat tints. Relegating fashion to the background, it is the coloured filters that engage with the nuanced hues of the tourmalines, emeralds, sapphires, topazes and other gemstones adorning the pieces of *Ondes et Merveilles de Chaumet*[14] collection. In his work, Timothy Schaumburg brings the light absorption capacity of black into play, along with a shallow depth of field, to reveal jewellery pieces by way of contrast against a shoulder, a neck or an upper arm.[15]

Through an intentional dissonance, High Jewellery also marries well with casual looks from the world of ready-to-wear, even just a pair of jeans and a T-shirt. Photographers like Emma Summerton and Quentin de Briey stick with stagings inspired by fashion, building genuine narrative sequences similar to those seen in editorial work for magazines. In Summerton's photographs, the models are transformed into fictional characters celebrating special occasions. De Briey takes up a long-used trope in reporting by tracking the movements of a young couple during their wedding day, showing jewellery as worn at an event to be cherished for years as well as in little private moments of happiness.

Fascination

In the May 1953 issue of *Vogue Paris*, Anne Gunning, the British model discovered by Henry Clarke, poses wearing a tiara set with both round and baguette diamonds, a pearl necklace as well as pearl pendant earrings, all by Chaumet. Shot from an angle slightly above the subject, this full-page photograph has the air of a royal portrait. The tiara, but also the earrings and the necklace, embellish the face and neckline of the future Lady Nutting, captured in a three-quarter pose and breathtakingly beautiful here. By framing the shot to feature the face, leaving the background hazy, Clarke achieves an image closer to a portrait than a fashion shot.

14. *Rendez-Vous,* n° 6, 2022, p. 39 to 49.
15. *Ibid,* pp. 82 to 93.

My main objective was that you be the one wearing the jewellery.

Already at the end of the nineteenth century, in photographic portraits of actresses or Parisian high-society women, couture ensembles were often accessorized with High Jewellery pieces as a sign of their rank or reputation, as seen in Paul Nadar's images of the Princess of Ligne or the Countess Greffulhe. In an 1896 photo, the countess poses facing her cheval glass in a stunning black velvet evening dress by C. F. Worth embroidered with pearls and silver lilies. Marcel Proust, who had seen the photograph at the home of his friend Robert de Montesquiou, asked the countess for a copy numerous times, and always in vain. These portraits, in which the jewellery reflects the exceptional personality of its wearer, are all about fascination and inaccessibility.

In this same spirit, Richard Burbridge's photographs of the actress Diane Kruger form a remarkable corpus. The photographer uses flash lighting, an aesthetic that gets close to "real life" in his view. The challenge for him, and for the actress, was to find the balance between the individual being photographed, her personality and the vitality and vigour of the High Jewellery pieces. In fact, the latter are *so precious and resplendent that you can't help looking at them,* says Kruger. *My main objective was that you be the one wearing the jewellery and not that the jewellery would be holding sway over you,* adds Burbridge.[16] The subject of the photos is Kruger's presence and her very personal way of making the jewellery her own. The photograph showing the actress wearing the wings from one of Chaumet's heritage collections, featured on the magazine's cover, is one of her favourites.[17]

Mobile jewellery

Chaumet's iconic tiaras, which occupy a unique place in the history of the Maison, call for very particular attention and pose a challenge for shots taken from life. By choosing to have the model Anna de Rijk pose like a dancer wearing both his-

.../...

16. "Mon principal objectif était que ce soit vous qui portiez les bijoux et non pas que les bijoux s'imposent à vous." *Rendez-Vous,* n° 5, 2021, p. 40.
17. *Ibid,* cover.

toric and contemporary pieces, Julien Martinez Leclerc has created a ravishing series. Through each of her movements, the young model expresses a certain nonchalance, a freedom of style, which seems to enter into conflict with the jewellery she wears, but which actually endows these pieces with an extremely refined aura, a lightness and an aerial dimension.

In a series from 2019, Julia Hetta introduces a discordance in the wearing of jewellery: the shots are framed in close-up on the faces and the hair, and the jewellery alights delicately like an insect or butterfly on the model, who seems to expect and welcome its arrival. The photographer encourages us to reinvent the way jewellery is worn, adding a touch of whimsy. Apart from the reinterpretation, the slight imbalance in the positioning of the jewellery conveys a feeling of life and fragility.

For the High Jewellery collection *Le Jardin de Chaumet*, Paolo Roversi uses a flashlight for his shots, a characteristic feature of his work in fashion. In following this approach with results that can sometimes be unpredictable, the photographer draws with light. Roversi's sessions leave much to improvisation and chance. *I work like a painter who sees how his canvas is evolving with each brushstroke,* says the photographer.[18] Each pose is long, four seconds or more. Some areas are hidden in the shadows. Light seems to be emanating from the model and our eyes travel from her face to the jewellery before coming back to her intense gaze.[19] For Roversi, every photograph is a portrait.

This same imaginary dimension is found in Elizaveta Porodina's work. The young photographer has said that she aims to show *something forceful and general, dark, strange and powerful that is literally going to bounce with this light or darkness from the picture, and will speak to the viewer directly about their fears, about their dreams.*[20] In the spirit of the Surrealists, Bourdin or Sassen, her images break down and expand reality through unsettling mirror effects. Her lighting brings out tones that are both soft and muffled, like dreams, and the Chaumet pieces take on a nearly supernatural dimension, transforming the women wearing them into fairy-tale characters.

By enlisting the talents of photographers of very different stripes, Chaumet ventures off the beaten path to offer surprises. For its technically complex and eminently creative High Jewellery collections, the Maison favours a kind of photography without any extra-aesthetic need, a photography that respects the jewellery and lends itself to poetic imagination. ❖

18. "Je travaille à la façon d'un peintre qui voit à chaque coup de pinceau comment évolue sa toile." "Au studio avec Paolo Roversi", *Réponses Photo,* n° 13, January 2003, p. 97.

19. *Rendez-Vous,* n° 7, 2023, p. 31 to 41.

20. Quoted in Orla Brennan, "This Photo Book Explores the 'Weird, Strange, Dark' Side of Humanity", *AnOther Magazine,* 3 May 2022, https://www.anothermag.com/art-photography/14069/elizaveta-porodina-photography-unmasked-book-interview-2022.

Antho
logy

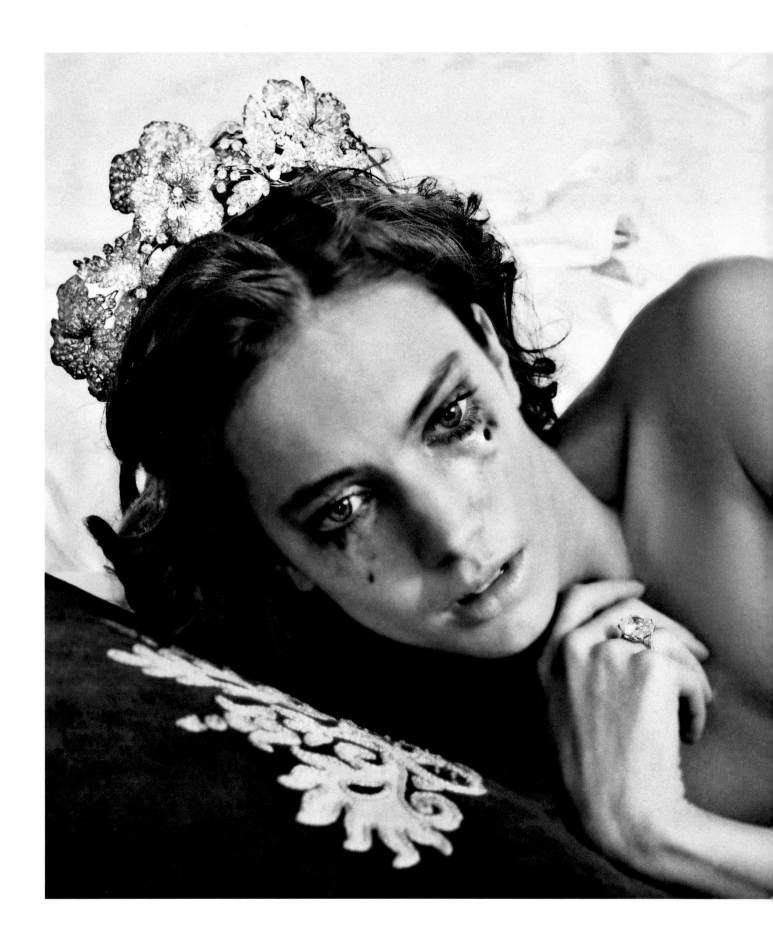

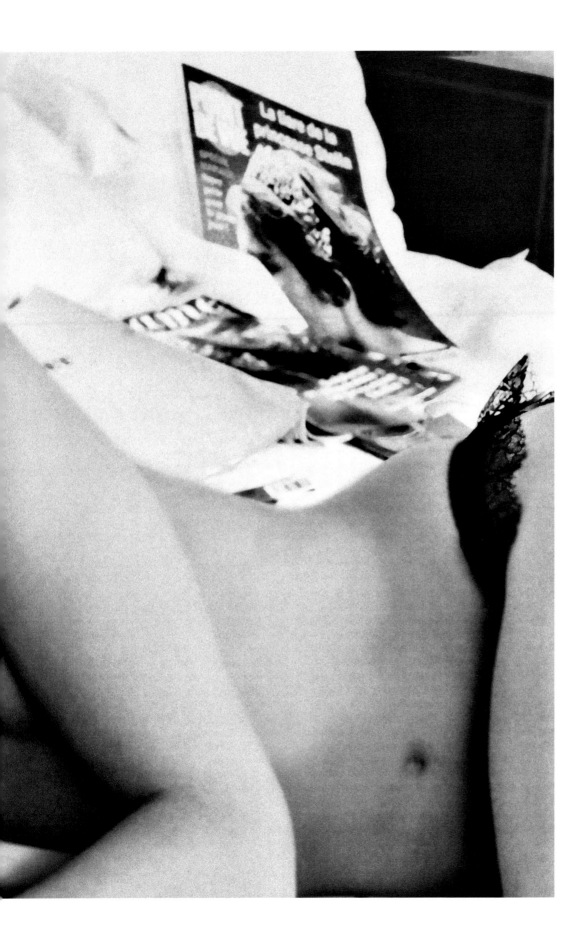

Bettina Rheims
Égoïste
2006

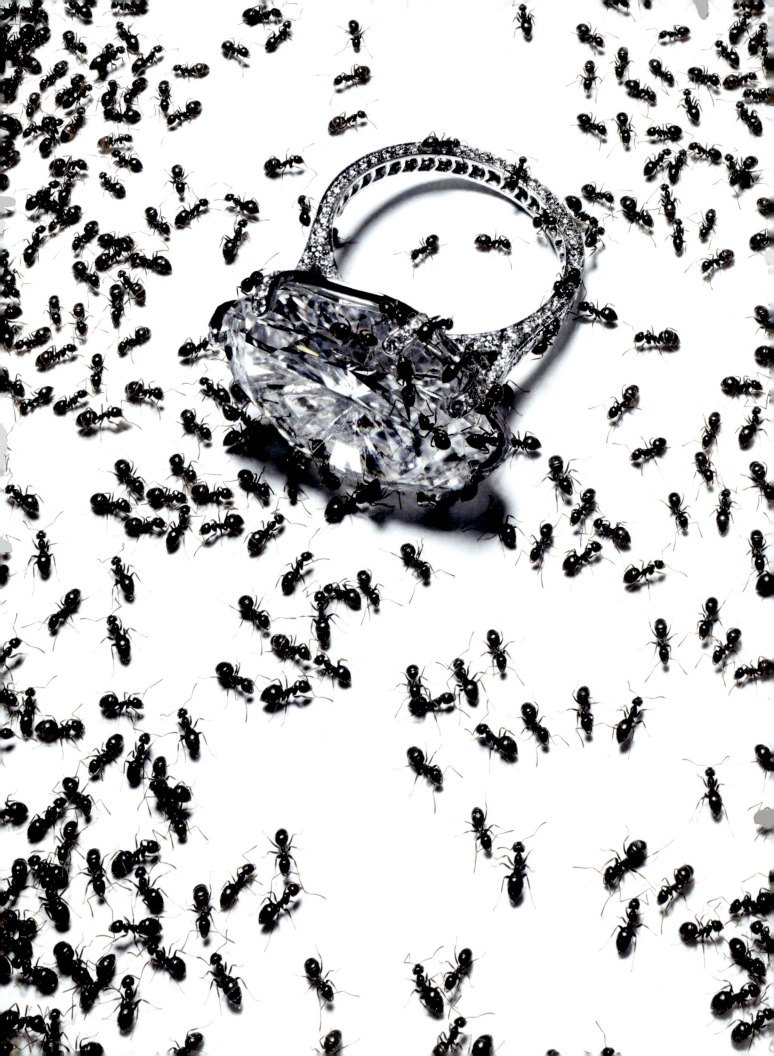

Guido Mocafico
Numéro
2006

Mario Testino
Vogue Paris
2003

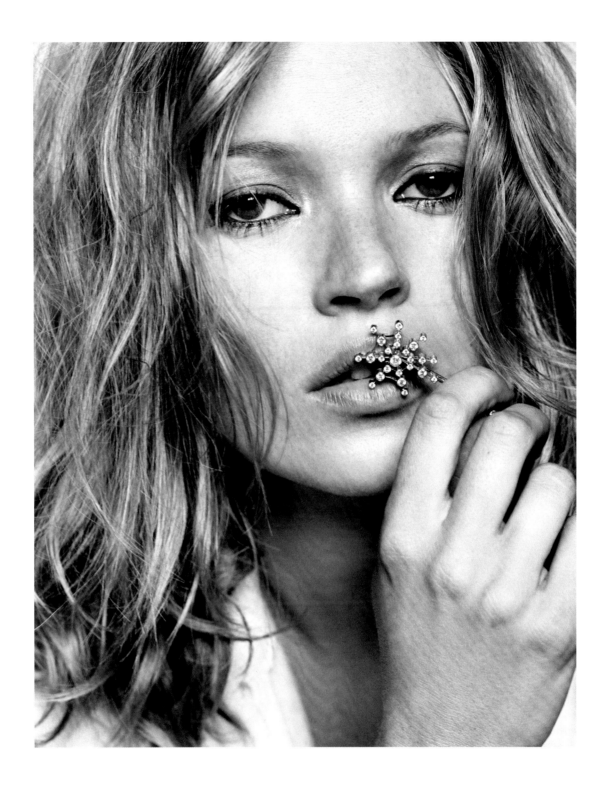

Following pages:
Rankin
Citizen K France
2003

ANTHOLOGY 157

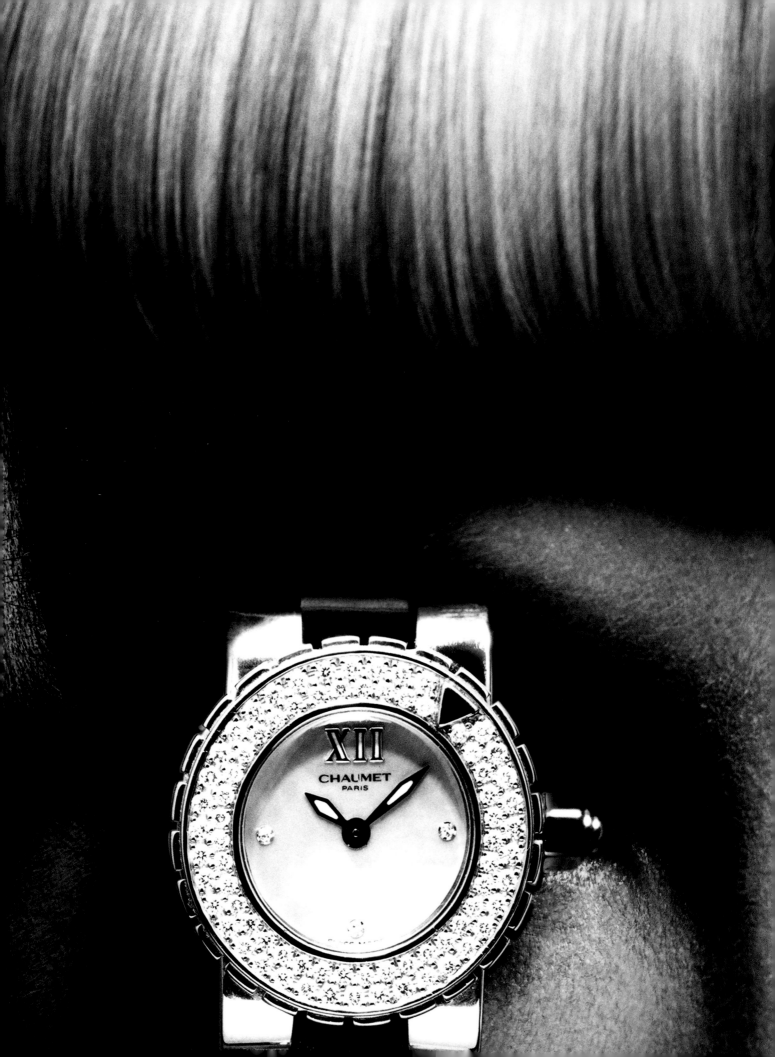

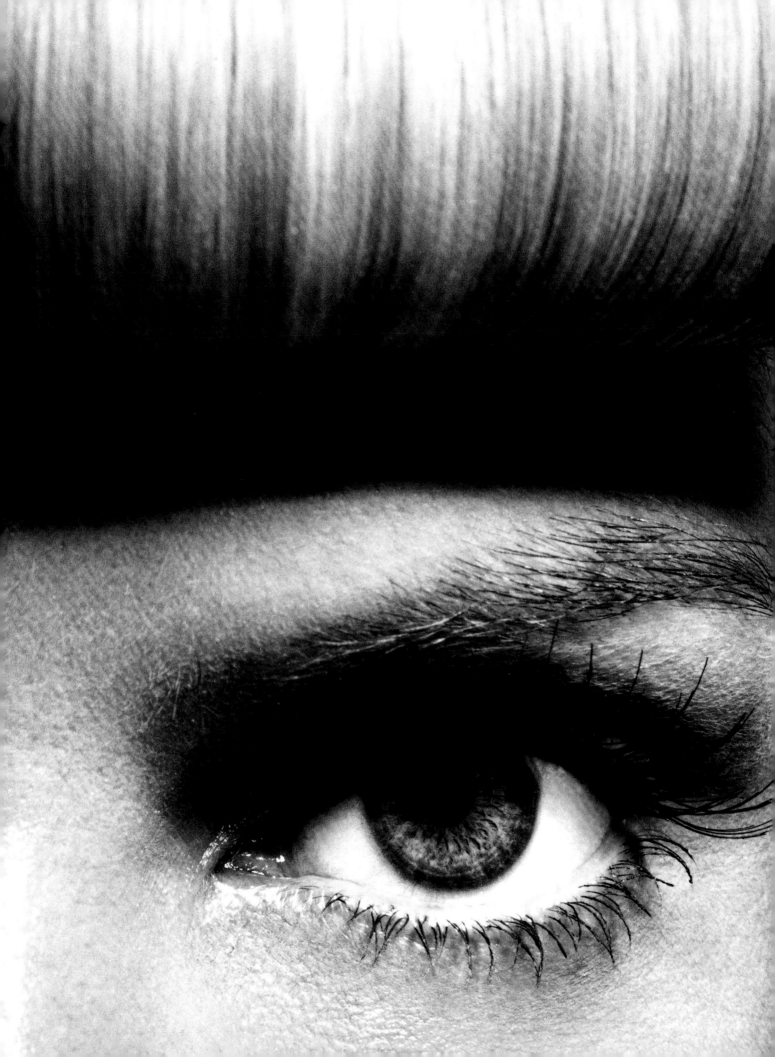

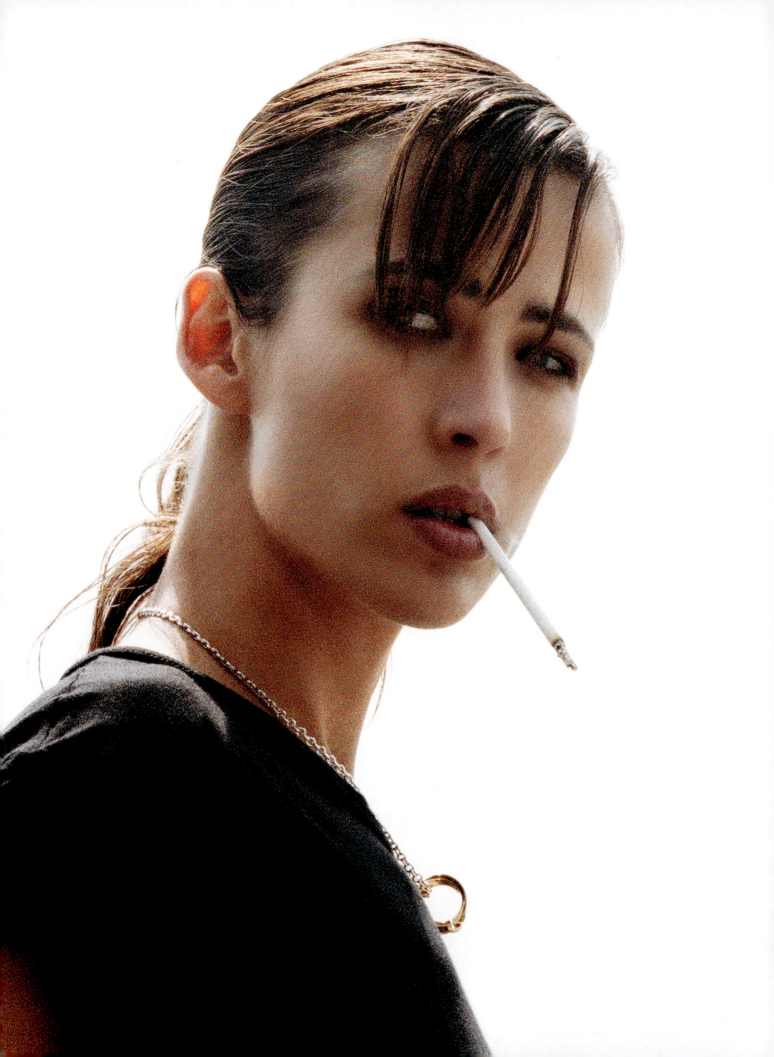

**Inez van Lamsweerde
and Vinoodh Matadin**

Vogue Paris

2003

Following pages:

Ellen von Unwerth

Égoïste

2000

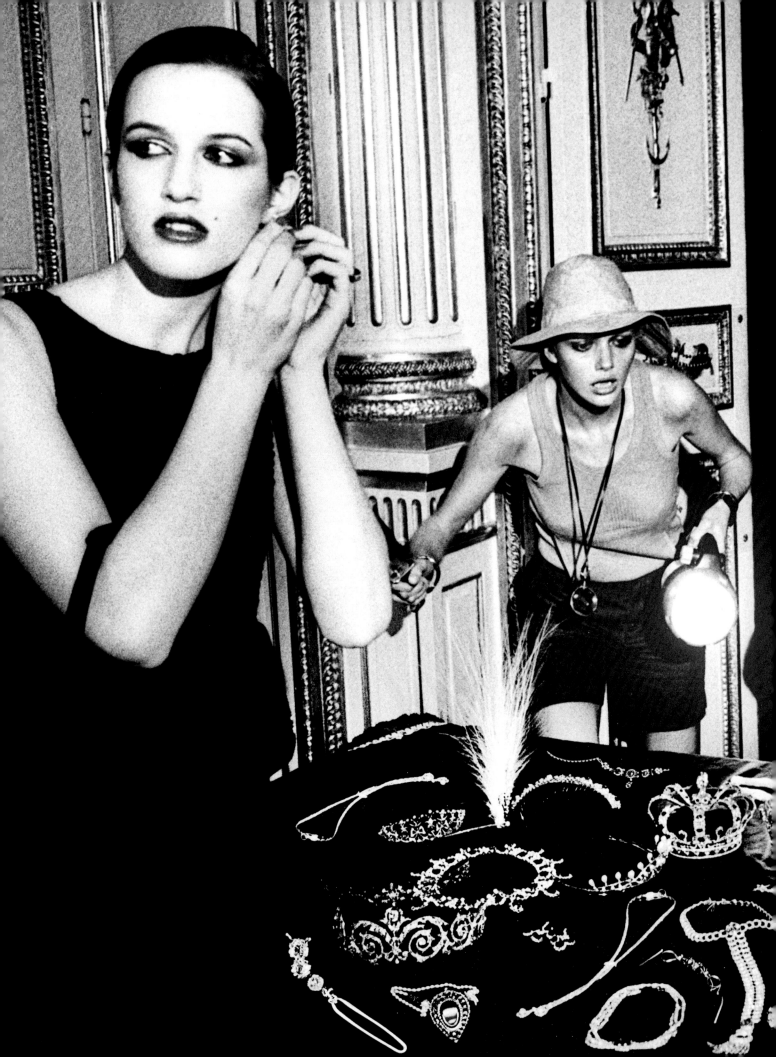

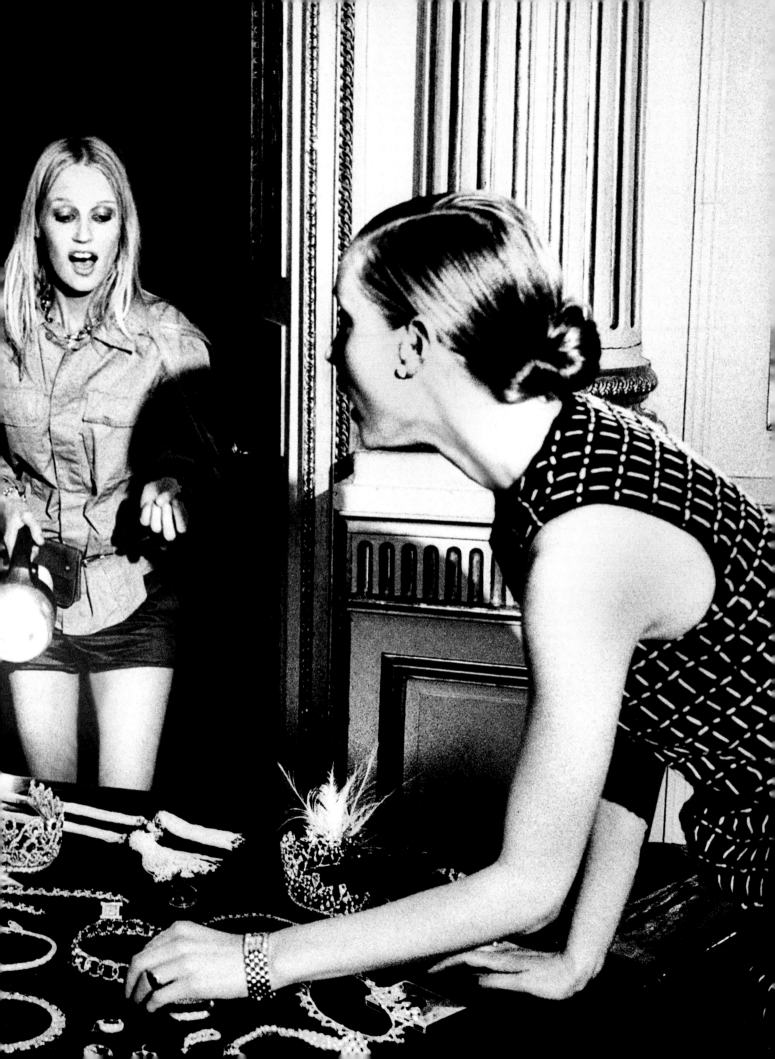

Jenny van Sommers
British Vogue
1998

Daniel Jouanneau
Vogue Paris
1996

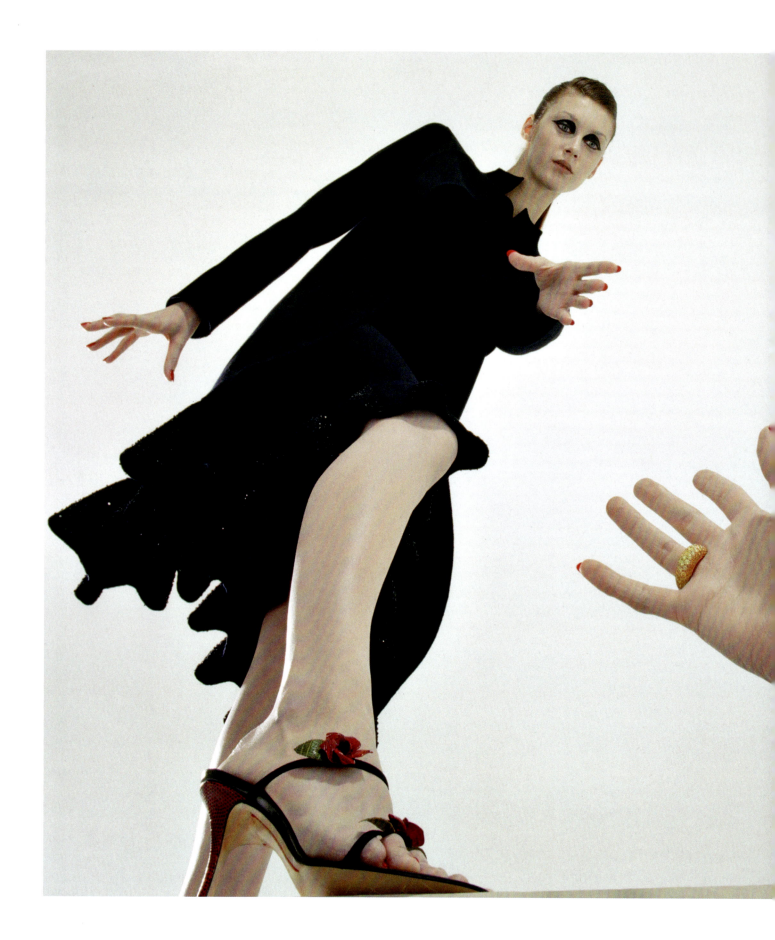

Miles Aldridge
Vogue Italia
1999

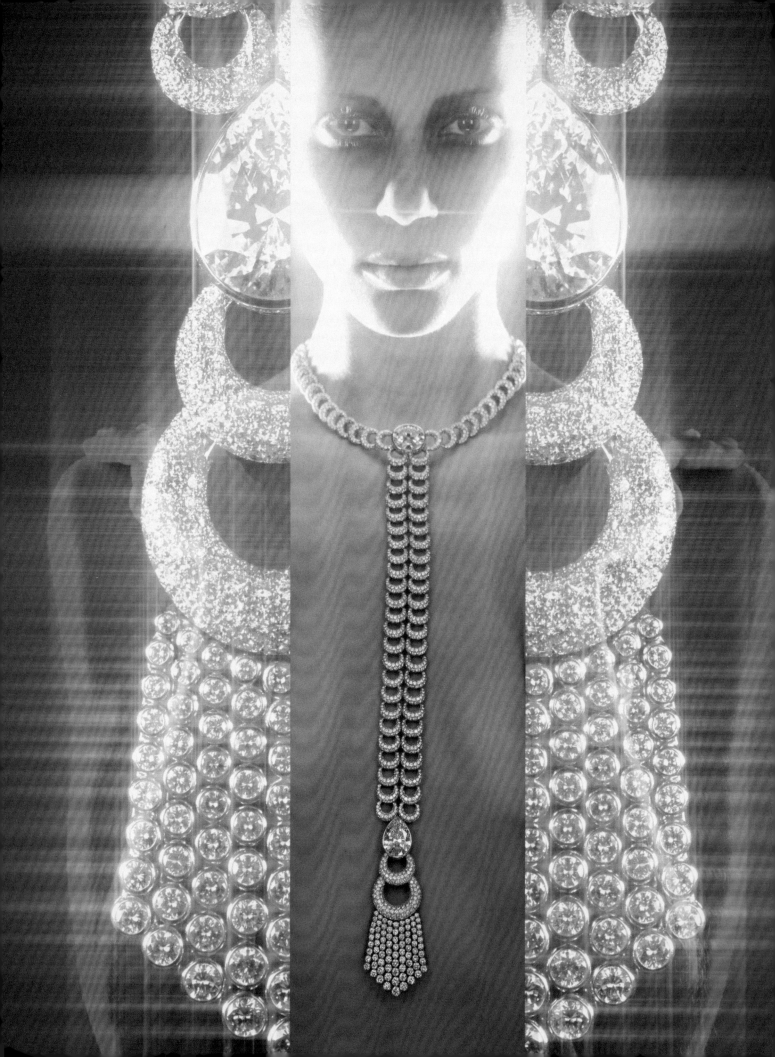

Sean Ellis
Numéro
1999

Raymond Meier
Vogue Paris
1997

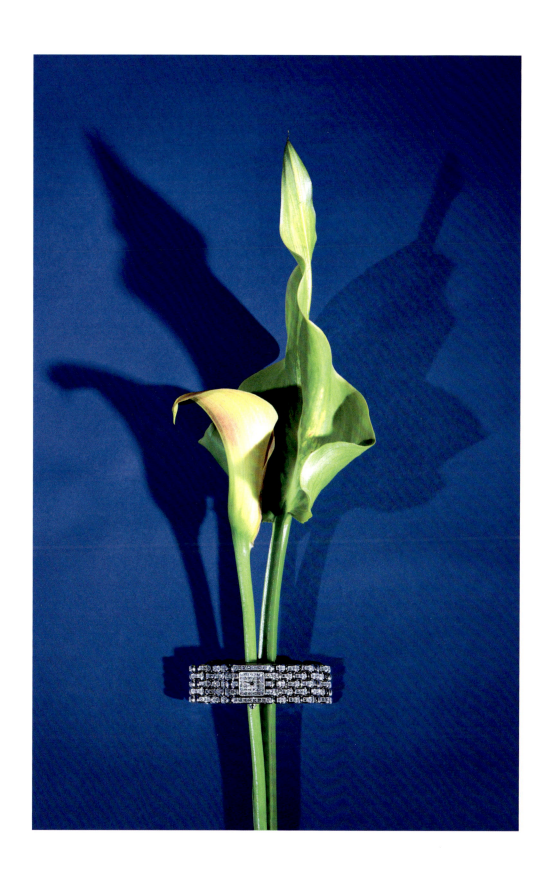

Bettina Rheims
Égoïste
1996

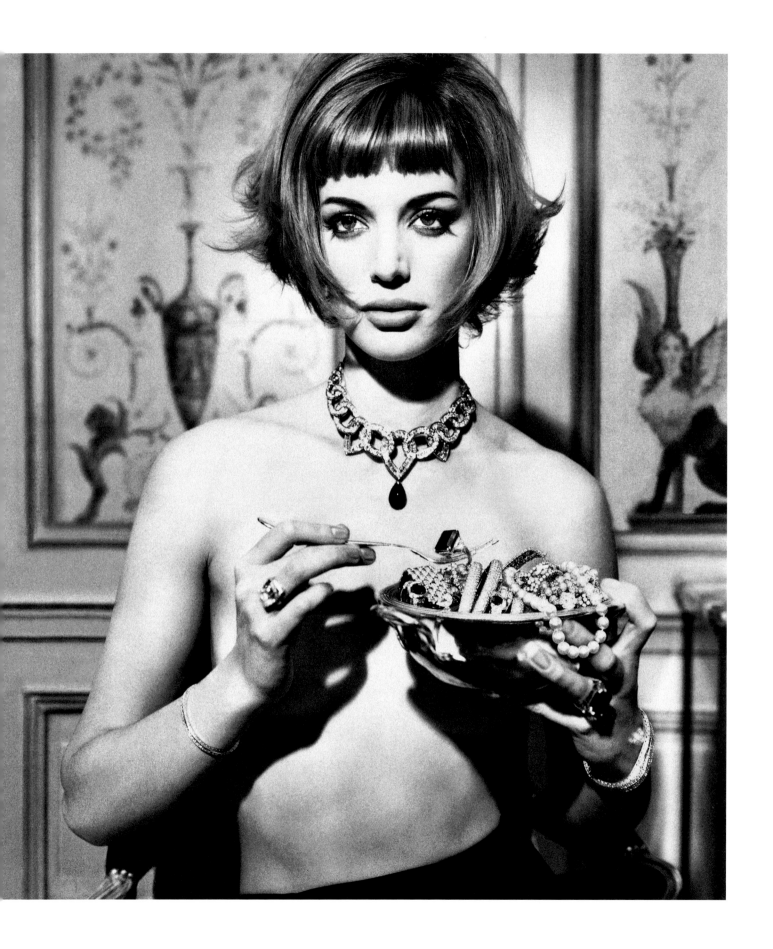

ANTHOLOGY

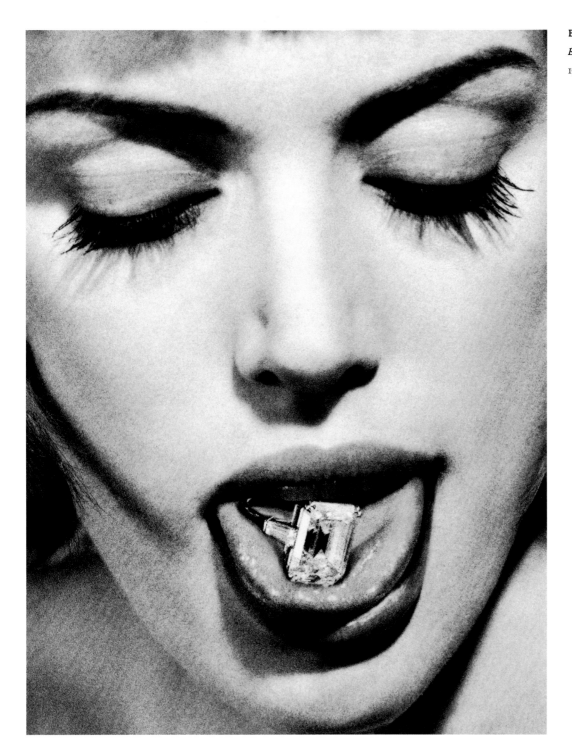

Bettina Rheims
Égoïste
1996

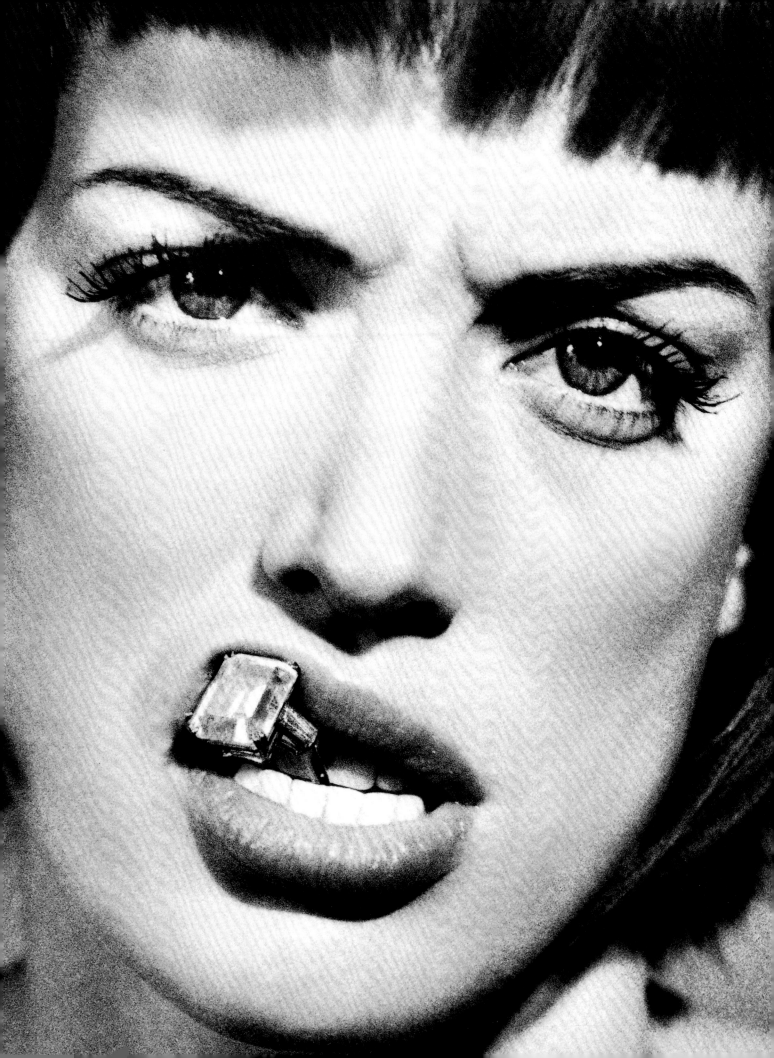

Craig McDean

Vogue Paris

1994

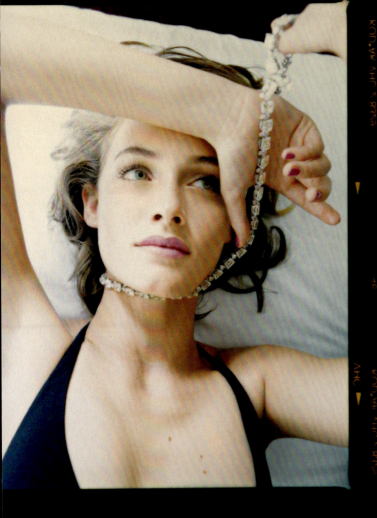
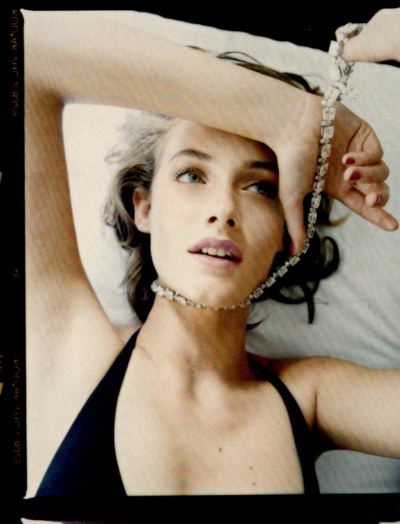
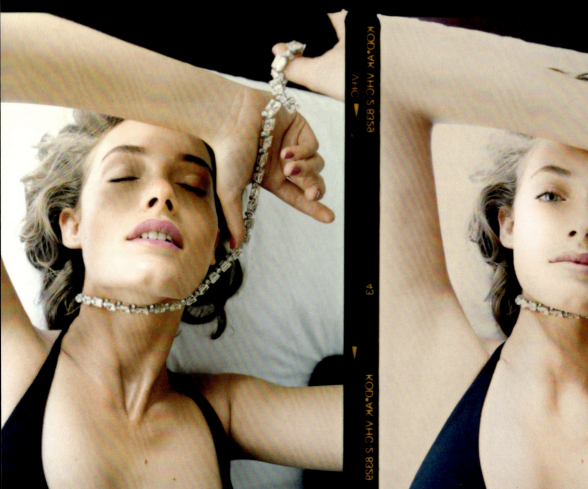
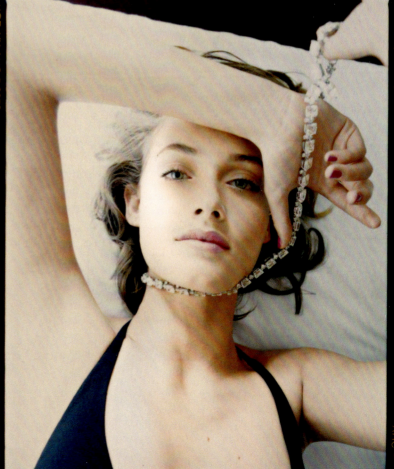

Max Vadukul
Égoïste
1992

Following pages:
Guy Bourdin
Vogue Paris
1984

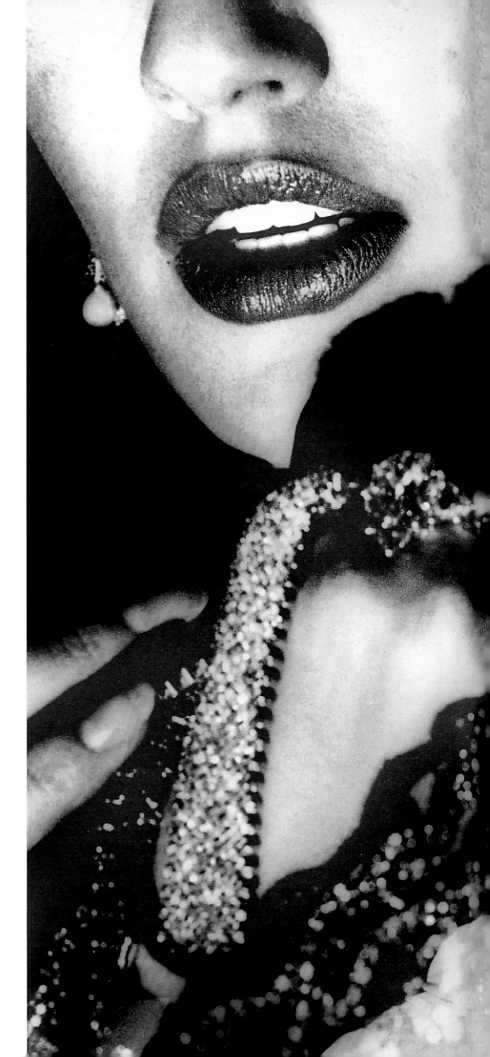

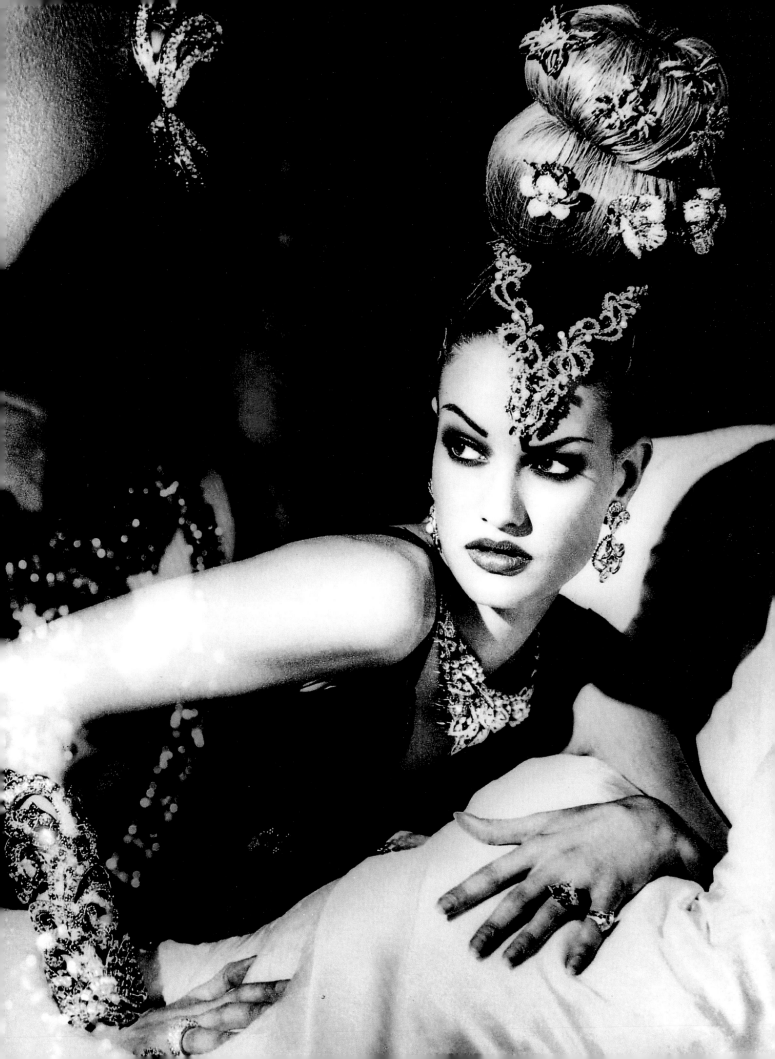

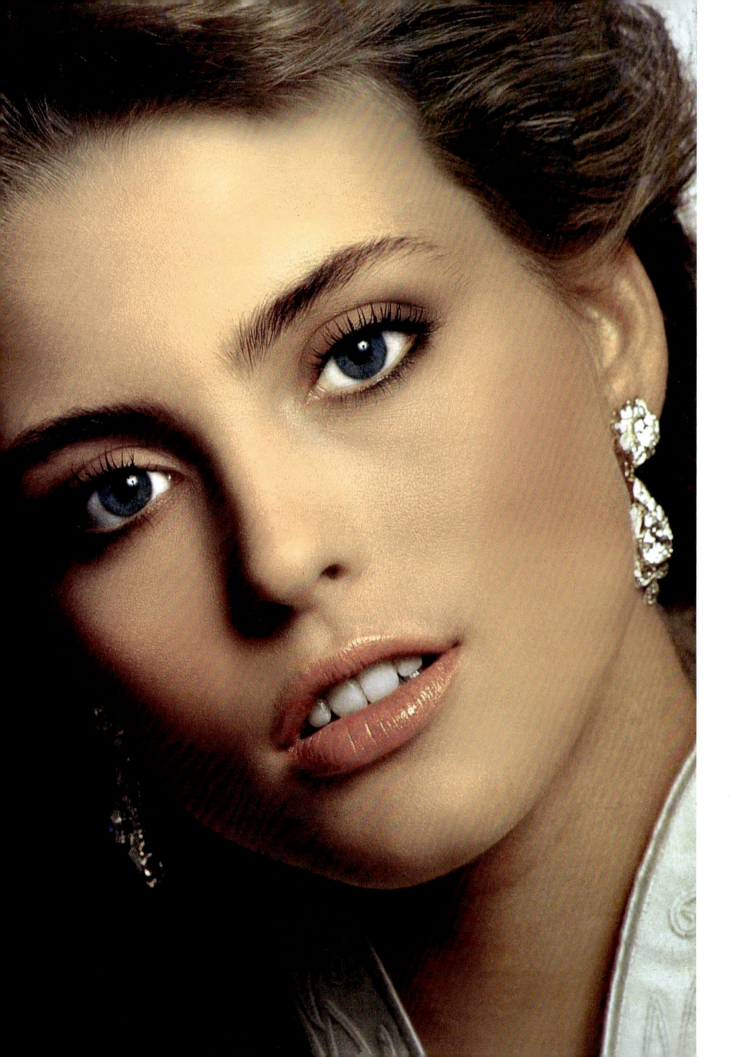

Arthur Elgort
Vogue Paris
1980

Denis Malerbi
L'Officiel
1983

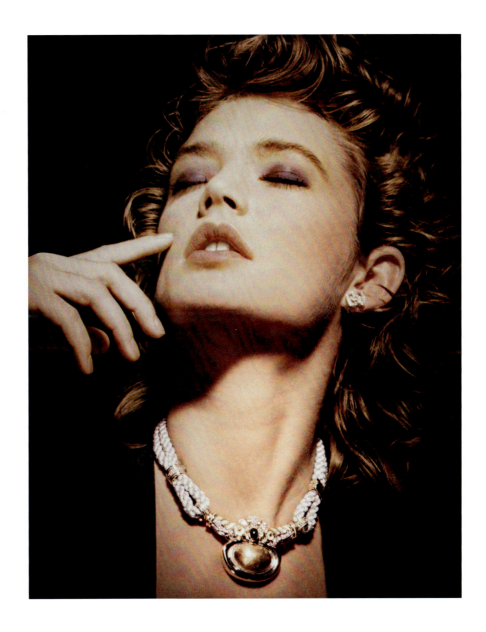

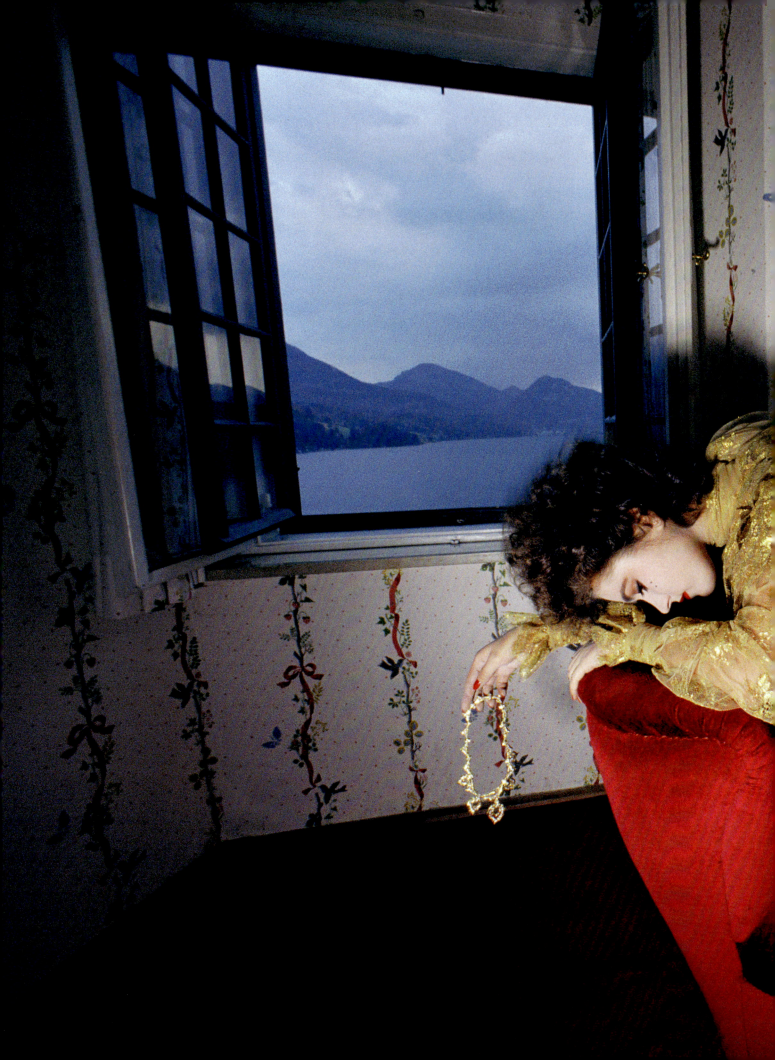

Guy Bourdin
Vogue Paris
1980

Guy Bourdin
Vogue Paris
1979

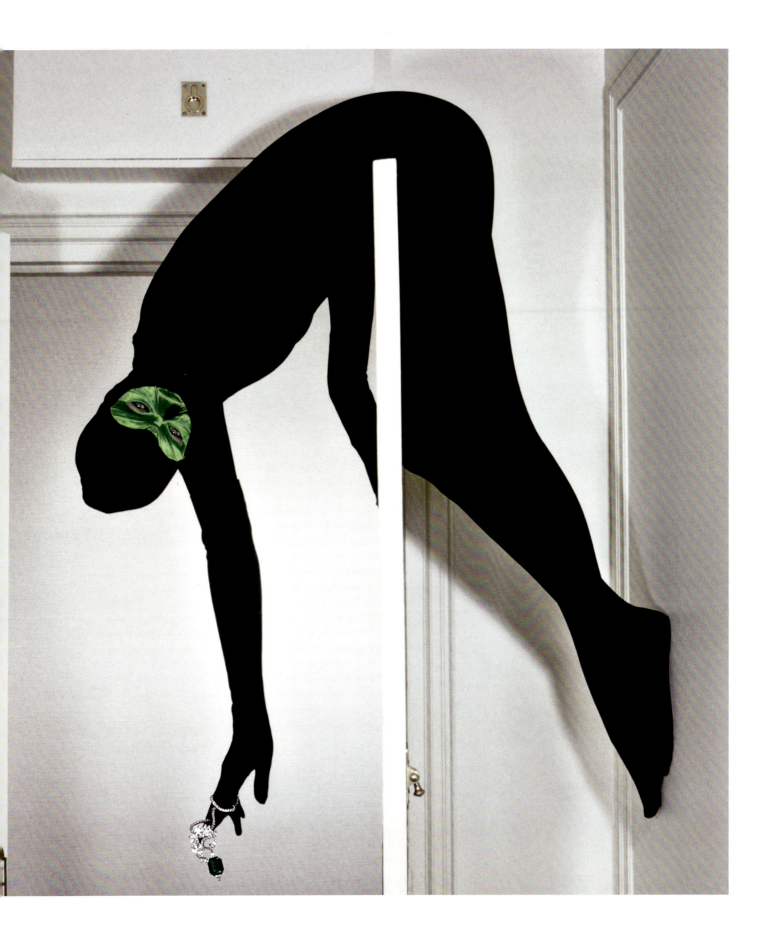

Guy Bourdin

Vogue Paris

1978

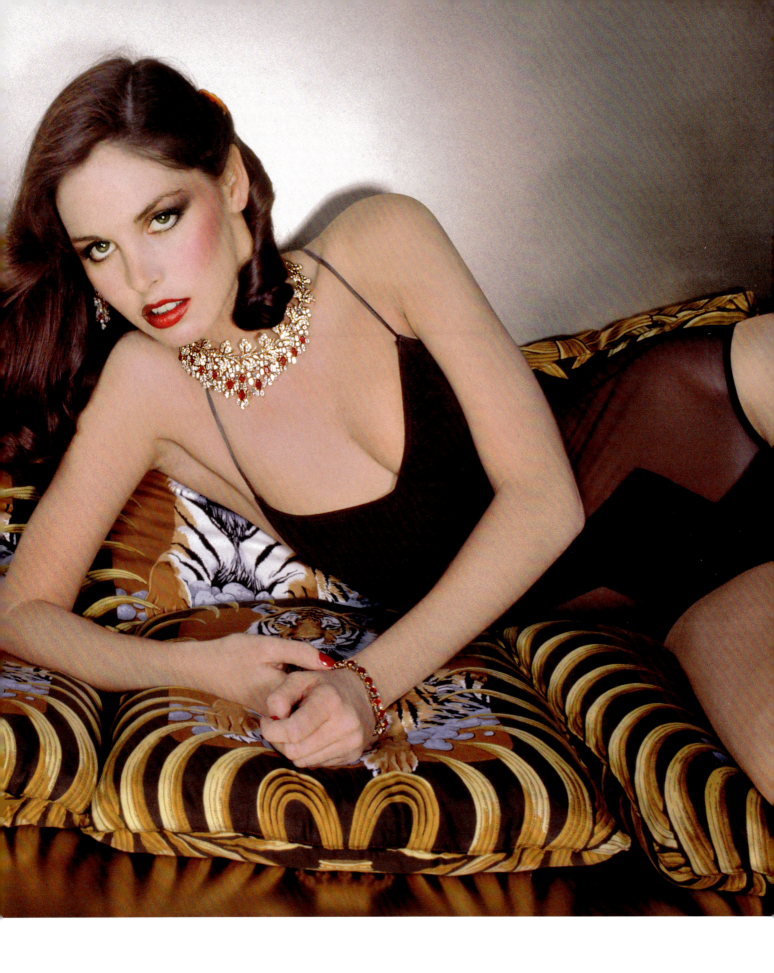

ANTHOLOGY 187

Otto Stupakoff
Vogue Paris
1975

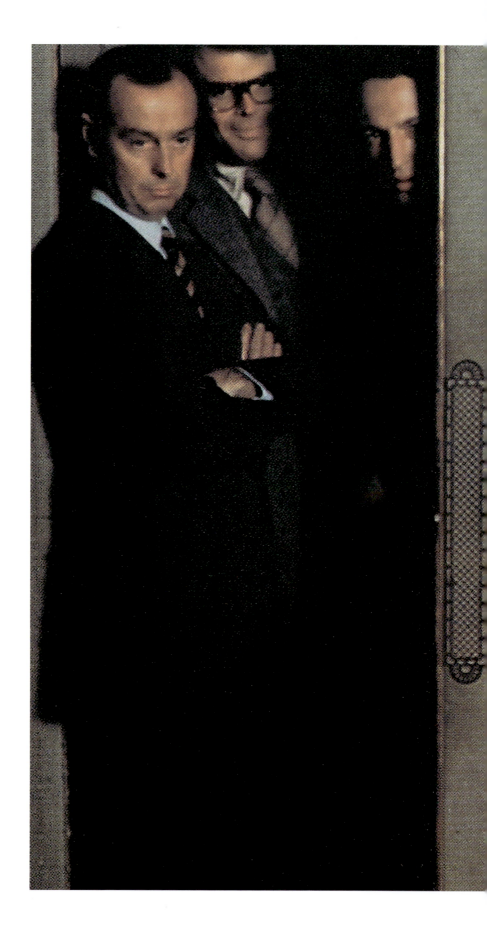

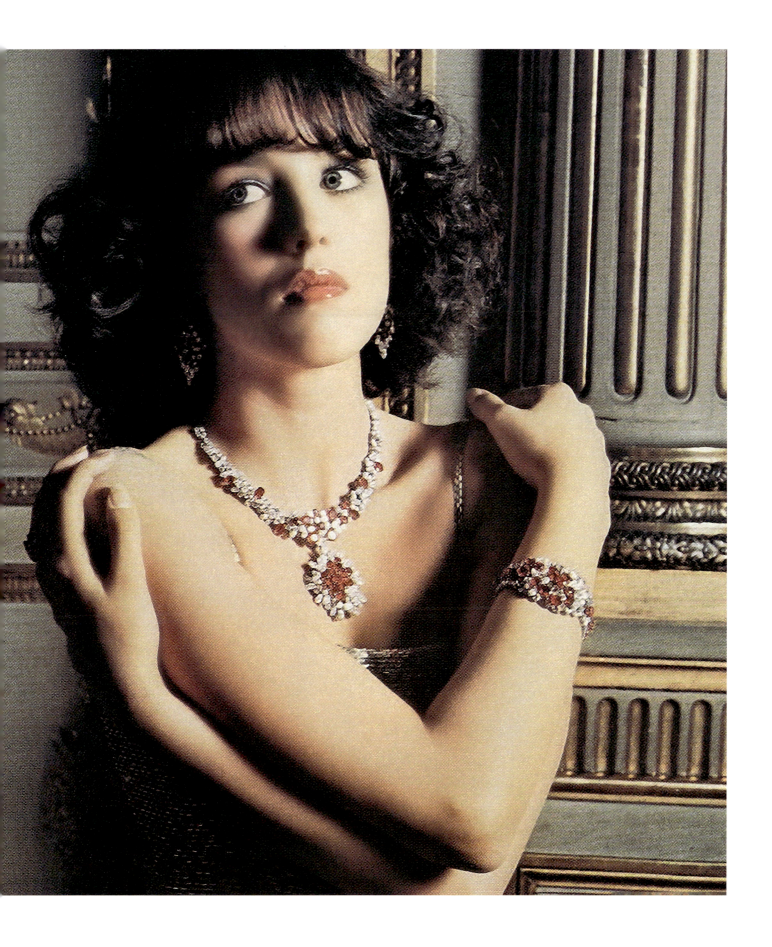

ANTHOLOGY 189

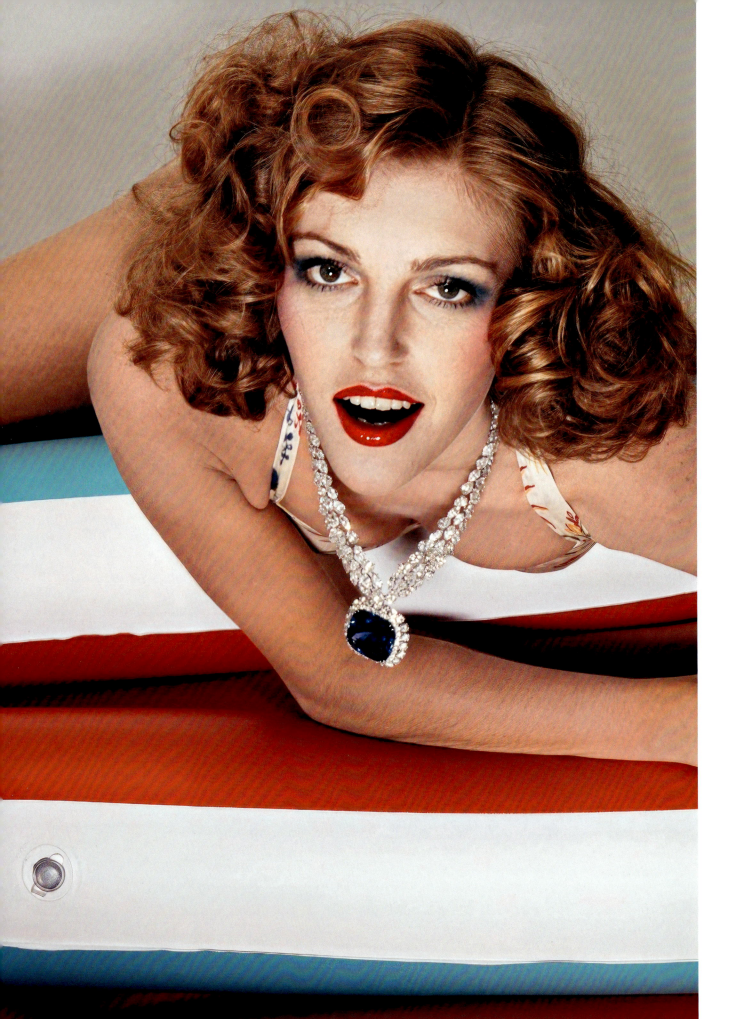

Guy Bourdin

Vogue Paris

1973

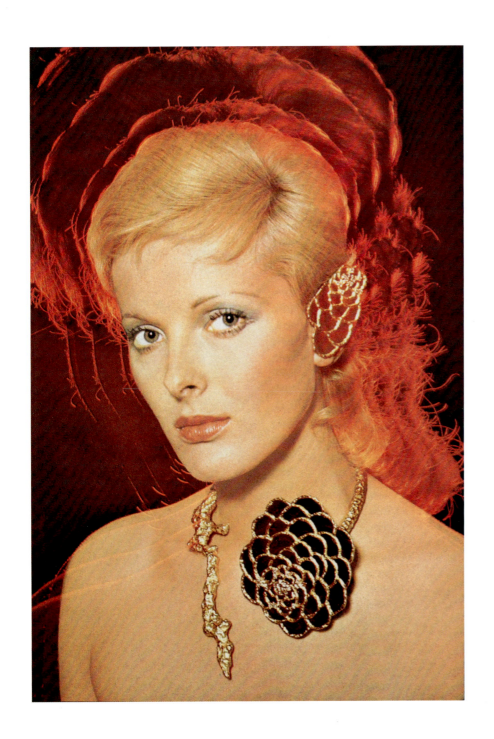

Jean-Louis Guégan
L'Officiel
1970

Roland Bianchini
L'Officiel
1972

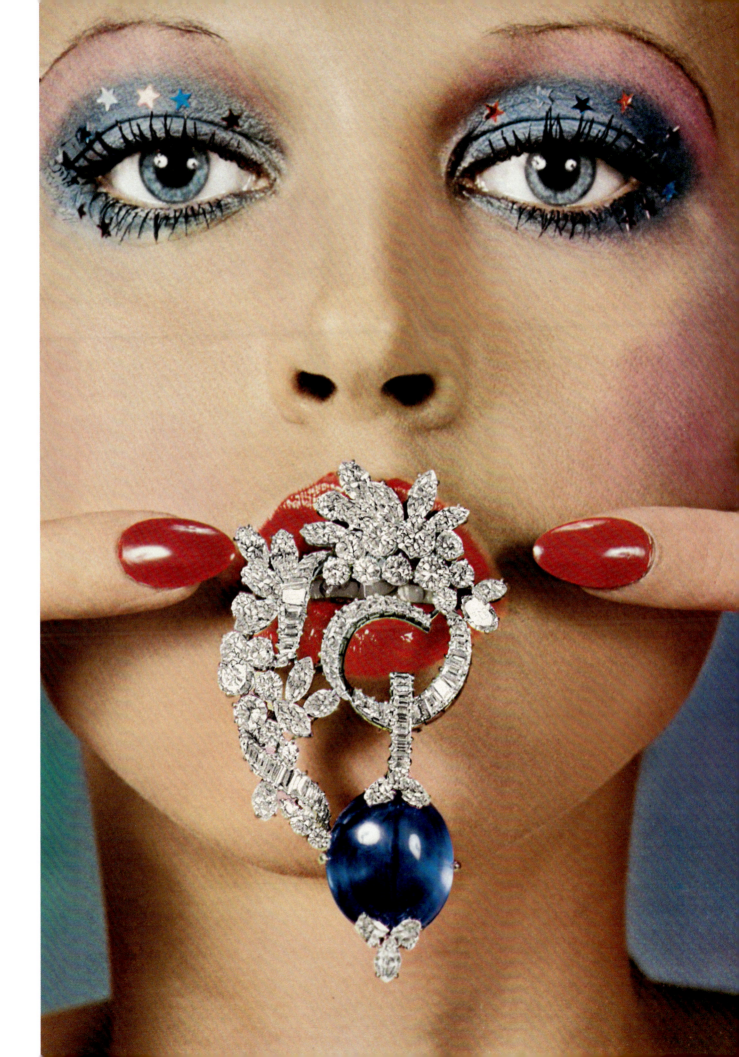

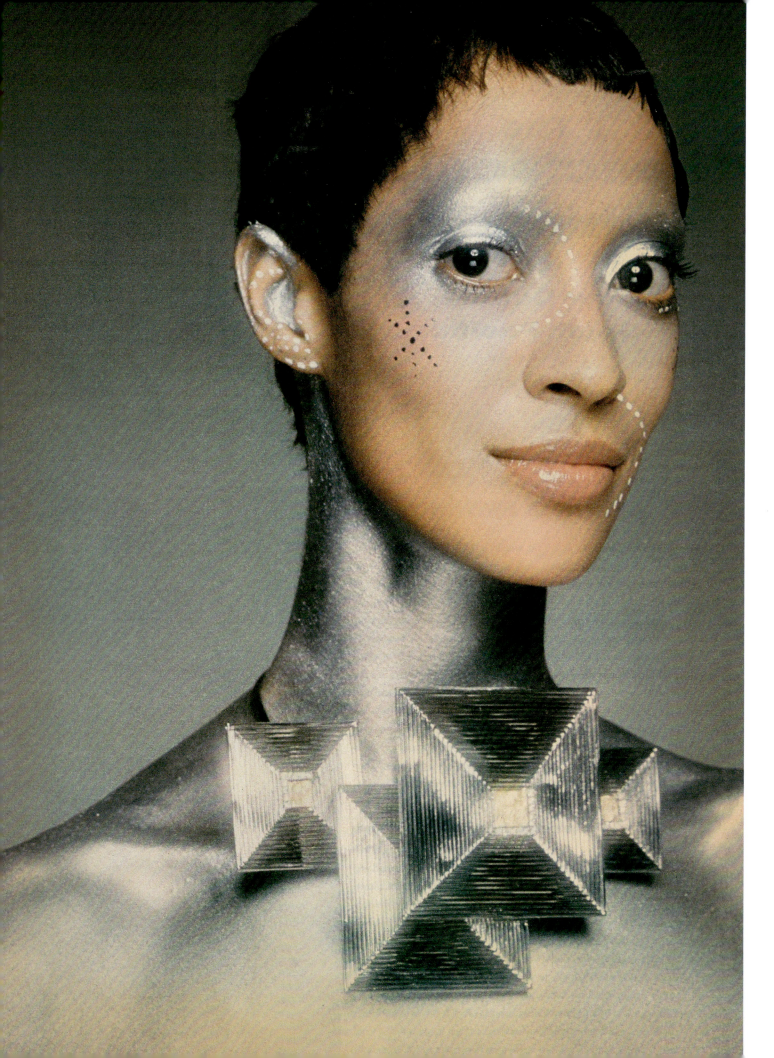

David Bailey

Vogue

1970

Jacques Rouchon
Unidentified publication
circa 1950

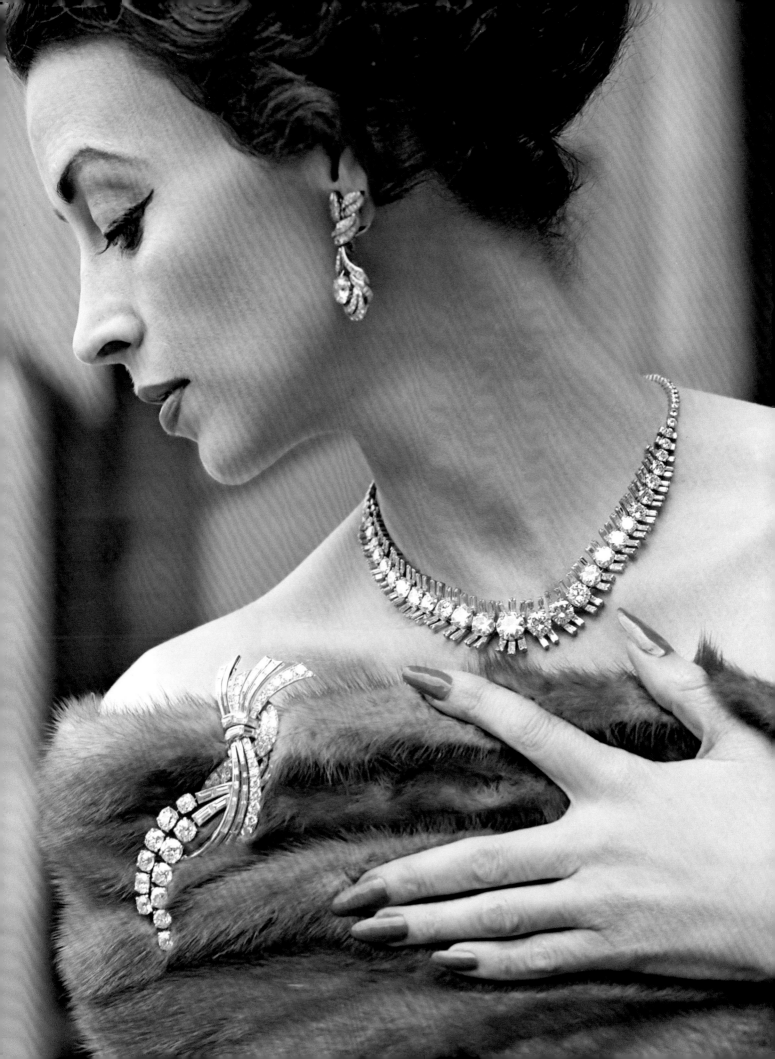

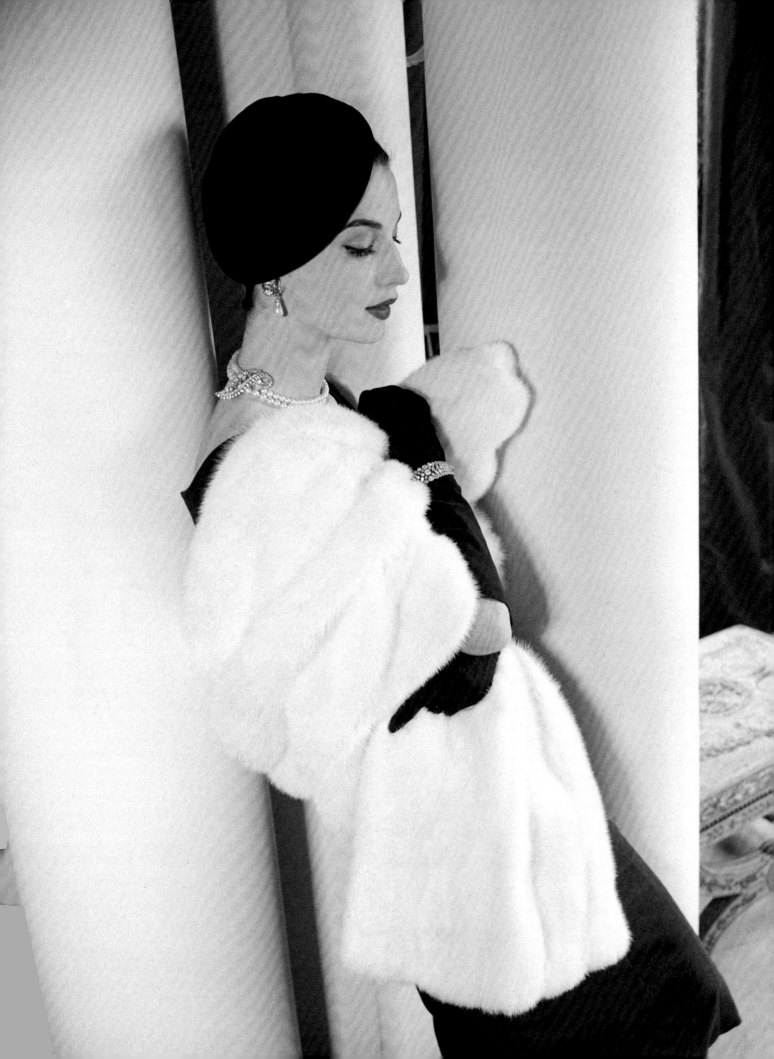

Henry Clarke
Vogue Paris
1955

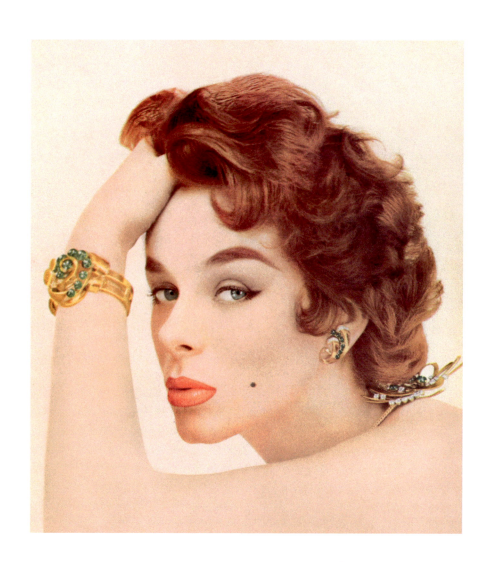

Louis-René Astre
Femme
1955

Jacques Rouchon
Femme, Beauté, Élégance
1954

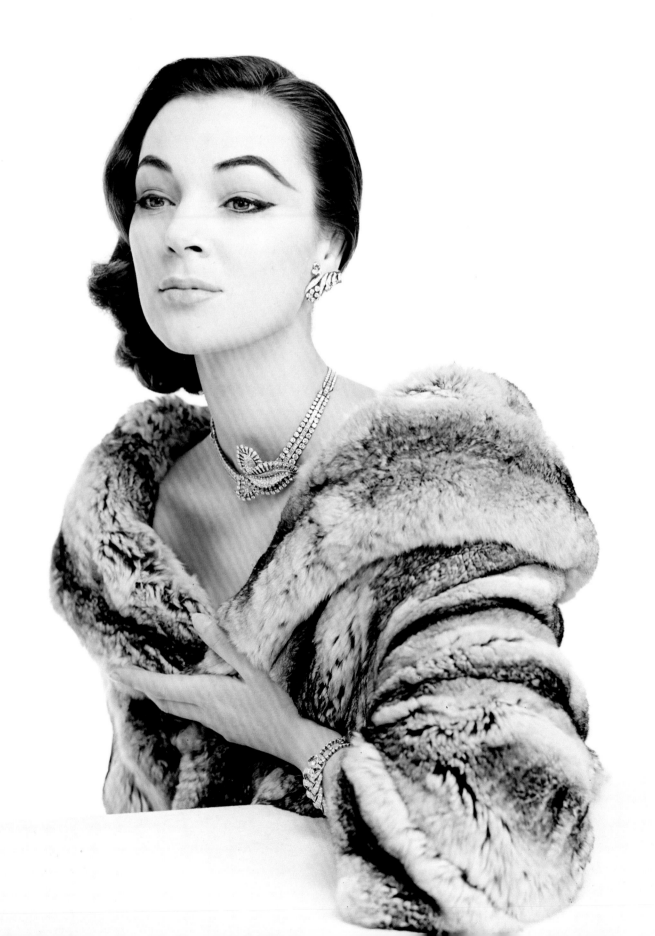

Jacques Rouchon
Femme, Beauté, Élégance
1954

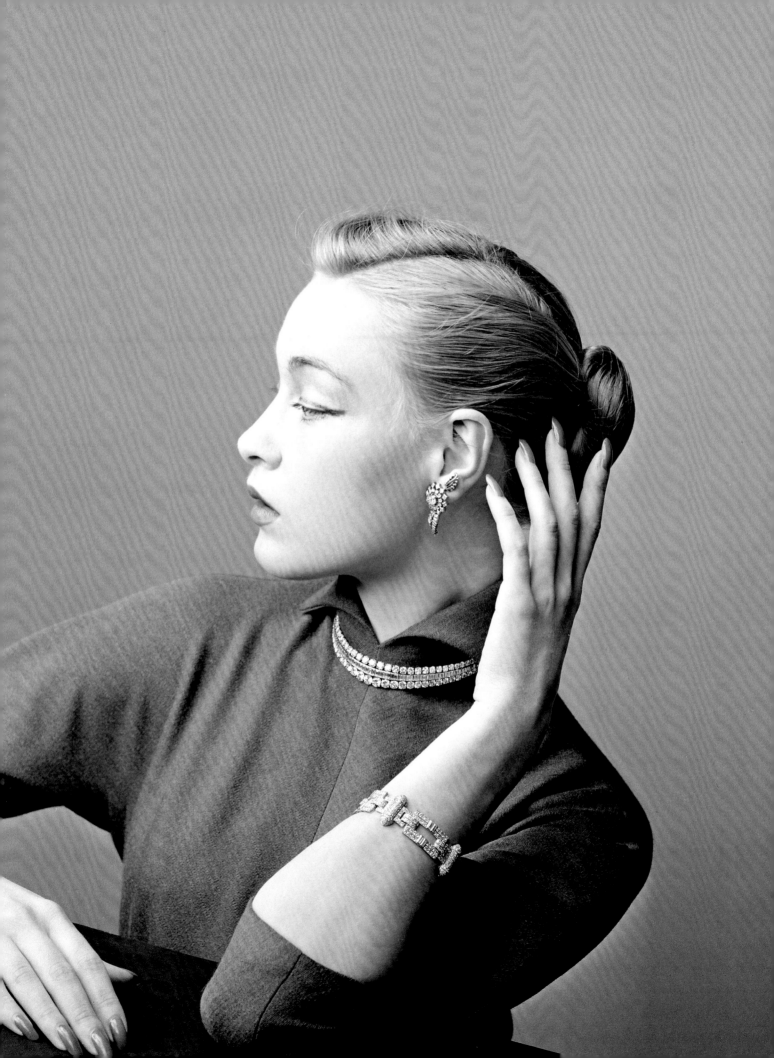

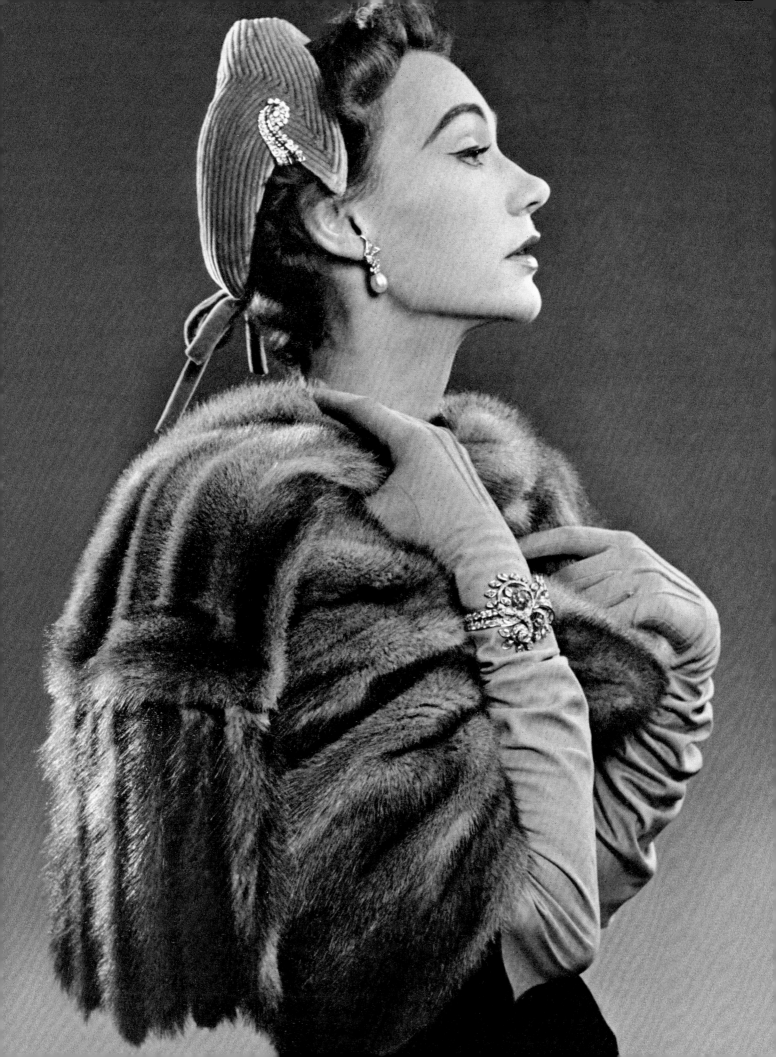

Philippe Pottier
Unidentified publication
1952

Horst P. Horst
British Vogue
1934

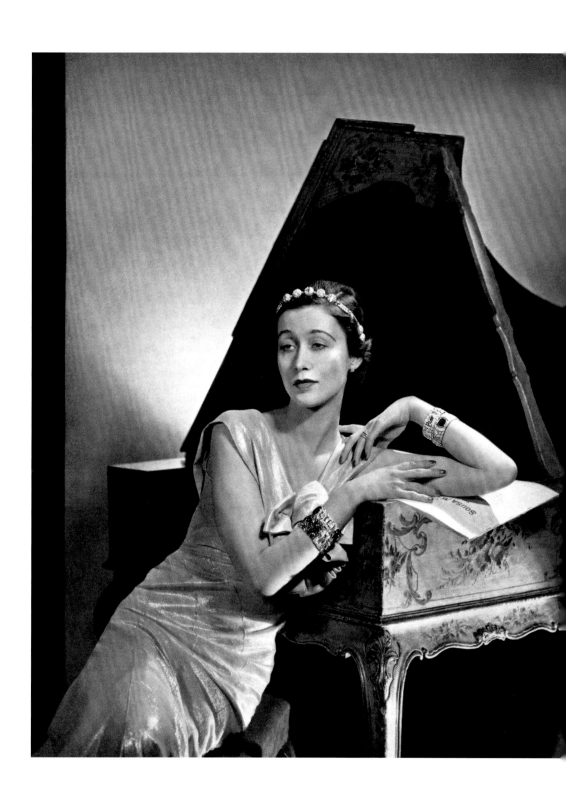

Sasha
Unidentified publication
1936

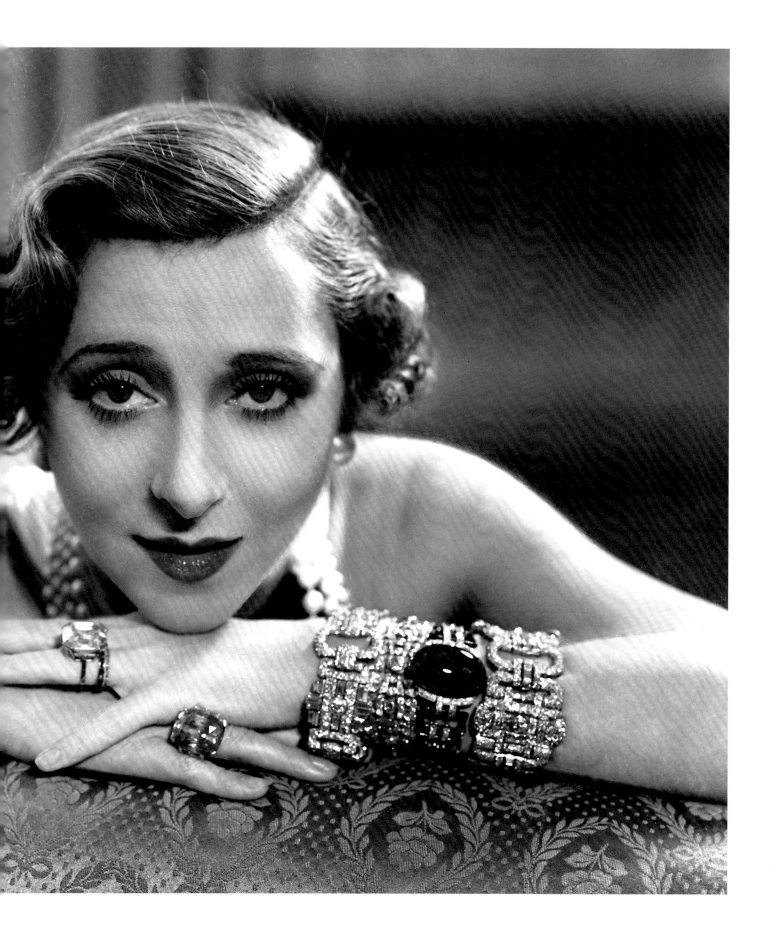

ANTHOLOGY

207

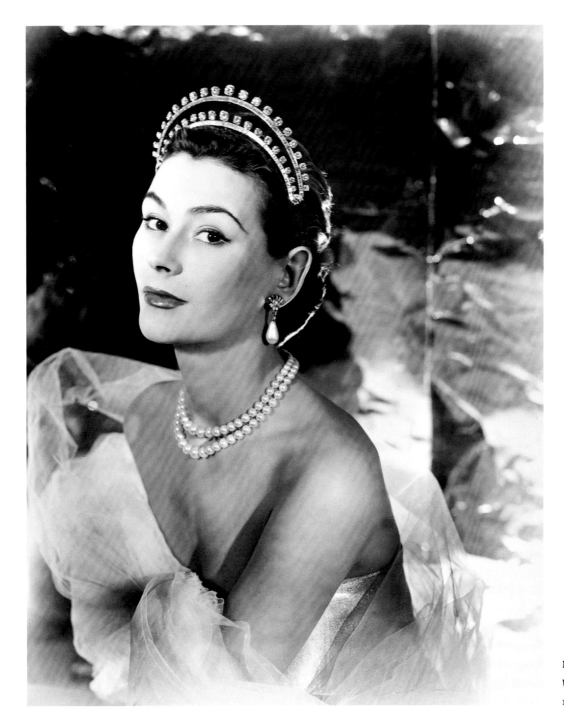

Henry Clarke
Vogue Paris
1953

Eyes *on* gemstones

Flora Triebel

Chaumet's photographic heritage constitutes an important resource, which has miraculously survived to the present day, in all its scope and complexity. The figures are more than impressive: 211,000 prints, 33,000 glass negatives and 34,000 film negatives are stored in the Maison's archives today. Added to these are a set of hybrid documents, somewhere between ledgers and photographic registers, with prints glued alongside figures and names. Over a century of images, produced methodically and with precision day in and day out, are thus spread out here before our eyes. The Maison began using photography very early in its history, at the urging of Joseph Chaumet who introduced it in 1889 as a key part of the Maison's strategies for inventory management and gemstone certification, but also to keep records of the Chaumet brand identity's ongoing evolution across generations. In short, it forms a historical photographic repository like no other.

.../...

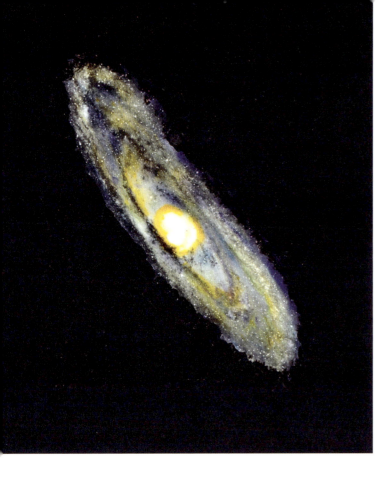

Autochrome glass plate depicting the creation of the world, early 1900s.

The constant efforts required are almost beyond imagining, when you consider that the photo studio was moved with the rest of the boutique in 1907 and that its location within the Hôtel Baudard de Sainte-James at the heart of the Place Vendôme has changed several times. On top of that, in the late 1980s, at a time when it was being stored in the cellar, the entire collection of photographs just barely missed being discarded. This last-minute rescue came about through prescient awareness of the intangible value represented by the company's archives, as a lodestar or reference point for the Maison's creations. In this same spirit, Jacques Chaumet set up a Heritage Department in 1980, with two restorers added to its staff in 1996 to take responsibility for the handling and preservation of negatives. Today, all of the negatives have been digitized, and the painstaking task of identifying and dating every item in the archive is in progress.

Due to its scope and singularity, this collection serves as far more than a simple photographic record of Chaumet's creations. It brings out two intertwined histories that shed light on each other, that of photography, its processes, its advances – Joseph Chaumet would unwittingly become a pioneer of microphotography – and that of jewellery. Browsing through these thousands of images is like exploring each page and chapter in the history of French jewellery. It is easy to get wrapped up in the fate of a gemstone, passing from one setting to the next, handed down from mother to daughter or between families, reset in tune with changing fashions and tastes, and tirelessly photographed, on glass or film, sometimes over intervals spanning decades, by Chaumet's photographers. Photography is an excellent way to capture the fluctuating and precarious art of jewellery-making. This is the dual and intertwined story told by this prodigious collection.

Strategist's eye

Joseph Chaumet organized the first sessions to photograph jewellery pieces crafted by his workshops in 1890 or 1891, the year when he took over the reins of the Maison. As Prosper Morel's main associate after marrying his daughter Marie in 1875, Chaumet brought a new energy to the Maison in the late 1880s and modernized its equipment. Photography played an unexpected role in this revival. At the time, pho-

tographer's studios were becoming quite prevalent in the district surrounding the Maison's premises. Apart from this geographic proximity, the Maison's participation in the 1900 Paris Exposition also likely inspired the director's focus on innovation and the desire to stand out from competitors by using photography in a new way. Above all, Chaumet showed himself to be a business leader especially intrigued by new ideas and inventions, having filed for about a dozen patents between 1904 and 1914.

There were several reasons behind the decision to begin documenting the Maison's art. Chaumet used photography as a link in a chain, to unify the inspirations of the Maison's designers, to keep a record of developments in its expertise, but also as reference material for his administrative staff, and as a marketing resource outside the boutique. Customers have often entrusted their pieces or gemstones with the Maison for a resetting. In Chaumet's day and afterward, a record was added to a register for each item having entered the premises, with a photographic print affixed to the page to accompany the written description. At the end of the process, whether newly crafted or reset, and whether intended to join its inventory or created for a special order, each piece was photographed, beginning in 1905. These prints fill some sixty albums categorized by theme, becoming veritable flipbooks for the Maison's evolving brand style and aesthetic preferences. A number of other potential uses readily come to mind (although not documented in the archives): for the arrangement of insurance policies, as supplements to pre-marital agreements, or to accompany the sumptuous collections of jewellery pieces presented as wedding gifts.

In the more than one hundred years since the creation of the Maison's photography studio, the approach and procedures applied for photographs have hardly changed. Black and white remained predominant until the late 1960s. In the 1950s, glass negatives were gradually abandoned in favour of film negatives. Dozens of photography notebooks still survive today, listing the details of each photograph taken, line by line: the number of the negative, the date and the customer's name. Unfortunately, the very first notebook is missing, thus shrouding the inaugural photograph in mystery. However, the initial forays by the photography studio were probably empirical and experimental in nature. One indication of this is the retrospective numbering of the first negatives, whose numerical sequence does not match the chronology for the production of the pieces. Four years after the first photograph was taken, as considerable experimentation had begun yielding the desired results and the system had obviously become cumbersome, an adjustment was inevitable. From 1894, the numerical sequence of the negatives was brought in line with the chronology of customer orders. The procedures became more firmly established and photography had earned its clear role among the Maison's practices.

.../...

Little is known about the photography studio's very first employees. Sophie Norguet was hired as a photographer on 4 July 1904. She would remain with the company for twenty-four years, methodically capturing piece after piece. Another woman by the name of Bina Edelman joined her in October 1923. She would leave the studio a few months after Norguet's departure in 1928. The Maison then hired a new photographer, André Chaponet, who was twenty-nine at the time. He was made redundant in December 1931 – the employee registers indicate that the year was a particularly difficult one for the Maison, compelled to drastically reduce its staff in the wake of the 1929 economic crisis. The studio's subsequent employees have yet to be identified.

Clinical **eye**

The exhaustive and methodical nature of the Maison's photographs casts them in a clinical light. After being extracted carefully, like potentially rare and precious insect specimens, the jewellery pieces are photographed following precise procedures allowing little room for variation or momentary whims. The viewer of these photos is in contact with the jewels in their raw state; they are rarely shown on Siegel mannequins or in cases. Necklaces, watches and bracelets are laid out flat, allowing them to be viewed in their entirety. The tiaras are displayed on small pedestals stuffed with feathers or cotton, or pinned to vertical stakes to ensure the stability of the piece. The fabric used on the props has remained fairly constant. A handful of attempts using velvet or satin made clear that these materials were ill suited to the task, as they reflected too much light and took away from the appreciation of the object. Making the best use of artificial lighting to fully render the brilliance of gemstones, which could be suppressed by certain backdrops, was the greatest technical challenge faced by the early photographers. A few unsuccessful shots give insight into the obstacles overcome along the way: warped plates, gelatin coming unglued, dull or washed-out gemstones in some cases and whitening due to intensive light in others, blurry shapes. The use of black and white is clearly another constraint, as it does a disservice to the polychromy of the pieces and makes it difficult to properly distinguish gemstones, although it perfectly enhances the lines of the settings. To address these issues, some of the prints were heightened with gouache. Lastly, the format of the glass plates was inadequate on occasion to contain the extravagance of some of the sautoirs, for which the photographer had to either layer multiple loops from sections of the piece or take several shots. Four 24 × 30 cm glass plates were needed to adequately depict the twelve rows of pearls of the shoulder necklace created for Countess Vitzthum in around 1889. However, the use of glass plates for negatives resulted in crisp image quality and detail, making it possible to discern the

These reproductions of jewellery reveal them before their debut on the scene.

high level of technical expertise brought to bear in the art of jewellery-making. The format of the plates varies in line with the pieces being photographed, to ensure reproduction on a 1:1 scale. Most of the pieces are photographed individually, but in a revealing reflection of the spirit of the interwar years, truly a golden age that saw an exponential rise in jewellery orders, some plates depict an impressive assortment of pieces. They sometimes create paradoxes in portraiture, when an entire set of jewellery pieces (tiara, necklace, brooch, earrings) is brought together within a single picture, such as the collection of jewels presented as a wedding gift for the marriage of Prince Sixtus of Bourbon-Parma and Hedwige de la Rochefoucauld, which was celebrated on 12 November 1919, marking the return of high-society events after the end of the First World War.

These reproductions of jewellery pieces reveal them before their debut on the scene, when the tiaras, sautoirs, rings or brooches were still sleeping beauties, awaiting the day they would be brought to light adorning their owner. Be that as it may, the photography notebooks bear witness to the throngs of high-born, worldly and sophisticated customers flocking to the Maison during this initial period. The litany of names, recorded in a fine and easily legible hand on a page selected at random from a 1910 notebook, offers a telling illustration: the Duchess of Doudeauville, the Countess de Vogüé, the Countess Sheremeteva, the Count of Paris, the Baroness de Barante and the Marquise de Montesquiou are just a handful of the thirty-four customers whose orders were photographed between 27 June and 25 July 1910.

Mystical eye

Despite the extraordinary scope of these photographic archives, they are not the only ones of their kind: Frédéric Boucheron deposited four albums containing photographs of his pieces with the professional library of the Chambre Syndicale de la bijouterie-joaillerie in 1894.

…/…

It was in an even more technically complex area that Joseph Chaumet proved to be a genuine pioneer: microphotography. Fascinated by new advances in both optics and photography, his stroke of genius was to bring them together to serve the needs of the Maison and the industry in general.

When Chaumet took over the direction of the Maison from his father-in-law, the community of Parisian jewellers was in the process of forming a more professional and structured network. Trade associations were beginning to appear: the Chambre Syndicale de la bijouterie, joaillerie, orfèvrerie et des industries qui s'y rattachent was founded in 1864, the Chambre Syndicale de la bijouterie imitation, bijouterie dorée, deuil, acier, écaille, petits bronzes et des industries qui s'y rattachent in 1873, followed by the Chambre Syndicale des négociants en diamants, perles, pierres précieuses et des lapidaires. Numerous trade journals were established, including *L'Écrin : Moniteur de la Bijouterie et de la Joaillerie* (1863), *Le Joaillier* (1874), *Le Bijou : Revue Artistique et Industrielle de la Bijouterie* (1874), *La Mode et le Bijou* (1900), *Revue de la Bijouterie, Joaillerie, Orfèvrerie* (1900) and *Art et Joaillerie* (1903). Shared tools were implemented across the industry.

In the 1900s, the community of Parisian jewellers was abuzz with the arrival of new categories of gemstones. Research conducted on synthetic rubies by Auguste Verneuil, a chemistry professor at France's National Museum of Natural History, culminated in the 1904 publication of his treatise on the artificial reproduction of rubies via flame fusion. Henri Moissan, also on the staff of the same museum, had already published his early-stage research on the reproduction of diamonds in the 1890s. Manufactured or reconstituted gemstones began to circulate. Chaumet played a particularly active role in promoting greater transparency in the market, using photography to support his research conclusions.

In 1902, Chaumet delivered a presentation to the French Academy of Sciences on the action of light on gemstones. In 1904, during a presentation on rubies delivered to the members of the French trade associations for diamond and lapidary merchants as well as jewellers, brought together in the main amphitheatre at the Conservatoire National des Arts et Métiers, he summed up his aim: "In the face of developments being made in the imitation of gemstones, let us be just as innovative with regard to their verification." To bring his point home, he presented photographs taken using a microscope and argued in favour of a certification process for gemstones accompanied by this type of photograph. The Maison still possesses several examples from the period of certificates of authenticity, identity and origin, in which the description of the gemstone (its fluorescence, density, striae, weight, shape and colour) is accompanied by a photograph of the piece featuring the gemstone and microphotographs showing the gemstone's inclusions. This type of document is still drawn up for the Maison's customers today.

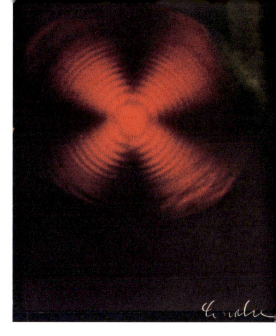

Observation of light effects induced by the passage of a polarized light beam through a cinnabar crystal (early 1900s), Chaumet photography laboratory, autochrome glass plate.

Chaumet carried out three types of photographic studies on gemstones, thankfully documented in an astonishing little album of modest appearance: photographs through a microscope of the inclusions within gemstones; photographs of various configurations of light beams after passing through gemstones, thus observing the effect of light on the gemstones by way of polarization; and photographs of gemstones penetrated by X-rays. His research went beyond gemstones to look at mica, coral, tempered glass and quartz, thus compiling a highly exhaustive gemmological vade mecum. Lastly, several Lumière autochrome plates reveal colour polarizations.

From the turn of the century, in order to successfully carry out his research, Chaumet put together an arsenal of state-of-the-art equipment, with his purchases meticulously documented in his ledgers. Already in 1895, he had installed electricity in his workshops. In 1904, he purchased a "special photographic microscope" as well as a "horizontal camera obscura for high-volume printing" from Nachet, a Parisian microscope manufacturer founded in 1839. In 1905, he expanded his range of devices by purchasing several items from Radiguet, one of the oldest dealers in optical equipment in Paris, founded in 1805. This company had begun marketing its induction coil in 1895, following the announcement of the German physicist Wilhelm Röntgen's discovery of X-rays. It is the cylinder topped with a half-length tube seen in several photographs of the Chaumet laboratory, used to examine the internal structure of solid objects. In addition, the jeweller paid 1,000 francs for a "No. 18 device", also purchasing a microscope for 700 francs, a phosphoroscope[1] and a polarizer. That same year, Chaumet purchased a camera obscura and a "simultaneous vision machine" from Fernand Monpillard. The latter was a member of the Société Française de Photographie, an association devoted to the history of photography, and had taken photographs through a microscope in 1900 to illustrate the research findings of Étienne Rabaud, who was developing a histology atlas for students. And in 1906, Chaumet bought a "large microscope with parallel and converging light beams"[2] as well as a "collection of cut crystals for the study of all optical interference phenomena"[3] from the lapidary dealer Wherlein. When he began using all of this equipment, microphotography was still in its infancy (the 1849 studies by the botanist Louis-Alphonse de Brébisson and the microphotographic studies shown by Auguste Bertsch at the 1855 Paris Exposition

.../...

1. A phosphoroscope is an apparatus for measuring the rate of decay of luminescence.
2. This type of microscope is equipped with lenses that can be used to change the direction of rays of light and thus expand the range of possibilities for observing and analysing gemstones without handling them.
3. These interference phenomena arise from the intersection of two light waves.

EYES ON GEMSTONES

were well ahead of their time) and confined to the medical realm. Chaumet thus benefited from a century of optical industry developments intended for bacteriological and astronomical research and adapted these advances to serve his own needs and rally his peers around the cause he advocated. By way of these photographs of light beams passing through gemstones, he aimed to provide experimental evidence of the differences between gemstones, without damaging the objects themselves. In 1904, he described his study of ruby fluorescence as follows: "The rubies are placed in a wax box and exposed to ultraviolet light from the arc lamp. Oriental rubies (named so because they traditionally came from Burma and East Asia) take on the colour of charcoal tinged in bright red. Siamese rubies are cast in a hue that is nearly black." In his studies using X-rays, natural diamonds show translucent spots on the prints, whereas simulated diamonds show opaque spots.

It was in 1929 that a gemstone analysis laboratory was established in Paris. As a trailblazer, Chaumet helped give rise to gemmology and the use of microphotography among jewellers' practices.

These photographs still hold considerable interest for gemmologists who will find the inclusions, polarizations and refractions depicted very revealing. For members of the general public, unfamiliar with the identification and examination of gems, these abstract views are astonishing in their beauty. The gemstone fades into the background, showing only its brilliance, the ultimate effect recorded on the plate. Some photographs recall floating planets in black and white, transporting us, through the microscope lens, into the infiniteness of unknown space. Our contemporary eye inevitably connects them to a modern aesthetics and derives, by way of a historical misconception, a satisfaction that Chaumet never intentionally sought to achieve. And yet, could this beauty have escaped his notice? His profile is that of a complex man, of mystical inspiration but also fascinated by science, plumbing the depths of materials and finding an exceptional energy within them. When it was displayed in one of the salons at the Hôtel Baudard de Sainte-James, his great jewelled monument, the *Via Vitae*, was surrounded by panels representing scientific diagrams of the infinitely small. Through his microphotographic research, Chaumet's aim was to make visible the invisible and reveal the truth of gemstones through light. The strictly documentary nature of this work is sustained by an ideal that associates each natural gemstone with a commercial value, which is never neglected, but also with a moral value encompassing truth and beauty that cannot be claimed by an artificial gemstone. In essence, these photographs perfectly encapsulate this jeweller's ultimate objective: conversing intimately with celestial bodies through every gemstone, an infinitely small universe that can be held in the palm of one's hand. ❧

Joseph Chaumet's studio

Joseph Chaumet studio

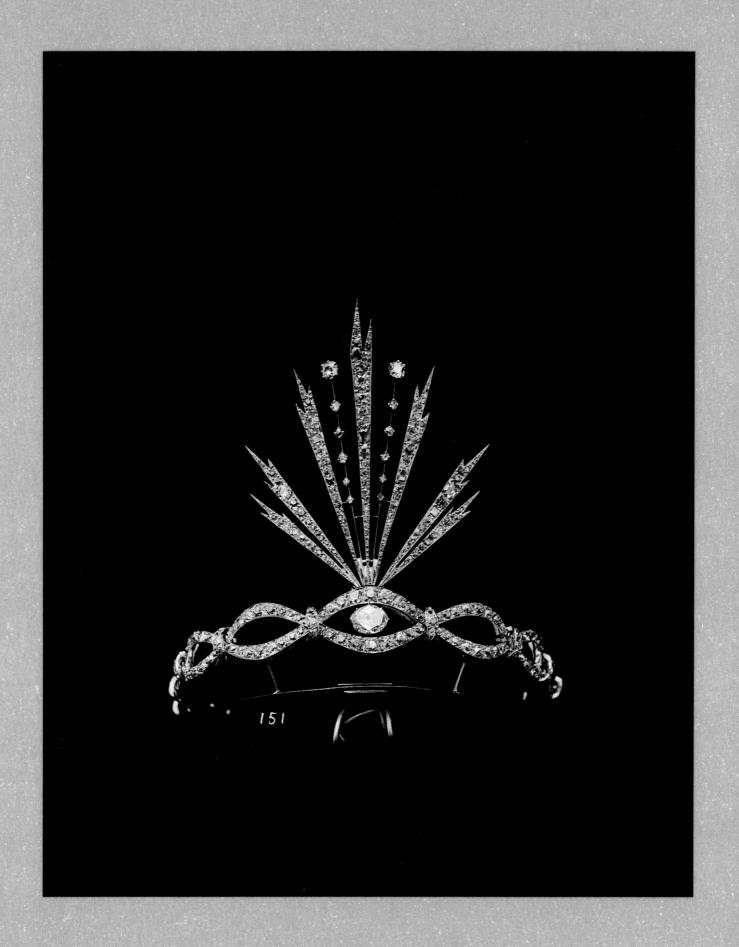

JOSEPH CHAUMET'S STUDIO

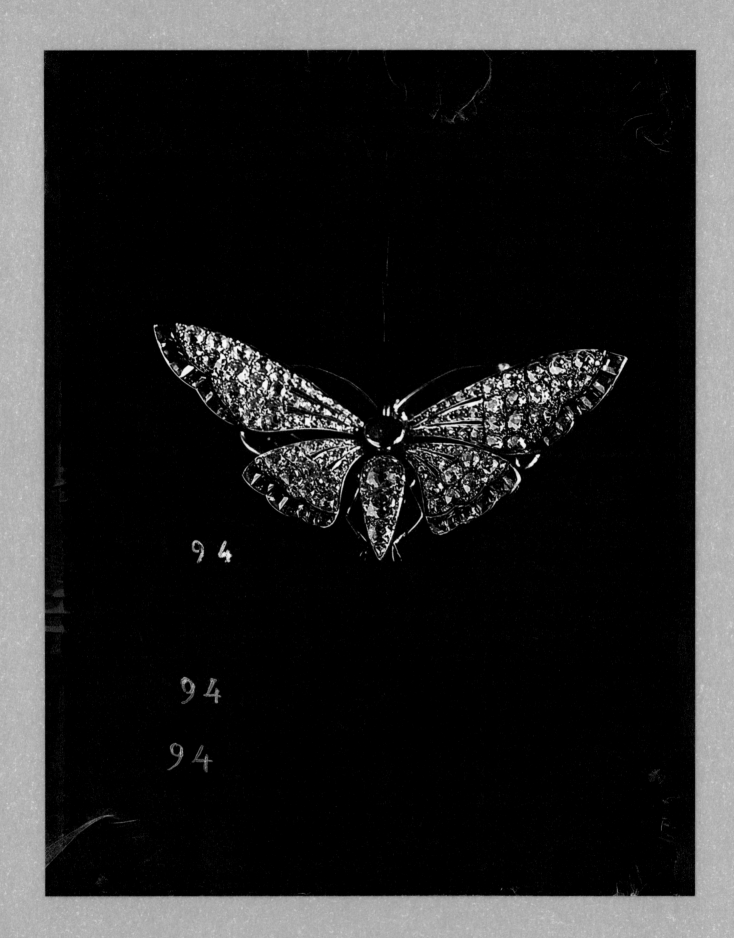

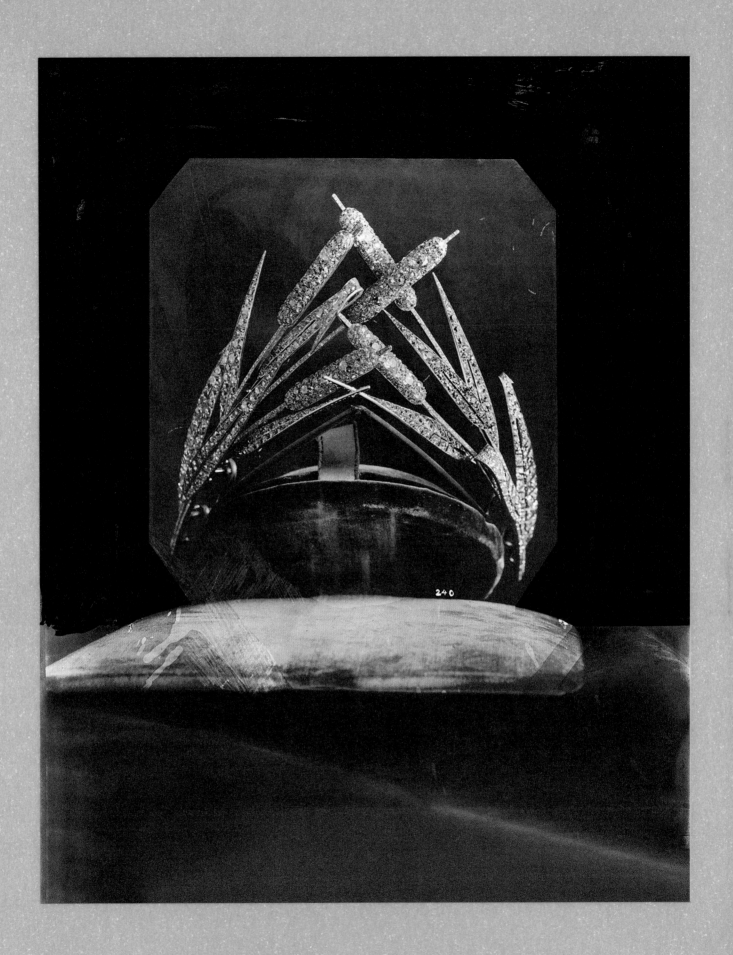

JOSEPH CHAUMET'S STUDIO

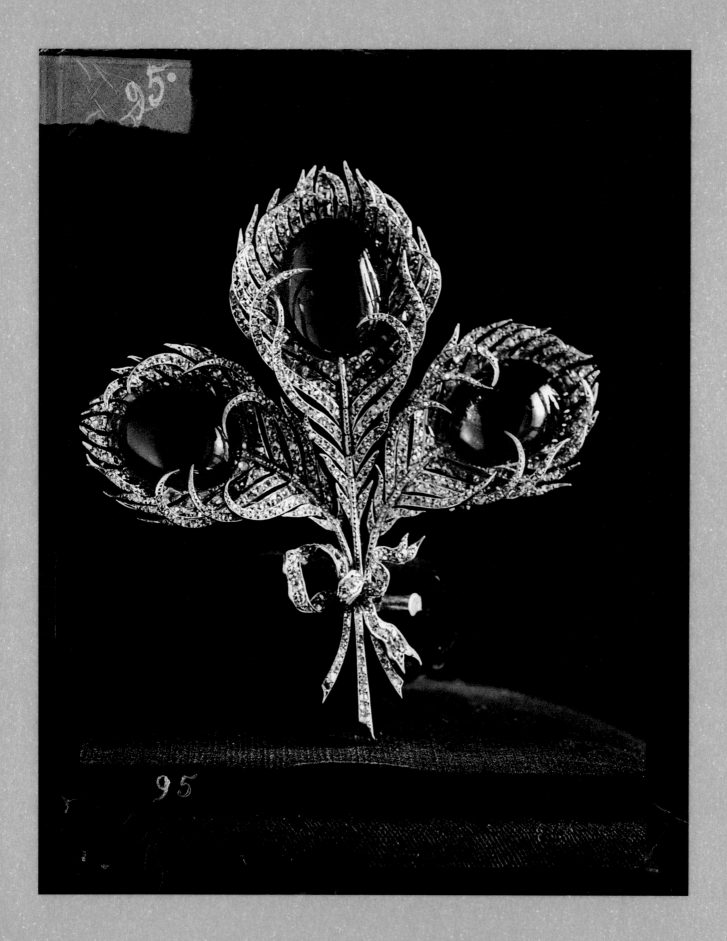

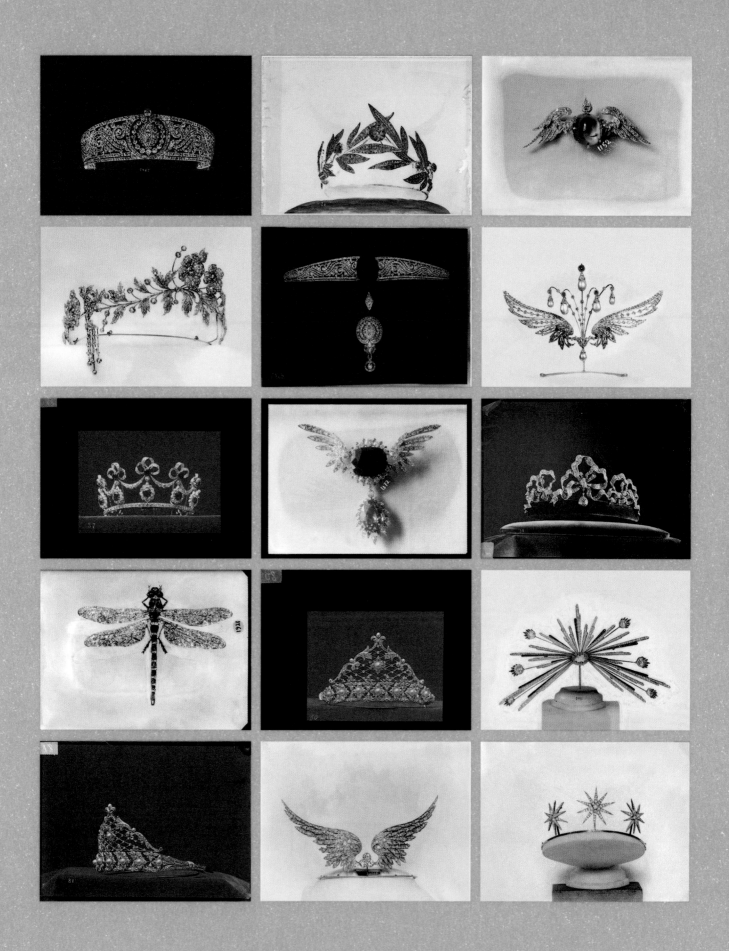

JOSEPH CHAUMET'S STUDIO

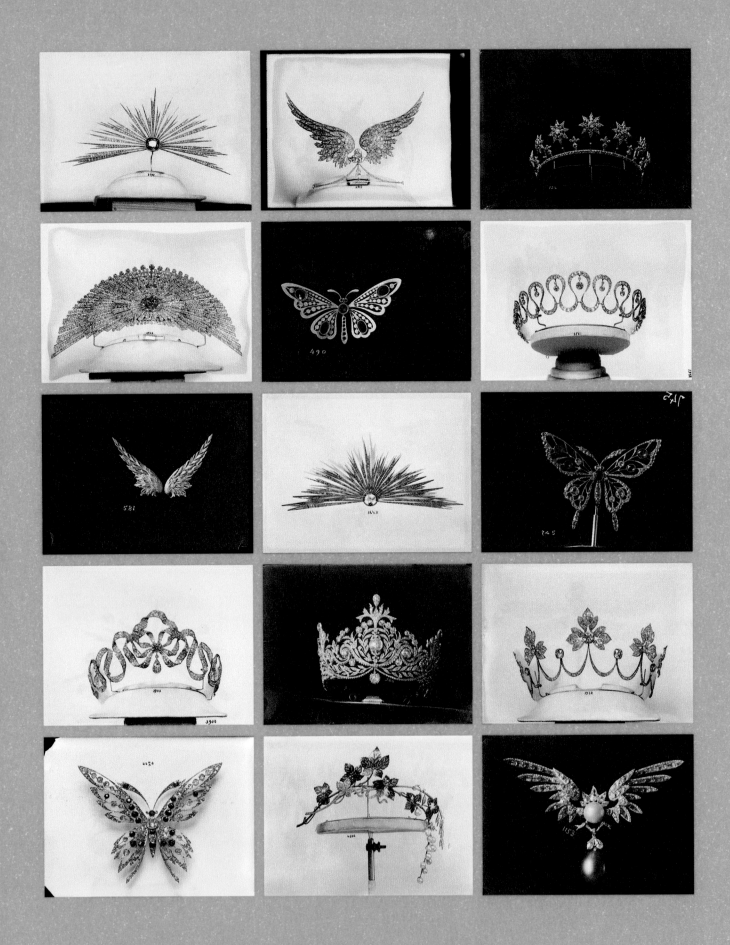

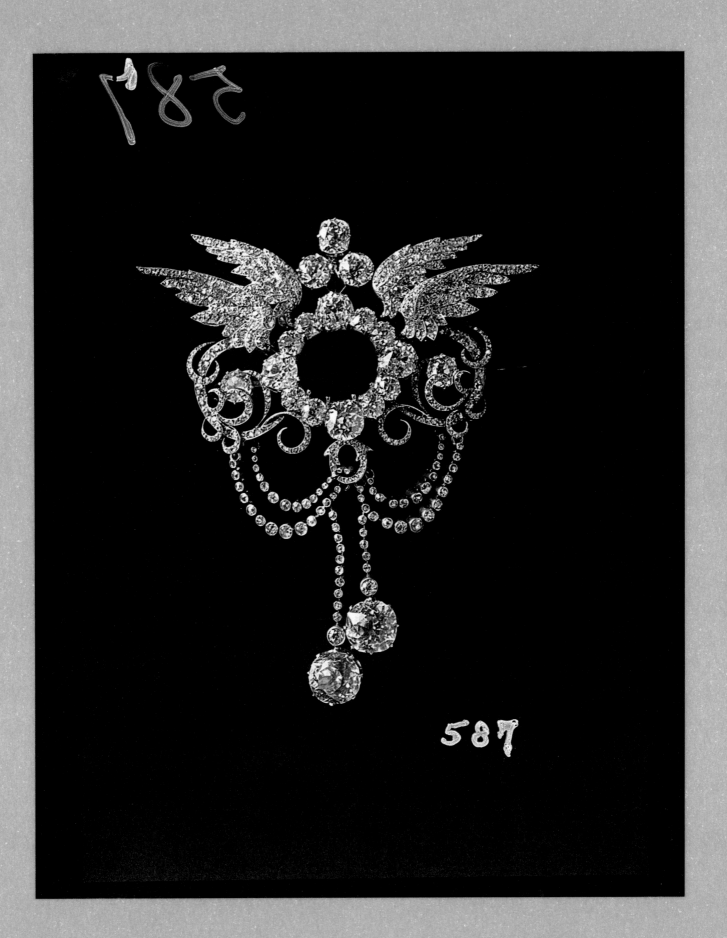

JOSEPH CHAUMET'S STUDIO

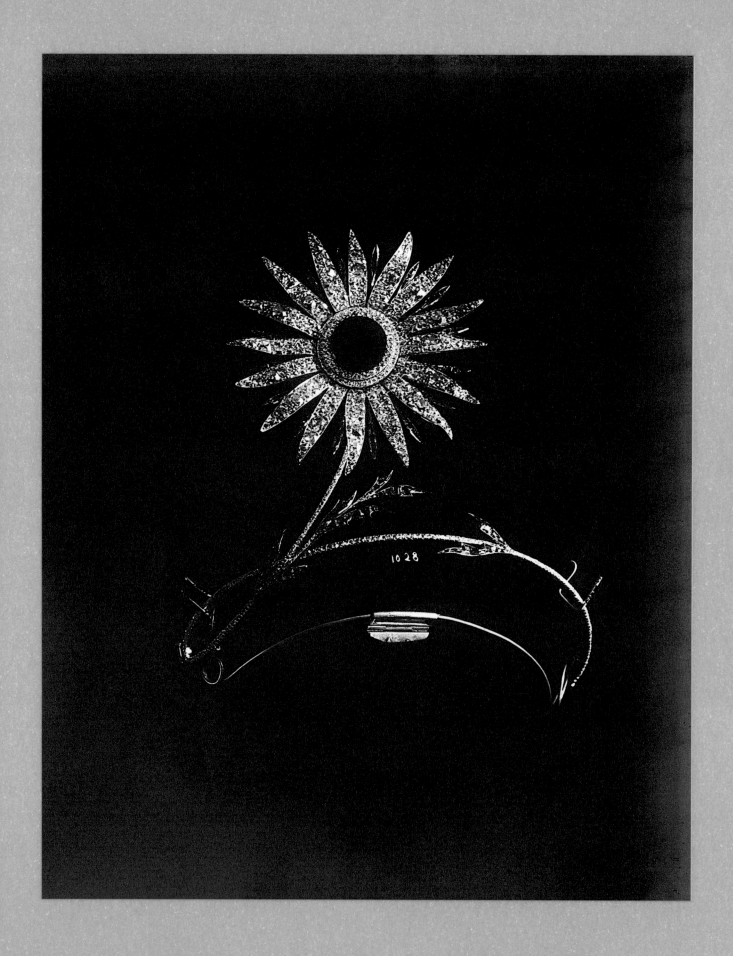

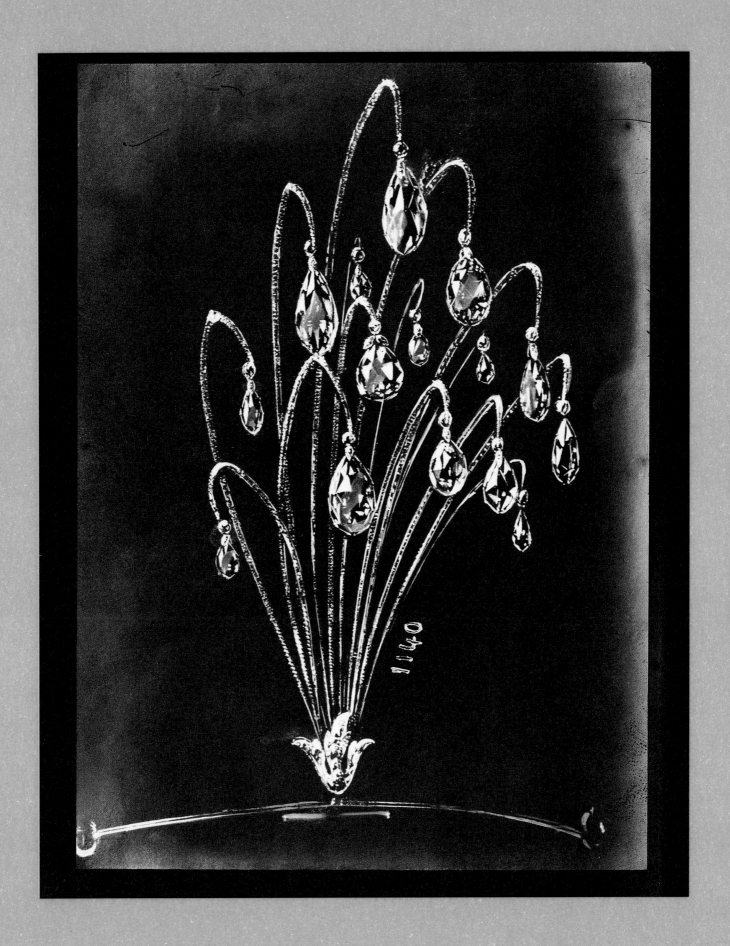

JOSEPH CHAUMET'S STUDIO

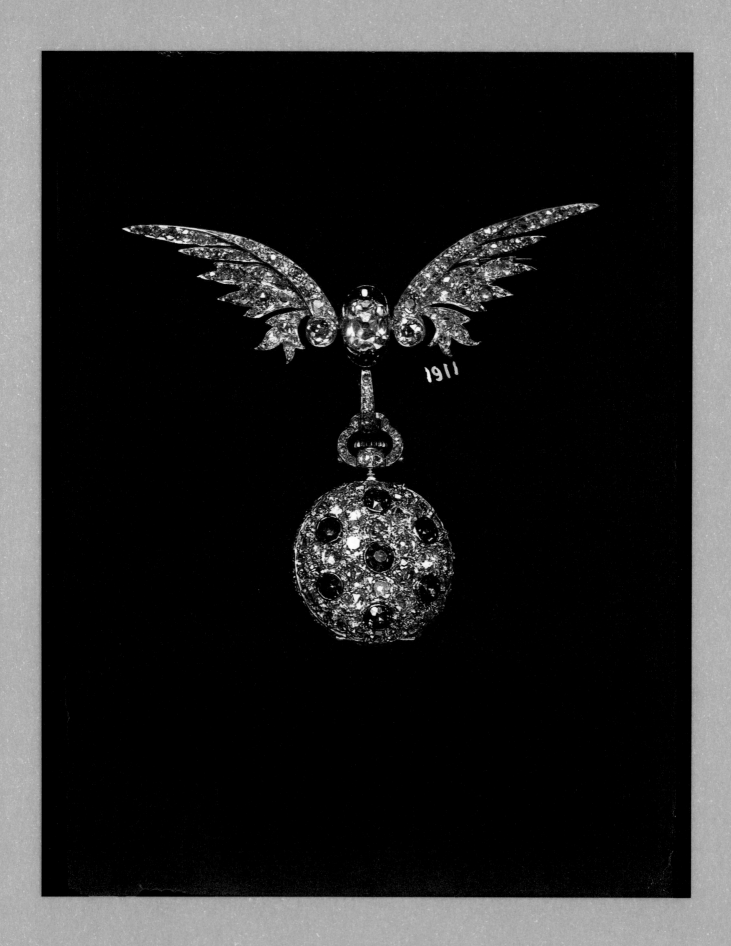

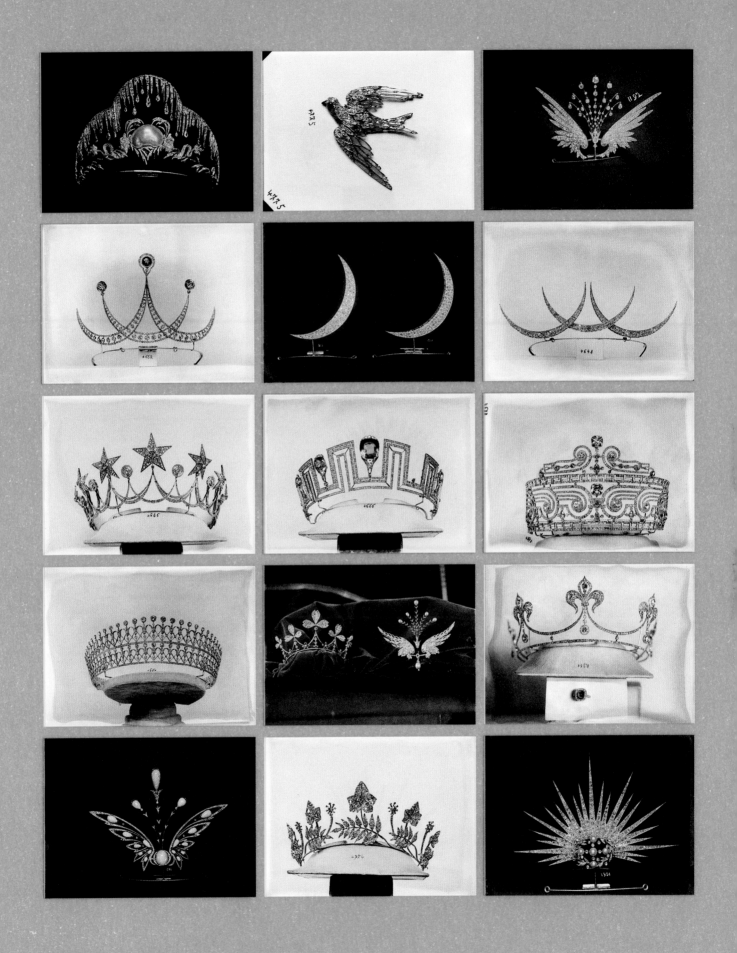

JOSEPH CHAUMET'S STUDIO

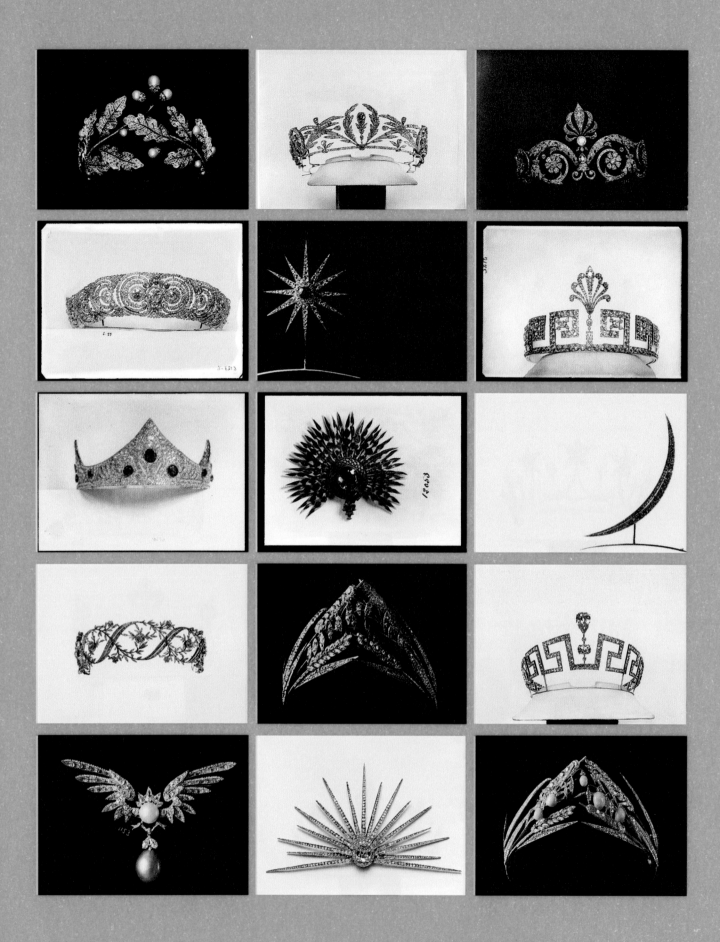

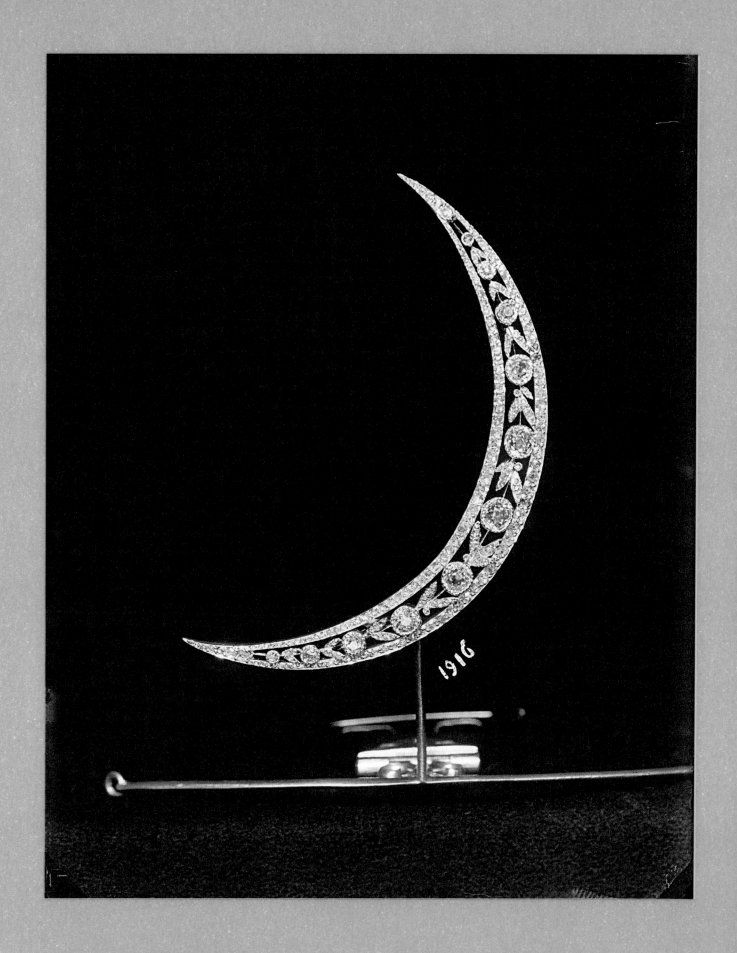

JOSEPH CHAUMET'S STUDIO

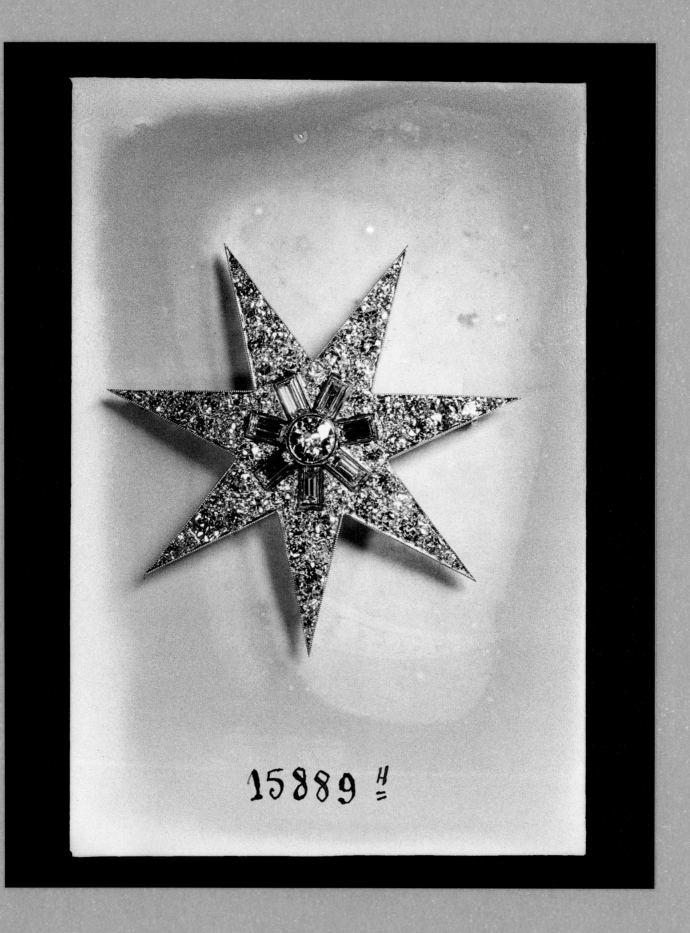

The glass plates on the preceding pages are from Chaumet's collections and were taken by the Chaumet photography studio between 1889 and 1931.

p. 219, glass plate no. 151, depicting a ribboned headband fitted with an aigrette adorned with a radiating motif, circa 1890.

p. 220, glass plate no. 94, depicting a butterfly brooch, circa 1890.

p. 221, glass plate no. 240, depicting a tiara with a design evoking a pair of reed stems, circa 1892.

p. 222, glass plate no. 95, depicting an aigrette with three peacock feathers, circa 1890.

p. 223, glass plates depicting tiaras and brooches created or transformed by Chaumet between 1889 and 1920.

p. 224, glass plates depicting tiaras and brooches created or transformed by Chaumet between 1889 and 1909.

p. 225, glass plate no. 587, depicting a brooch with a design featuring a clover motif, four wings and feathers, circa 1895.

p. 226, glass plate no. 1028, depicting an aigrette featuring an ox-eye daisy decoration with leaves.

p. 227, glass plate no. 1140, depicting a waterfall aigrette, with each slender jet cradling a briolette diamond.

p. 228, glass plate no. 1911, depicting a watch and its clasp featuring a pair of wings, circa 1902.

p. 229, glass plates depicting tiaras and brooches created or transformed by Chaumet between 1898 and 1927.

p. 230, glass plates depicting tiaras and brooches created or transformed by Chaumet between 1898 and 1927.

p. 231, glass plate no. 1916, depicting a crescent-shaped aigrette ornamented with diamonds, circa 1902.

p. 232, glass plate no. 15889, depicting a star brooch with a baguette diamond motif in the centre, 1931.

Index of photographers

Paginations in italics refer to in-text mention.

Akehurst, John ... p. 73

Aldridge, Miles ... p. 84-85, 166-167

Araki, Nobuyoshi ... p. *28,* 92

Astre, Louis-René ... p. 200

Atkins, Anna ... p. *148*

Bailey, David ... p. 194

Bailey, Lachlan ... p. 48

Beaton, Cecil ... p. *35*

Bertsch, Auguste ... p. *215*

Bianchini, Roland ... p. 193

Bihr, Cédric .. p. 111-113, 136-137

Blumenfeld, Erwin ... p. *146*

Bourdin, Guy ... p. *26, 145, 146,*
.. *178-179, 182-187, 190*

Burbridge, Richard ... p. 96, 126-127

Cattelan, Maurizio and Pierpaolo Ferrari p. 106-109, *149*

Cavadini, Simone ... p. *148*

Chabani, Blandine .. p. 46

Chaponet, André .. p. *212*

Chaumet, Joseph .. p. *29, 32, 33, 40, 210,*
.. *211, 214, 215, 216*

Claessens, Julien and Thomas Deschamps p. 144, *148*

Clarke, Henry ... p. *151,* 198-199, 208

Collins, Liz .. p. 91

Daguerre, Louis-Jacques-Mandé p. 29

De Briey, Quentin .. p. *150*

Deschamps, Thomas and Julien Claessens p. 144, *148*

Edelman, Bina .. p. *212*

Elgort, Arthur ... p. 180

Ellis, Sean .. p. 168

Escobosa, Ramòn and Mélanie Lyon p. 122

Ferrari, Pierpaolo and Maurizio Cattelan p. 106-109, *149*

Frotin, Erwan ... p. *148*

Giacobetti, Valentin ... p. 51

Goldberg, Nathaniel ... p. 49

Guéguan , Jean-Louis p. 192

Hamani, Laziz ... p. 140, *147*

Harris, Gregory .. p. 52

Harris, Sarah .. p. *39*

Hassett, Ben ... p. 88-89

Hetta, Julia .. p. *33,* 115-119, *148*

Horst, P Horst .. p. *34, 150,* 205

Hoyningen-Huene, George p. *34*

Jansson, Mikael .. p. 65

Jelenska, Philipp .. p. 44

Jouanneau, Daniel .. p. 165

Kollar, François ... p. *150*

K.T. .. p. 61

Lawrence, Robbie .. p. 98-99

Le Goues, Thierry .. p. 81

Lotus, Greg .. p. *31,* 72

Lyon, Mélanie and Ramòn Escobosa p. 122

Maillet, Eric ... p. 62

Malerbi Denis ... p. 181

Martinez Leclerc, Julien p. 120-121, *152*

Matadin, Vinoodh and Inez van Lamsweerde p. 55, 78-79, 160

McDean, Craig .. p. 175

McFarlan Pond, Toby p. 39, 56, 63

Meerson, Harry .. p. 149

Meier, Raymond .. p. 169

Milon, Candice .. p. 32

Mitchell, Jem .. p. 70

Mocafico, Guido p. 26, 28, 36, 82,

.. 147, 156

Mongiello, Mauro and Sofia Sanchez p. 125

Morel, Paul .. p. 45

Munro, Tom .. p. 36, 75

Musso, Franco and Luciana Val p. 95

Nadar, Paul .. p. 151

Negre, Charles .. p. 53

Niedermair, Brigitte...................................... p. 57

Niépce, Joseph Nicéphore................................ p. 29

Noni, Julia.. p. 123

Norguet, Sophie p. 212

Porodina, Elizaveta p. 18-24, 38,

.. 101-102, 152

Pfeiffer, Walter p. 87

Pottier, Philippe p. 204

Rankin .. p. 34, 158-159

Rémy-Lonvis, Maud p. 142-143, 147

Rheims, Bettina p. 28, 154-155,

.. 170-173

Rouchon, Jacques p. 197, 201, 203

Roversi, Paolo p. 32, 34, 152

Sadli, Karim p. 11-16, 129-130, 150

Sanchez, Sofia and Mauro Mongiello p. 95

Sasha .. p. 37, 206-207

Sassen, Viviane p. 133-135, 150

Schall, Roger p. 146

Schaumburg, Timothy p. 26, 104-105, 150

Schirmacher, Tom p. 28, 77

Sjodin, Andreas p. 86

Sorrenti, Mario p. 26, 138, 146

Steichen, Edward p. 35

Stupakoff, Otto p. 188-189

Summerton, Emma p. 150

Tempest, Emma p. 71

Testino, Mario p. 157

Trautman, Mathieu p. 66

Troost, Amy p. 68

Vadukul, Max p. 176-177

Val, Luciana and Franco Musso p. 95

Van Lamsweerde, Inez and Vinoodh Matadin p. 55, 78-79, 160

Van Sommers, Jenny p. 38, 59, 164

Villiard, Sabine p. 39, 67

Von Unwerth, Ellen p. 34, 42-43, 80,

.. 162-163

Wales, Charlotte p. 58

Wetherell, Paul p. 76

The authors

Carol Woolton
Jewellery historian, author, and editor-in-chief of the jewellery section of *British Vogue* for over twenty years. She was the first editor-in-chief of the jewellery section at *Tatler* magazine and has contributed to numerous magazines worldwide, including *The Financial Times, Vanity Fair, Air Mail, Vogue,* and *The Daily Telegraph.* She curates jewellery exhibitions and has published five books on antique and iconic jewellery as well as contemporary styles.
Her recent publications include *Vogue: The Jewelry* exploring a century of style and *The New Stone Age.*

Sylvie Lécallier
Curator in charge of photographic collections at Palais Galliera, Fashion museum of Paris. With extensive experience in curating exhibitions, including *Henry Clarke, Fashion Photographer.* She was notably responsible for the centennial retrospective of *Vogue Paris* magazine in 2021 and the monographic *Paolo Roversi* exhibition in 2024. Additionally, she is the author of numerous books on photography and she regularly contributes to the *Fashion Eye* series by Louis Vuitton Éditions.

Flora Triebel
Former student of the École Normale Supérieure de la rue d'Ulm, curator responsible for the 19th-century photography collection at the Prints and Photography Department of the National Library of France. She teaches Photography history at the École du Louvre. She was co-curator at the BnF of the exhibitions *Degas in Black and White* (2023) and *Black & White, aesthetic of photography* (2024). Her research focuses on the history of photography. Her text highlights the pioneering and innovative use of photography by Chaumet, a connection woven by Joseph Chaumet that continues to this day.

Acknowledgments

Chaumet warmly thanks authors Carol Woolton, Sylvie Lécallier, and Flora Triebel, without whom this book could not have come to life. It also thanks its collaborators who each contribute, in their own way, to the radiance of the Maison. This unique work is a testament to the pride of belonging to Chaumet, shared with all those who have passionately and excellently built its history and reputation for over 240 years.

Flora Triebel extends her heartfelt thanks to the Chaumet heritage team, especially Violaine Bigot, Thibault Billoir, Michaël Lepage and Alix Moreau.

Photo credits

All the jewels in this book are Chaumet's, with the exception of the following pieces: men's ring p. 58, earrings p. 71, necklace p. 76, earrings and necklace p. 82, bracelets and rings p. 207.

Every effort has been made to contact the copyright holders of the images reproduced in this book. Any omissions will be rectified in subsequent printings if notice is given to the publisher.

Cover and p. 11-16: © Karim Sadli / Art + Commerce; artistic direction Spela Lenarcic / 3rd Man; models Alix Bouthors / Apparence Agency, Cheikh Diakhate / Elite Paris; hair Stéphane Lancien / Calliste Agency; makeup Christelle Cocquet / Calliste Agency; manicure Julie Villanova / Walter Schupfer Management; clothing Dilek Hanif / Station Service, Dice Kayek / Station Service, Sean Suen / PR Consulting, Figaret, Mugler / KCD, Dior Men, Mokuba / DM Media, Akris, Jarel Zhang / Totem Fashion, Rami Al Ali / Station Service.

Cover and p. 18-24: © Elizaveta Porodina / Concrete Rep; artistic direction Spela Lenarcic / 3rd Man; model Maike Inga / Women Management; hair Claire Moore / Streeters; makeup David Koppelaar / Bryant Artists; manicure Brenda Abrial / Wise and Talented; scenery Emilia Margulies / Concrete Rep; clothing Stéphane Rolland / Station Service, Natan Couture / Caroline Charles Communication, Theunissen / Totem Fashion, Marciano by Guess / Dresscode, Pain de Sucre / Dresscode, Fendi, Akris.

p. 42-43: © Ellen von Unwerth / Trunk Archive; models Cindy Bruna / Makers by Metropolitan Models, Émile Fofana / Kult Models, Gabriel Ahmed / MGM Models.

p. 44: © Philipp Jelenska / Trunk Archive; model Amira Al Zuhair / Next Models Paris.

p. 45: © Paul Morel / Trunk Archive; model Liu Xinjie.

p. 46: © Blandine Chabani / Trunk Archive.

p. 47 : © Lachlan Bailey / Art Partner / Trunk Archive; model Rianne van Rompaey @ Viva Model Management.

p. 48: © Nathaniel Goldberg / Trunk Archive; model Rebecca Leigh Longendyke / Women Management Paris.

p. 51: © Valentin Giacobetti; model Marie-Agnès Diène / The Claw Models.

p. 52: © Gregory Harris.

p. 53: © Charles Negre / Carole Lambert; model Francis Villalva / Success Models.

p. 55: © Inez Van Lamsweerde and Vinoodh Matadin / Trunk Archive; model Arizona Muse / Oui Management.

p. 56: © Toby McFarlan Pond / Trunk Archive.

p. 57: © Brigitte Niedermair.

p. 58: © Charlotte Wales / Trunk Archive; models Anna Ewers / Women Management Paris; Lukas Ionesco / Safe Management.

p. 59: © Jenny van Sommers / Trunk Archive.

p. 61: © K.T / Trunk Archive; model Ella Merryweather / Kult Models.

p. 62: © Eric Maillet / Trunk Archive.

p. 63: © Toby McFarlan Pond / Trunk Archive.

p. 65: © Mikael Jansson / Trunk Archive; model Edie Campbell / Viva Model Management.

p. 66: © Mathieu Trautmann / Trunk Archive.

p. 67: © Sabine Villiard / Trunk Archive.

p. 68: © Amy Troost / Trunk Archive; model Ari Westphal / New Madison.

p. 70: © Jem Mitchell / Trunk Archive; model Mae Laprès / Lola Management.

p. 71: © Emma Tempest / Trunk Archive; model Soekie Gravenhorst.

p. 72: © Greg Lotus / Trunk Archive; model Liza Ostanina / Marilyn Agency.

p. 73: © John Akehurst / Trunk Archive; model Josefien Rodermans / Touche Models.

p. 75: © Tom Munro / Trunk Archive; Bérénice Bejo.

p. 76: © Paul Wetherell / Trunk Archive; model Sibui Nazarenko / Grace Models.

p. 77: © Tom Schirmacher / Trunk Archive; model Dorothea Barth-Jorgensen / Mikas Models.

p. 78-79: © Inez Van Lamsweerde and Vinoodh Matadin / Trunk Archive; model Edie Campbell / Viva Model Management.

p. 80: © Ellen von Unwerth / Trunk Archive.

p. 81: © Thierry Le Goues / Trunk Archive; model Anastasia Lagune / Vivienne Models.

p. 82: © Guido Mocafico, 2013; director: Spela Lenarcic; post-production: Marie Zacchi; sosie.

p. 84-85: © Miles Aldridge / Trunk Archive; models Kätlin Aas / Supreme Management, Luis Batalha, Youri Dedeurwaerde, Nicolas Kaintoch / Elite Paris.

p. 86: © Andreas Sjodin / Trunk Archive; Marine Vacth.

p. 87: © Walter Pfeiffer / Trunk Archive; model Laetitia Casta / Viva Model Management.

p. 88-89: © Ben Hassett / Trunk Archive; model Constance Jablonski / Viva Model Management.

p. 91: © Liz Collins / Trunk Archive; model Jourdan Dunn / The Squad Management.

p. 92: © Nobuyoshi Araki, courtesy of the artist and the office of Yoshiko Isshiki, Tokyo.

p. 95: © Luciana Val and Franco Musso / Trunk Archive; model Mona Johannesson / Le Management.

p. 96: © Richard Burbridge / Art + Commerce; model Stella Tennant / Viva Model Management.

p. 98-99: © Robbie Lawrence; model Coco Rocha / Girl Management.

p. 101-102: © Elizaveta Porodina /
Concrete Rep / Trunk Archive;
models Aylah Peterson / Oui Management.

p. 104-105: © Timothy Schaumburg;
model Henry Makuntima / Premium Models.

p. 106-109: © Maurizio Cattelan and Pierpaolo
Ferrari; courtesy of TOILETPAPER Magazine;
artistic direction 3rd Man.

p. 111: © Cédric Bihr; model Henry
Makuntima / Premium Models.

p. 112: © Cédric Bihr; model
Lisa Louis Fratani / Titanium Management.

p. 113: © Cédric Bihr;
model Cynthia Wrobel / Premium Models.

p. 115: © Julia Hetta / Art + Commerce;
model Brooke Elaine Durrant.

p. 116-117: © Julia Hetta / Art + Commerce;
models Avril Diaz / Premium Models,
Estella Boersma / Viva Model Management.

p. 118: © Julia Hetta / Art + Commerce,
model Anna Valahu / City Models.

p. 119: © Julia Hetta / Art + Commerce,
model Natsuko Natsuyama / Marylin Agency.

p. 120-121: © Julien Martinez Leclerc -
Art Partner / Trunk Archive; model
Anna de Rijk / Viva Model Management.

p. 122: © Mélanie Lyon and Ramòn Escobosa;
model Sarah van der Hoek / VDM Models.

p. 123: © Julia Noni / Trunk Archive;
Cindy Bruna / Makers by Metropolitan Models.

p. 125: © Sofia Sanchez and Mauro
Mongiello / Trunk Archive;
model Valery Kaufman / Elite Models.

p. 126-127: © Richard Burbridge /
Art + Commerce; Diane Kruger.

p. 129-130: © Karim Sadli / Art + Commerce;
model Giedre Dukauskaite /
Women Management.

p. 133-135: © Viviane Sassen / We Folk; model
Anjali Torvi / Viva Model Management.

p. 136-137: © Cédric Bihr;
model Paula Soares / Select Models.

p. 138: © Mario Sorrenti-Art Partner /
Trunk Archive; Marine Vacth.

p. 140: © Laziz Hamani.

p. 142-143: © Maud Rémy-Lonvis.

p. 144: © Julien Claessens
and Thomas Deschamps.

p. 154-155: © Bettina Rheims / Adagp,
Paris 2006; model Jessica Miller /
Next Management.

p. 156: © Guido Mocafico, 2006; post-
production Marie Zacchi; director: Capucine
Safyurtlu; ant master: Alain Roussel.

p. 157: © Mario Testino – Art Partner;
model Kate Moss / KMAgency.

p. 158-159: © Rankin / Trunk Archive;
model Heidi Klum / HK New York.

p. 160: © Inez Van Lamsweerde and Vinoodh
Matadin / Trunk Archive; Sophie Marceau.

p. 162-163: © Ellen von Unwerth / Trunk Archive.

p. 164: © Jenny van Sommers / Trunk Archive.

p. 165: © Daniel Jouanneau / Condé Nast.

p. 166-167: © Miles Aldridge / Trunk Archive;
model Anastassia Khozissova.

p. 168: © Sean Ellis;
model Colette Pechekhonova.

p. 169: © Raymond Meier.

p. 170-173: © Bettina Rheims / Adagp, Paris 1996;
model Sibyl Buck / Oui Management.

p. 175: © Craig Mc Dean / Art+Commerce;
model Amber Valletta /
Women Management Paris.

p. 176-177: © Max Vadukul;
model Karen Mulder.

p. 178-179: © The Guy Bourdin Estate 2024,
courtesy of Louise Alexander Gallery.

p. 180: © Arthur Elgort / Condé Nast;
model Kim Alexis.

p. 181: © Denis Malerbi.

p. 182-187: © The Guy Bourdin Estate 2024,
courtesy of Louise Alexander Gallery.

p. 186: model Donna.

p. 188-189: © Otto Stupakoff / Condé Nast;
Isabelle Adjani.

p. 190: © The Guy Bourdin Estate 2024,
courtesy of Louise Alexander Gallery;
model Carol Singleton.

p. 192: © Jean-Louis Guégan, rights reserved.

p. 193: © Roland Bianchini / BNF.

p. 194: © David Bailey / Condé Nast;
model Carol Labrie.

p. 197: © Jacques Rouchon;
model Dorian Leigh.

p. 198-199: © Henry Clarke,
Musée Galliera / Adagp, Paris 1955.

p. 200: © Louis-René Astre.

p. 201: © Jacques Rouchon;
model Ivy Nicholson.

p. 203: © Jacques Rouchon.

p. 204: © Philippe Pottier / BNF;
model Sophie Litvak.

p. 205: © Horst P. Horst / Condé Nast;
model Toto Koopman.

p. 206-207: © Sasha / Hulton Archive /
Getty Image; Yvonne Printemps.

p. 208: © Henry Clarke / Condé Nast;
model Anne Gunning Parker.

p. 210, 215, 219-232: © Chaumet collections,
rights reserved.

CHAUMET, PARIS

Chief Executive Officer
Charles Leung

**Global Chief Marketing
and Communications Officer**
Raphaël Mingam

**International Director
of Contents and Publications**
Isabelle Vilgrain

Senior Contents Project Manager
Hélène Yvert

Assistant Contents Project Manager
Emma Janin-Sartor

CITADELLES & MAZENOD, PARIS

Chief Executive
Matthieu de Waresquiel

Editor in Chief
Geneviève Rudolf

Editor
Valérie Viscardi

Art Director
Olivier Foltzer - Studio Foltzer

Photographic research
Patrick Rémy Studio

**Orders and authorisations
for photographers and models**
Marjorie van Hoegaerden

Translation and Proofreading
mot.tiff inside

Photo-engraving
Grafiche Milani, Milan

This book is set in Exposure, a typeface designed by Federico Parra Barrios in 2022 and distributed by 205TF.

The book is printed on a selection of papers: the texts are on Arena Natural Rough 140 g, the "Anthology" sections on Symbol Freelife Gloss 170 g, the "New shared perspectives" chapter on Symbol Matt Plus 170 g and "The Studio of Joseph Chaumet" on Symbol Freelife Satin 150 g. These papers come from sustainably managed forests.

This book is published with two different covers, each reproducing a photograph specifically taken for this publication, by Karim Sadli and Elizaveta Porodina respectively (see photo credits on page 238).

This book was printed in Italy on the presses of Grafiche Milani Spa, in July 2024.

© 2024, Editio – Citadelles & Mazenod
8, rue Gaston-de-Saint-Paul, 75116 Paris
www.citadelles-mazenod.com
© Carol Woolton, 2024
© Sylvie Lécallier, 2024
© Flora Triebel, 2024

ISBN : 978 2 85088 956 1
Legal deposit: November 2024

In accordance with the French Intellectual Property Code, this book may not be reproduced, in whole or in part, in any form, without written permission from the publisher or the Centre Français d'Exploitation du Droit de Copie (18, rue du Quatre-Septembre, 75002 Paris, France).